ALONG THE RIVERBANK

Chinese Paintings from the

C. C. Wang Family Collection

Maxwell K. Hearn Wen C. Fong

The Metropolitan Museum of Art, New York

Distributed by Harry N. Abrams, Inc., New York

This catalogue is published in conjunction with the exhibition "The Artist as Collector: Masterpieces of Chinese Painting from the C. C. Wang Family Collection," held at The Metropolitan Museum of Art, New York, September 3, 1999–January 9, 2000.

The exhibition and catalogue are made possible with the support of the Tang Fund.

Published by The Metropolitan Museum of Art
John P. O'Neill, Editor in Chief
Emily Walter, Editor
Bruce Campbell, Designer
Gwen Roginsky and Hsiao-ning Tu, Production
Ilana Greenberg, Desktop Publishing

Color photographs in this publication are by Bruce Schwarz, The Photograph Studio, The Metropolitan Museum of Art. Photographs of *Riverbank* (pl. 1) are by Malcolm Varon.

Riverbank (pl. 1) has been reproduced in a tone that is lighter than the original painting in order that the drawing is more easily legible.

Typeset in Centaur by Professional Graphics Inc., Rockford, Illinois
Printed on 148 gsm Aberdeen Silk
Duotones and color separations by Professional Graphics Inc., Rockford, Illinois
Printing and binding by CS Graphics PTE Ltd., Singapore

Jacket/Frontispiece: Attributed to Dong Yuan (active 930s–60s), *Riverbank*. Details, plate 1

LIBRARY OF CONGRESS CATALOGING-IN-PUBLICATION DATA
Hearn, Maxwell K.
 Along the riverbank: Chinese painting from the C. C. Wang family collection/
Maxwell K. Hearn, Wen C. Fong
 p. cm.
 Includes bibliographical references and index.
 ISBN 0–87099–905–2 (hc).—ISBN 0–8109–6541–0 (Abrams)
 1. Painting, Chinese Catalogues. 2. Wang, Chi-ch'ien—Art collections Catalogues.
I. Fong, Wen. II. Metropolitan Museum of Art (New York, N.Y.) III. Title.
NDI043.3H43 1999 99–27286
759.951′074′7471—dc21 CIP

Contents

Director's Foreword

This publication celebrates the promised gift to the Metropolitan Museum by the Oscar Tang family of twelve masterworks from the C. C. Wang Family Collection. Ranging in date from the tenth to the early eighteenth century, these works significantly extend the Museum's holdings. One of the foremost collectors of Chinese painting in the twentieth century Ch'i-ch'ien Wang, a resident of New York City since 1949, is also an accomplished artist who has collected paintings since he began practicing his own art in China more than seventy years ago, when he was in his early twenties. For Mr. Wang, collecting has always been a means of enriching his knowledge of the styles of earlier masters. Studying in Shanghai in the 1930s with the artist-connoisseur Wu Hufan, Mr. Wang learned by viewing, copying, and creatively reinterpreting masterpieces from the orthodox traditions of scholarly art. His tastes later broadened to include outstanding works in all the major schools and genres of Chinese painting.

In the course of this long career, Mr. Wang has assembled the most comprehensive private collection of Chinese old master paintings formed since the seventeenth century, with particular strengths in monumental landscape painting of the tenth and eleventh centuries, Song figure paintings of the twelfth and thirteenth centuries, Yuan scholar painting of the fourteenth century, and Qing orthodox and individualist paintings of the seventeenth century. Works from the C. C. Wang Family Collection, long known to Western scholars and connoisseurs, are in many American public institutions and universities including those in Cleveland, Boston, San Francisco, Chicago, and Princeton. But by far the largest concentration of paintings—some sixty works—is now at the Metropolitan Museum.

The process whereby so many of Mr. Wang's treasures came to the Metropolitan began in 1973, when the Museum acquired twenty-five Song and Yuan masterpieces with the help of Douglas Dillon and the Dillon Fund as a first step toward expanding

its holdings of Asian art. Since that time, twenty-three additional works have come to the Museum from other collections. The twelve paintings presented here constitute yet another important group of paintings assembled by Mr. Wang.

At the time of the Museum's initial acquisition in 1973, the Metropolitan lacked even a permanent space for the display of Chinese painting. Twenty-five years later, in 1998, the Museum completed an entire wing devoted to Asian art, a virtual museum within a museum, incorporating the largest permanent exhibition space for Chinese painting and calligraphy outside Asia. This space includes the renovated Douglas Dillon Galleries, first opened in 1981, as well as two new galleries, the C. C. Wang Gallery and the Frances Young Tang Gallery, the latter named in honor of Oscar Tang's late wife. This dramatic transformation in the Museum's capacity to display Chinese painting would not have been possible without the support of many generous patrons and collectors, foremost among them Douglas Dillon, John M. Crawford Jr., Robert H. Ellsworth, John B. Elliott, Earl Morse, and the members of the P. Y. and Kinmay W. Tang family. The promised gift from the Oscar Tang family represents another major addition.

This volume is published on the occasion of the exhibition "The Artist as Collector: Masterpieces of Chinese Painting from the C. C. Wang Family Collection," which includes most of the works acquired by the Metropolitan from Mr. Wang together with a selection of loans both from the family and from other sources. For the opportunity to preserve and exhibit these masterpieces, we are indebted to the generosity of many donors and patrons, in particular Museum trustees Douglas Dillon and Oscar Tang, and, of course, C. C. Wang and his family.

Philippe de Montebello
Director

Acknowledgments

The opportunity to acquire, preserve, study, and publish the works catalogued here as part of the permanent collection of the Metropolitan Museum is due to the generosity of many friends and colleagues. Above all, we are grateful to C. C. Wang and his family—particularly his daughter Y. K. Wang and his son S. K. Wang—who have steadfastly supported the goal of preserving the core of the Wang Family Collection intact at the Metropolitan. Long a resident of New York City, Mr. Wang has always believed that his collection could best serve the interests of the field within the context of American public collections, and he shares the Museum's commitment to making these works of art accessible to the widest possible audience. In concluding the negotiations for this group, Mr. Wang observed that each work was like a cherished daughter for whom it was his responsibility to find the right match. We are honored by his trust.

Oscar L. Tang and his family have enthusiastically supported this entire project: the acquisition of these works of art as promised gifts to the Metropolitan, their display in the Museum's recently renovated and expanded permanent display space, including the Frances Young Tang Gallery, named for Mr. Tang's late wife, and the publication of these works in this volume. Without their generous and enlightened patronage, this endeavor would not have been possible.

Research on these works was greatly aided by a number of colleagues. We would like in particular to thank Kathleen and Dennis Yang for their unstinting generosity in sharing their research on the collectors' seals impressed on *Riverbank*, and Mr. Ding Xiyuan, who made available his photographs of Xu Beihong's letter detailing his acquisition of this painting. Professor Qi Gong of Beijing Normal University shared his insights about the inscription on *Riverbank*, and Professor Fu Xinian of the Research Institute of Chinese Architecture, Beijing, offered helpful comments about both *Riverbank* and *Palace Banquet*. Joseph Chang, formerly Research Associate at the Metropolitan Museum and now Associate Curator of Chinese Art at the Freer Gallery of Art in Washington, assisted with the initial transcription of seals and inscriptions on all the paintings presented here. Yiguo Zhang, Research Associate at the Metropolitan, continued this work and spent countless hours tracking down note references and illustrations. Douglas Dillon, Professor Richard Barnhart of Yale University, Kathleen Yang, and C. C. Wang all read early versions of Wen Fong's essay

and offered helpful comments. Thanks are due also to all of those colleagues whose institutions graciously provided photographs of works in their collections.

In the Museum's Starr Asian Art Conservation Studio, Takemitsu Oba, Starr Conservator, and Sondra Castile, Conservator, restored, remounted, and significantly extended the life of many of these works. They also created the detailed map of restorations on *Riverbank* that enables us to see clearly what remains of the original painting.

We are greatly indebted to members of the Museum's Photograph Studio under the direction of Barbara Bridgers, particularly photographers Bruce Schwarz and Oi-Cheong Lee, whose conventional and digital images have enabled us to see these works more clearly, and printer Robert L. Goldman, whose computer enhancements rendered legible many of the seals on these paintings. The darkened surface of *Riverbank* presented a particularly difficult challenge and we are grateful to photographer Malcolm Varon for the highly readable images of that painting reproduced here.

In preparing the manuscript for publication, we greatly benefited from the high standards and professionalism of the Museum's Editorial Department under Editor in Chief John P. O'Neill. Emily Walter, editor extraordinaire, devoted her energy, patience, and thoughtful consideration to the numerous drafts of our manuscripts in a never-ending effort to make our comments clear, concise, and worthy of the paintings about which we have written. Bruce Campbell transformed images and text into a beautifully integrated design. Hsiao-ning Tu, under the supervision of Gwen Roginsky, took responsibility for all aspects of the book's production. Ilana Greenberg was responsible for the desktop publishing. And Jean Wagner tirelessly and meticulously edited every note and compiled the bibliography.

Our families have been very supportive of our efforts and indulgent of our time; heartfelt thanks to Vera, Connie, Garrett, and Alex for their warm encouragement and good humor, particularly in graciously allowing the preparation of this book to intrude on many evenings and weekends.

Because of the generosity, knowledge, and support of all these people, we have been granted the privilege of studying these wonderful works of art and of sharing our appreciation with a wider audience. To them fell all the burdens, to us, all the pleasure.

Maxwell K. Hearn Wen C. Fong

ALONG THE RIVERBANK

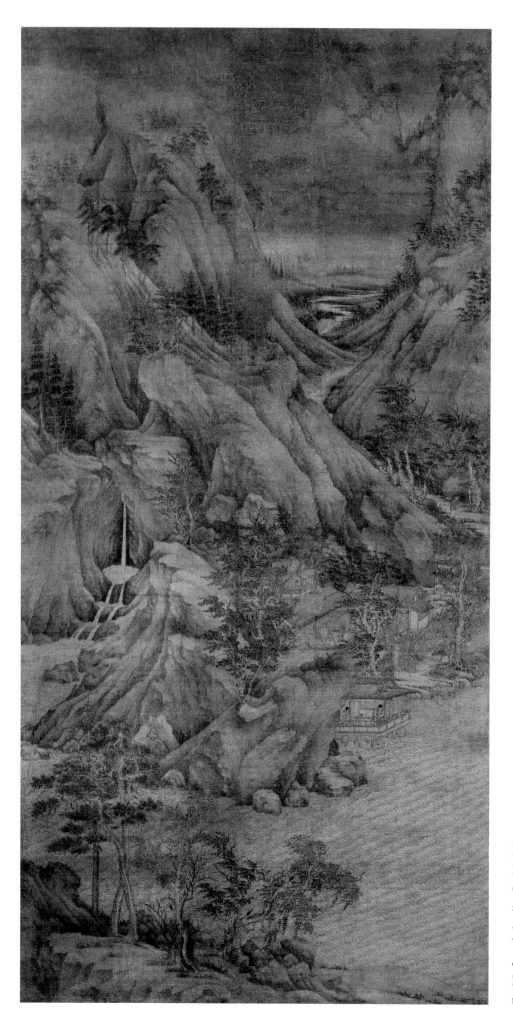

Plate 1. Attributed to Dong Yuan (active 930s– 60s), *Riverbank*. Hanging scroll, ink and color on silk, 87 x 42⅞ in. (221 x 109 cm). The Metropolitan Museum of Art. Ex. Coll.: C. C. Wang Family. Promised Gift of the Oscar L. Tang Family

Riverbank

Wen C. Fong

In 1955, a noted Hong Kong art dealer, J. D. Chen, published a catalogue of his collection of early Chinese paintings, *The Three Patriarchs of the Southern School of Chinese Painting*, in which he listed a large hanging scroll, *Travelers amid Autumn Mountains* (fig. 1), a modern forgery of a work by the early-tenth-century master Dong Yuan (active 930s–60s), as an original painting by Dong, a founding patriarch of the Southern school of Chinese landscape painting.[1] The basis for Chen's attribution was a colophon by the early-seventeenth-century painter and critic Dong Qichang (1555–1636) in "To See Large Within Small," an album of Song and Yuan landscape compositions by Chen Lian (active early 17th century) dating to soon after 1627.[2] Included in the album was a reduced copy of a composition by the Yuan master Wang Meng (ca. 1308–1385; fig. 2). The colophon reads:

> Wang Meng's *After Dong Yuan's "Travelers amid Autumn Mountains"* was once in my collection. When I saw this work, I recognized that it derived from Dong Yuan. A masterwork, it was done before Wang Meng transformed the earlier master's style.

Chen assumed that the hanging scroll in his collection was the same work referred to by Dong Qichang in his colophon. The attribution thus appeared to be supported by both Wang Meng and Dong Qichang.

In early Chinese painting no attribution can be accepted without careful examination. There is general agreement that the two finest surviving examples of early Chinese monumental landscape painting are believably signed works by Fan Kuan (active ca. 990–1030; fig. 3) and Guo Xi (ca. 1000–ca. 1090; fig. 4). Predating these masters, the founding fathers of the landscape tradition, Jing Hao (ca. 870–930), Guan Tong (active ca. 907–23), and Li Cheng (919–967) in the north and Dong Yuan and Juran (active ca. 960–95) in the south, are known only by paintings attributed to them rather than by authenticated works, or they are known through later copies. A court painter of the Southern Tang kingdom in Nanjing, Dong Yuan is of particular significance to this tradition because works attributed to him inspired major changes in later landscape painting. Leading landscape masters from the Yuan dynasty (1279–1368) through the early twentieth century have sought to re-create Dong Yuan in their own works, while critics and art

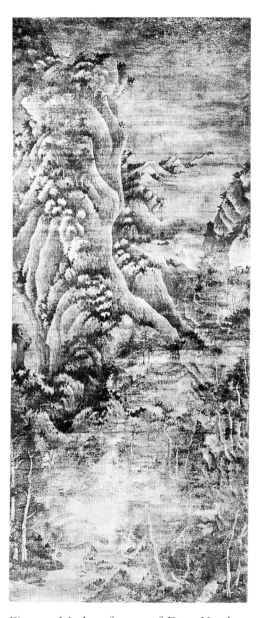

Figure 1. Modern forgery of Dong Yuan's *Travelers amid Autumn Mountains*. Hanging scroll, ink and color on silk, 94 x 38½ in. (246.5 x 97.8 cm). Formerly J. D. Chen Collection

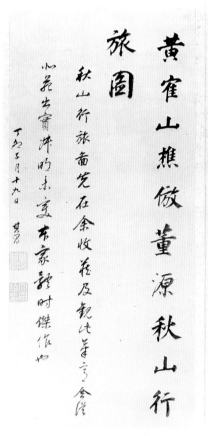

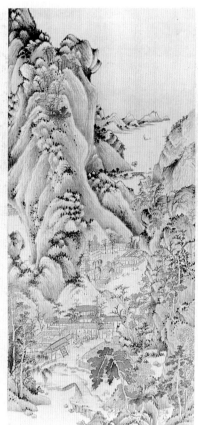

Figure 2. Chen Lian (active early 17th century), *After Wang Meng's "Travelers amid Autumn Mountains,"* with facing page inscribed by Dong Qichang (1555–1636). From the album "To See Large Within Small," ca. 1627. Album leaf, ink on paper, 27⅝ x 15⅞ in. (70.2 x 40.2 cm). National Palace Museum, Taipei

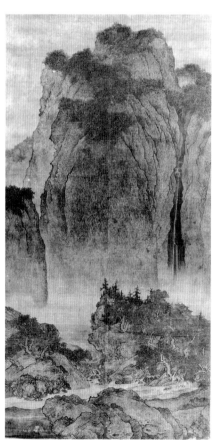

Figure 3. Fan Kuan (active ca. 990–1030), *Travelers amid Streams and Mountains*, ca. 1000. Hanging scroll, ink and color on silk, 81¼ x 40⅝ in. (206.3 x 103.3 cm). National Palace Museum, Taipei

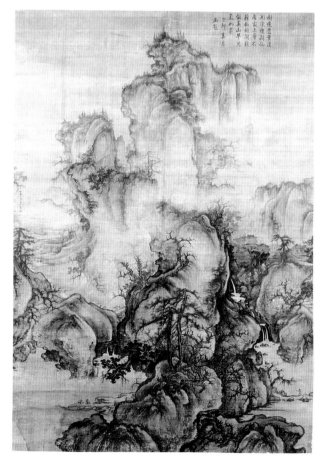

Figure 4. Guo Xi (ca. 1000–ca. 1090), *Early Spring*, dated 1072. Hanging scroll, ink and color on silk, 62⅜ x 42½ in. (158.3 x 108.1 cm). National Palace Museum, Taipei

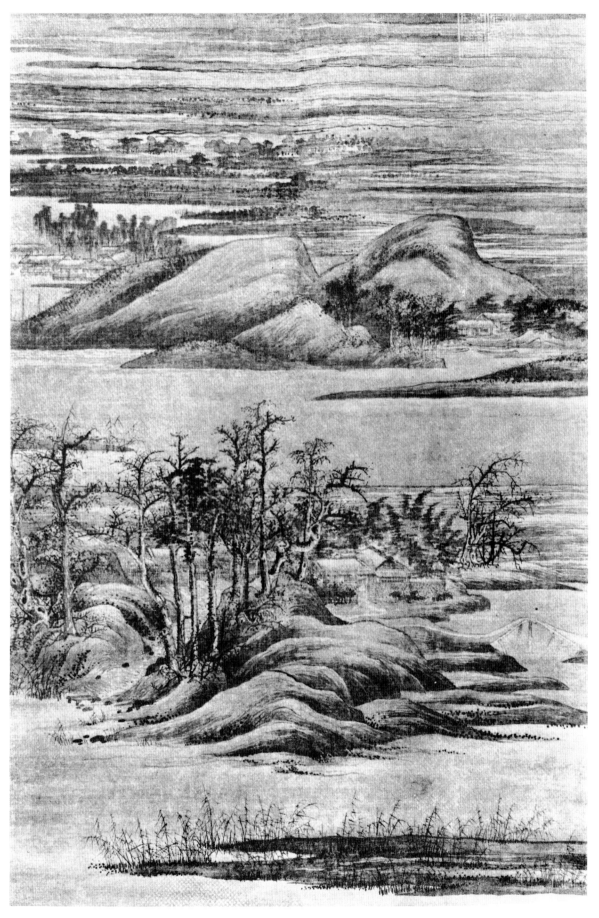

Figure 5. Attributed to Dong Yuan (active ca. 930s–60s), *Wintry Groves and Layered Banks*. Hanging scroll, ink and color on silk, 71½ x 45⅞ in. (181.5 x 116.5 cm). Kurokawa Institute of Ancient Cultures, Hyōgo Prefecture, Japan

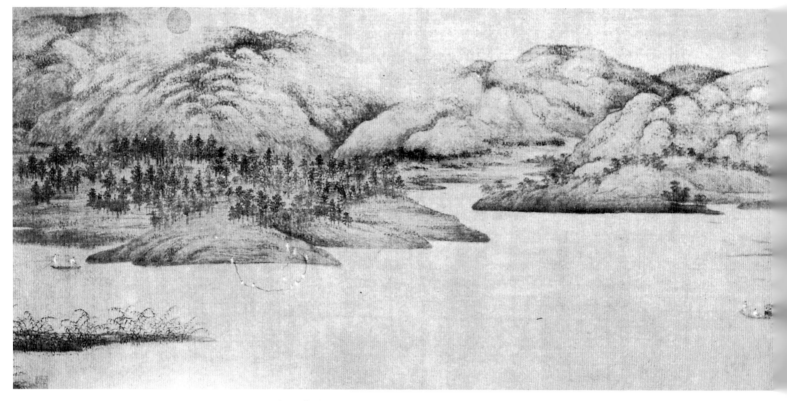

Figure 6. Unidentified artist (late 11th century), *After Dong Yuan's "The Xiao and Xiang Rivers."* Detail. Handscroll, ink and color on silk, 19¾ x 55½ in. (50 x 141 cm). Palace Museum, Beijing

1a. Detail, plate 1

historians have struggled to sort out the various works attributed to him. Until the early 1980s, two Dong Yuan compositions were recognized as best representing Dong's style: *Wintry Groves and Layered Banks* (fig. 5), datable stylistically to the tenth century, and *The Xiao and Xiang Rivers* (fig. 6), a close copy of Dong's late style dating to the late eleventh century.³ In 1983, Richard M. Barnhart proposed another painting, *Riverbank* (pl. 1), as an early work by Dong Yuan.⁴ To authenticate *Riverbank*, and to date it accurately, it is necessary to reconstruct the development of both early Chinese landscape painting and Dong Yuan's style as perceived by later painters and collectors through modern times.

RIVERBANK

Measuring 87 by 42⅞ inches, *Riverbank* is the tallest of all extant early Chinese landscape paintings, as compared with the most celebrated surviving Northern Song landscape hanging scroll, *Travelers amid Streams and Mountains* (fig. 3), by Fan Kuan, which measures 81¼ inches in height. In the lower-left corner is an inscription that reads: "Painted by the Assistant Administrator of the Rear Park, Servitor Dong Yuan" (1a). The imposing landscape, painted in monochrome ink with light colors on silk now darkened with age, shows in the foreground a pavilion structure at a river's edge (frontispiece); a scholar wearing a cap and gown, accompanied by his wife and child and a boy servant, sits in a yoke-back chair by the railing to look out on the gathering storm; beyond the pavilion great pines and deciduous trees along the riverbank bend omi-

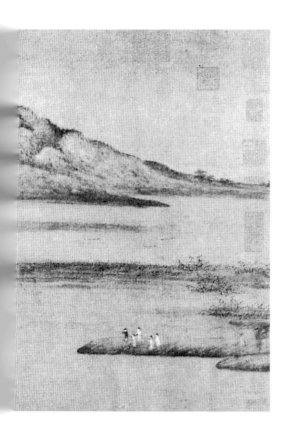

nously in the wind, and the water rises in choppy, netlike waves (pl. 1b). Behind the pavilion a steep foothill ascends leftward in a series of thrusting boulders, and to the left a waterfall rushes down to the river (pl. 1c). A winding pathway connects the foreground with a mist-covered river valley in the deep distance (pl. 1d), wild geese fly by in formation, and hills beyond the river loom under a darkening sky. Scurrying along the narrow path six travelers, one of them wearing a thatch cloak and hat, hurry back to the mountain villa through the rain. A boy on a water buffalo at water's edge heads toward a courtyard compound surrounded by a bamboo grove; inside the compound a woman prepares the evening meal while another woman carries a tray of food along the covered porch. With the family residence visible behind the courtyard, the master and his family assemble in the pavilion on the riverbank—a perfect metaphor for a safe haven in a threatening world.

In the most thorough analysis of *Riverbank* to date, Richard Barnhart has studied the painting's style, state of preservation, and collectors' seals, which range from the mid-thirteenth to the late-fourteenth century.[5] He observes that the painting is formed of two pieces of silk joined down the center (the left piece measures 20¼ inches in width, the right piece 23 inches in width). Noting that three important attributions to Dong Yuan's follower Juran measure, respectively, 22⅝, 23½, and 21⅞ inches in width, he concludes that 23 inches was the approximate width of silk rolls commonly used for paintings throughout the early Northern Song period.[6] He further suggests that in the fourteenth century the two panels of the painting were separated.

The chronological sequence of the seals on the painting begins with those of the late Southern Song prime minister Jia Sidao (1213–1275) and the collector Zhao Yuqin (late 13th century), a member of the Song imperial family, continues with three seals of the Yuan connoisseur Ke Jiusi (1290–1343), and ends with the official half-seal of the Ming imperial collection, which dates to about 1374–84.[7] Barnhart finds the seal evidence corroborated by the historical record: "Dong Yuan's *Riverbank*" is, for example, recorded by the late-thirteenth-century scholar-connoisseur Zhou Mi (1232–1298) as having been among the paintings in the collection of Zhao Yuqin; and in the collected works of Zhao Mengfu (1254–1322), the leading calligrapher and painter of the early Yuan, there is a poem entitled "For Dong Yuan's *Riverbank*."[8]

Barnhart compares *Riverbank* stylistically with authenticated works by two lesser tenth-century masters. And he discusses affinities with other Dong Yuan attributions. He concludes that "while there is no way to confirm or to deny the authenticity of

1b (overleaf). Detail, plate 1

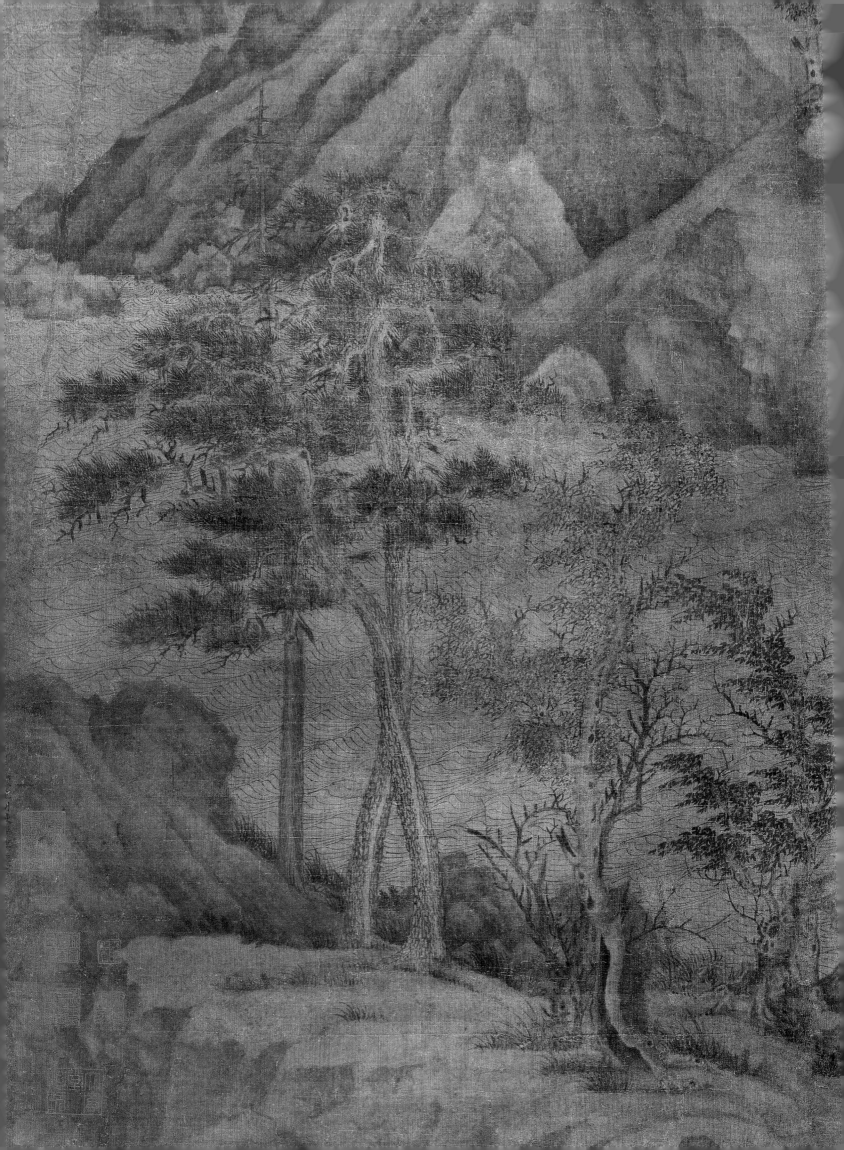

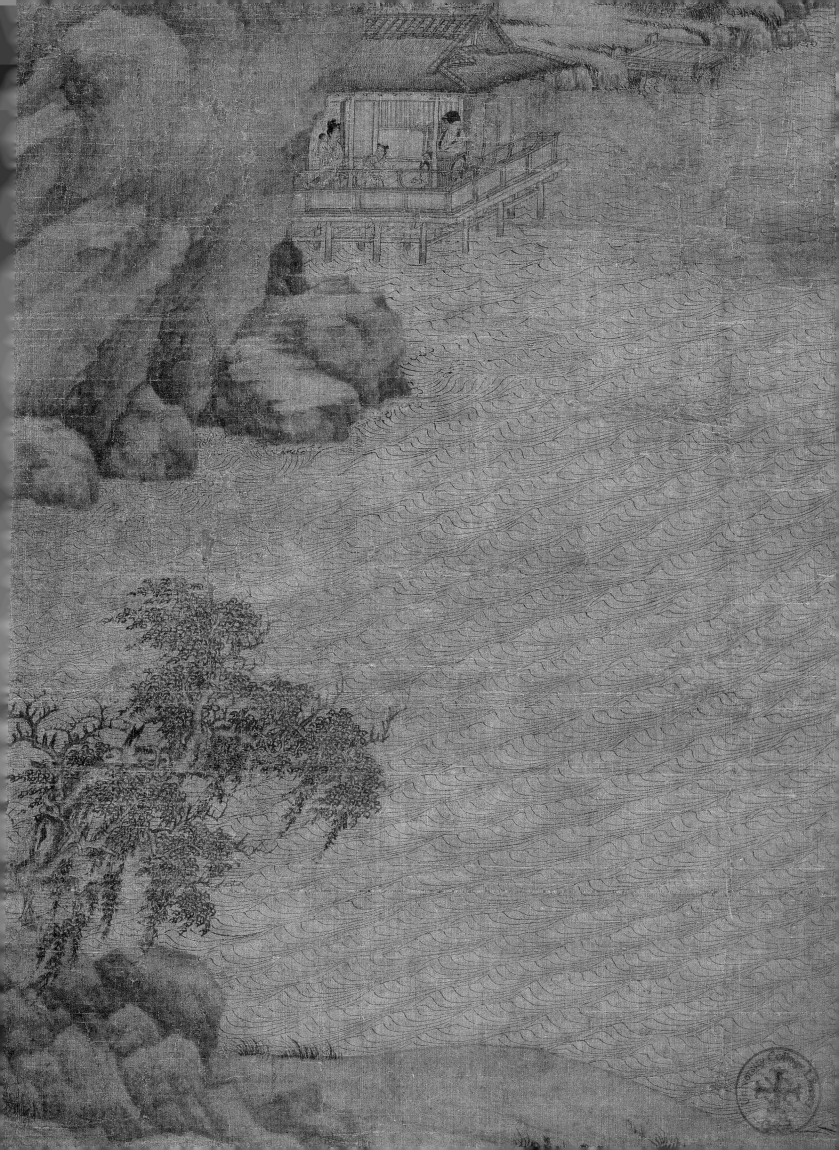

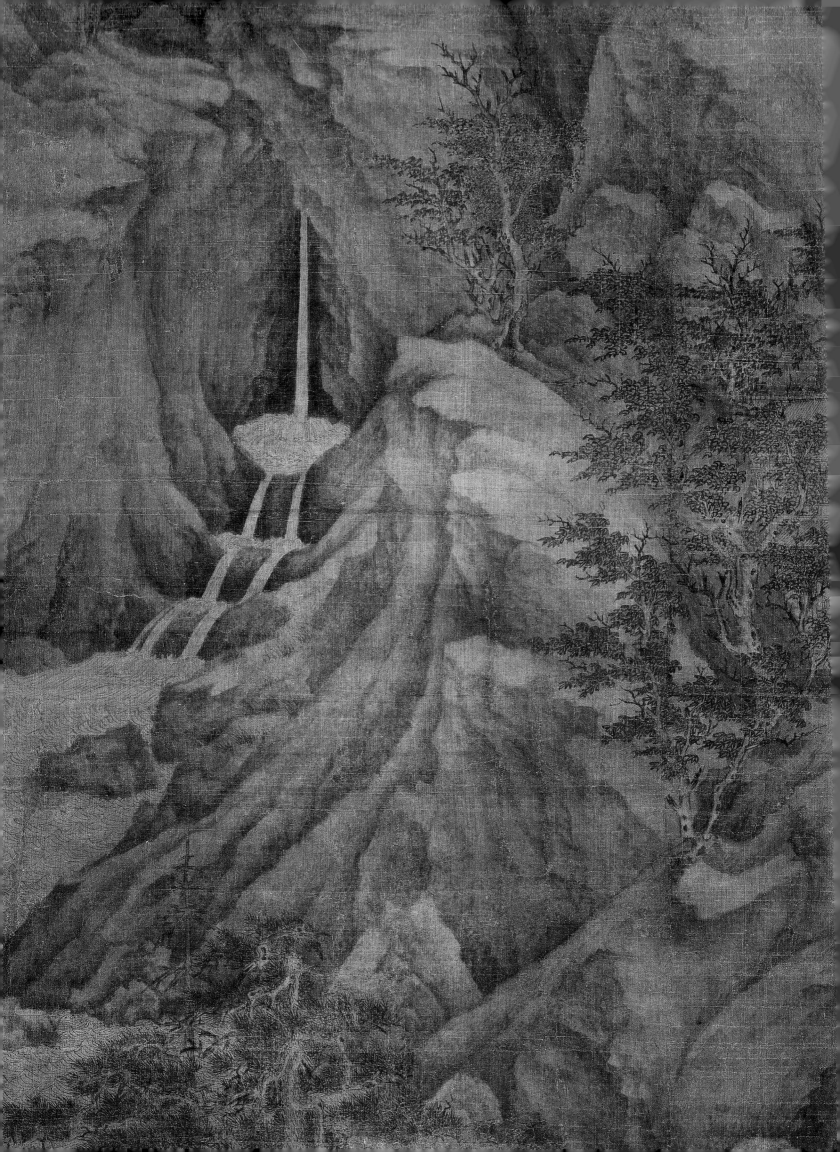

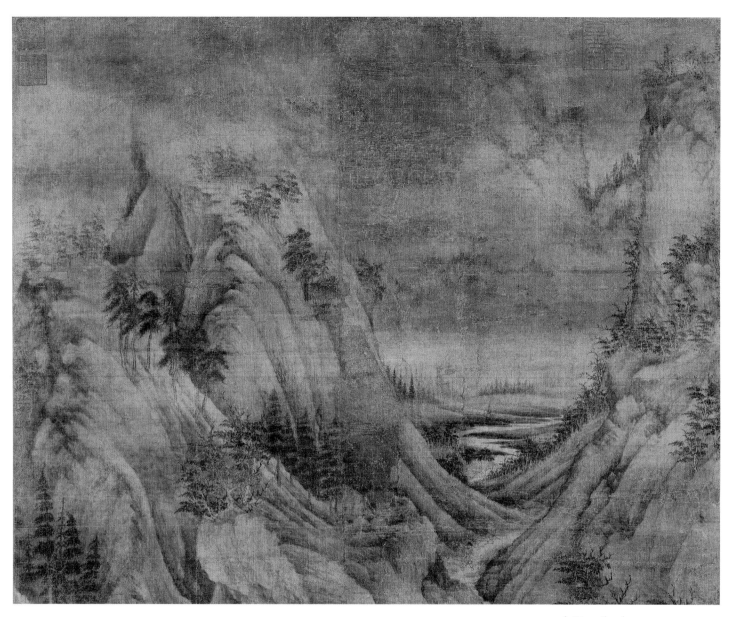

1d. Detail, plate 1

the signature, *Riverbank* gives every indication of being a tenth-century painting, and its importance to the history of Chinese landscape painting can scarcely be overstated."[9]

A different opinion has been expressed by James F. Cahill. In his *Index of Early Chinese Painters and Paintings*, published in 1980, Cahill lists the painting with the query: "Important early work? Or modern fabrication?"[10] And at a symposium on the modern Chinese painter Zhang Daqian (1899–1983), held on the occasion of an exhibition of his works in 1991, Cahill delivered a paper on Zhang as a forger of early Chinese paintings, citing *Riverbank* as one example of his handiwork. In support of his argument, Cahill offered the following description: "The whole composition, to my eye, is full of spongy, ambiguous forms and spatial contradictions." "Zhang was fond . . . of long, continuous, winding movements connecting near to far along ziz-zag streaks of white that can be either roads or rivers—and it is often unclear which. In *Riverbank*, what must be a distant river turns imperceptibly into a road with people walking on it.

1c (opposite). Detail, plate 1

Furthermore, the whole upper part is obscure, neither the top of the main mountain nor the distant ones to the right being really readable—not because of damage or concealing mist (which would be anachronistic in so early a work) but because they were never clearly painted in."[11]

To resolve the question of whether *Riverbank* is an important tenth-century work or a modern fabrication, a difference in date of a thousand years, we must better understand the way forms were conceptualized in different periods and the changing art-historical contexts in which such forms developed.[12] In Cahill's words, "Much hangs on the judgment of *Riverbank*. . . . To admit [it] into the small canon of believably signed, early Chinese paintings would allow us—or oblige us—to rewrite our histories."[13]

LANDSCAPE AS ARCHITECTURAL DECORATION

Screens decorated with landscape compositions were popular in China from the early Tang dynasty.[14] Fu Xinian has identified the hanging scroll *Riverboats, Storied Pavilions* (fig. 7), a blue-green landscape attributed to the eighth-century master Li Sixun (651-716), as the left panel of what was originally a three-fold landscape screen composition similar to that in the handscroll *Spring Outing* (fig. 8), attributed to the early-seventh-century painter Zhan Ziqian (ca. 550–604).[15] A six-fold screen dating to the late eleventh century in the Kyoto National Museum, *Landscape with Figures* (fig. 9), reflects a similar Tang model.[16] It is not unlikely that *Riverbank*, whose composition recalls both *Riverboats, Storied Pavilions* and the left side of *Spring Outing*, originally constituted the left panel of a three-panel screen similar to that seen in *Scholar Examining Books* (fig. 10), a handscroll attributed to another Southern Tang painter, Wang Qihan (active ca. 961–75). Assuming that the lost central panel was twice the width of each of the side panels, the original three-fold screen would have been four times the width of the present painting, measuring over seven feet high and fourteen feet wide.

To argue that *Riverbank* was the left panel of a horizontal screen composition, we may first examine other early landscape paintings in a vertical format. Beginning in the eighth century, as seen in paintings on lute plectra guards in the Shōsō-in Treasury, Nara (figs. 11a-c), three vertical schemata emerged as ways of representing landscape. As later described by Guo Xi, the leading landscape master of the eleventh century, a scene dominated by tall vertical peaks represents a "high-distance" view; a panorama filled by a series of horizontal elements is a "level-distance" view; and a composition combining the two creates a "deep-distance" view.[17] The Shōsō-in paintings are early examples of vertical landscape views, with the carefully chosen elements perfectly balanced and framed within the four borders of the composition. By comparison, *Riverbank* does not resemble these or any known early vertical compositions. Rather than rising vertically in a monolithic mass as in Fan Kuan's *Travelers amid Streams and Mountains* (fig. 3), the mountain boulders are stacked diagonally across the picture plane and the mountain slope in the upper-right corner suggests a structure that continues

on into another space. Compositionally, it also resembles the left sections of several tenth-century horizontal landscapes, the woodblock prints in the *Bizangquan* (fig. 12), an imperial commentary to the Buddhist Tripitaka.[18] This comparison enables us to visualize *Riverbank* as the left side of a wide panoramic riverscape. Bearing in mind the compositional similarity between *Riverbank* and *Riverboats, Storied Pavilions*, we may now address the differences between the two paintings. In fact, the paintings diverge in both style and content, and it is this divergence that marks the advent of monumental land-scape painting in tenth-century China.

The devastation of northern China by continuous warfare in the late Tang peri-od was followed by a resurgence of artistic and cultural activity in the mid-tenth cen-tury in the Jiangnan (south of the Yangzi River) and southwestern Sichuan regions. At the same time that Dong Yuan was painting revolutionary landscapes at the Southern Tang court in Nanjing under the patronage of Emperor Li Yu (r. 961–75), renowned figure painters such as Zhou Wenju and Gu Hongzhong (both active ca. 943–75) were chronicling the opulent life-style of the ruling aristocracy.[19] Li Yu, him-self a renowned poet, contributed to the development of a new lyric aesthetic, one that changed the course of both art and literature.[20] The majestic landscape of *Riverbank* is pervaded by the deep melancholy that characterizes this new aesthetic. In contrast to the festive blue-green idiom of *Riverboats, Storied Pavilions* and *Spring Outing*, in which aristocrats and their families travel on horseback or in pleasure boats to their various palatial mansions, the landscape of *Riverbank*, painted in somber ink mono-chrome, shows a reclusive scholar lost in thought.

Ink monochrome landscape painting was an innovation of the Tang period, one in which the artist could, in the words of the ninth-century art historian Zhang Yanyuan (active ca. 847), represent in graded ink wash a world of variegated colors:

> Now *yin* and *yang* fashion and form all things. . . . Grasses and trees may display their glory without the use of reds and greens; clouds and snow may swirl and float aloft without the use of white color; mountains may show greenness without the use of blues and greens; and a phoenix may look colorful without the use of the five colors. For this reason a painter may use ink alone, and yet all five colors may seem present in his painting.[21]

Until the late Tang, the ruling class was composed largely of elite families whose power was based on hereditary entitlement. Beginning in the ninth century a rising scholar-official class, chosen through an examination system, replaced entrenched hereditary interests with government bureaucrats whose authority was conferred by the state. After the fall of the Tang, in the early tenth century, many scholars, choosing a life of seclusion and self-cultivation, retreated to the mountains. *Riverbank* shares the theme of reclusion with two important ink monochrome landscape paintings datable to the tenth century: *The Lofty Scholar Liang Boluan* (fig. 13), by Wei Xian (active ca. 960–75), a colleague of Dong Yuan's in Nanjing, and *A Chess Party in the Mountains* (fig. 14), by an unidentified artist. The former painting, which is recorded in the *Xuanhe huapu* (preface dated 1120), the official catalogue of the imperial paintings collection of Emperor Huizong, was

Figure 7. Attributed to Li Sixun (651–716), *Riverboats, Storied Pavilions*. Hanging scroll, ink and color on silk, 40⅛ x 21½ in. (101.9 x 54.7 cm). National Palace Museum, Taipei

Figure 8 (far right). Attributed to Zhan Ziqian (ca. 550–604), *Spring Outing*. Handscroll, ink and color on silk, 16⅞ x 31¾ in. (43 x 80.5 cm). Palace Museum, Beijing

Figure 9. Unidentified artist (11th century), *Landscape with Figures*. Six-fold screen, ink and color on silk, each panel 57½ x 16¾ in. (146.1 x 42.6 cm). Kyoto National Museum

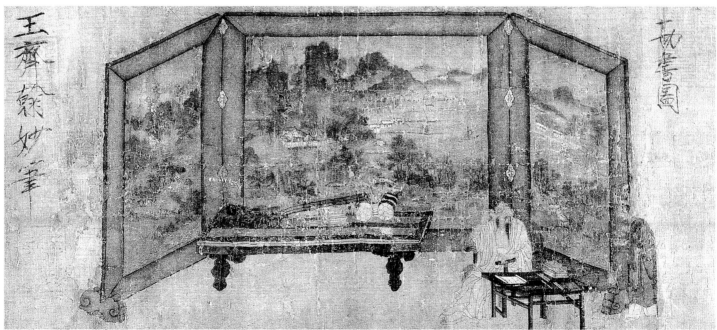

Figure 10. Attributed to Wang Qihan (active ca. 961–75), *Scholar Examining Books*. Handscroll, ink and color on silk, 11⅛ x 25⅞ in. (28.4 x 65.7 cm). Nanjing University

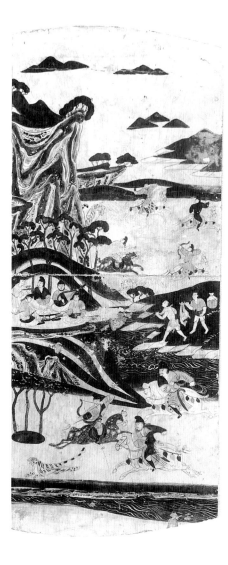

Figure 11a. Unidentified artist (8th century), *Sitting under a Mountain*. Painting on a lute plectrum guard. Shōsō-in Treasury, Nara

Figure 11b. Unidentified artist (8th century), *Hawk and Ducks*. Painting on a lute plectrum guard. Shōsō-in Treasury, Nara

Figure 11c. Unidentified artist (8th century), *Tiger Hunt*. Painting on a lute plectrum guard. Shōsō-in Treasury, Nara

Figure 12. Unidentified artist (10th century), *Bizangquan* (vol. 13, pl. 3). Woodcut. Arthur M. Sackler Museum, Harvard University Art Museum, Cambridge, Massachusetts

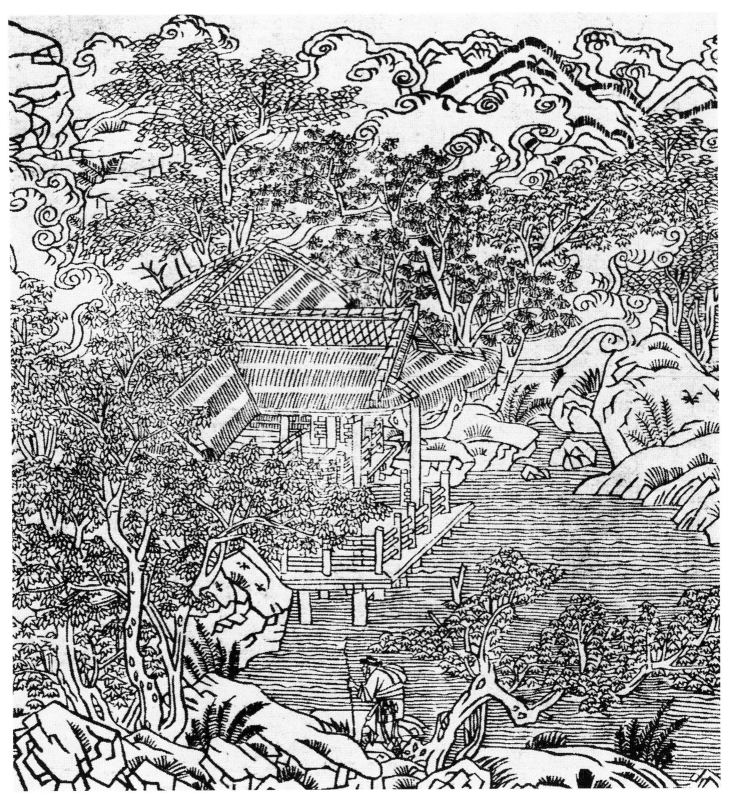

12a. Detail, figure 12

one of a set of six panels representing "lofty scholars" (*gaoshi tu*), presumably the last, leftmost panel of the set.[22] I would like to suggest that both *Riverbank* and Wei Xian's *Lofty Scholar* were screen paintings executed for the Southern Tang court.

As the creator of a screen decoration for a palatial building, the painter of *Riverbank* was concerned with its orientation in an architectural setting. Facing south, the scholar's pavilion in the composition appears on the viewer's left—that is, the right side of the

Figure 13. Wei Xian (active ca. 960–75), *The Lofty Scholar Liang Boluan*. Hanging scroll, ink and color on silk, 53 x 20⅝ in. (134.5 x 52.5 cm). Palace Museum, Beijing

screen—which is traditionally associated with the direction of the west, with the season of autumn, and with a place of retreat from the affairs of the world. This is the same symbolic orientation followed by decorative programs of pre-Tang and Tang tomb structures, as well as in Buddhist cave temples at Dunhuang, where the left signifies the place of exiting or departing from the world.[23]

In its thematic underpinning as well, *Riverbank* reveals its origins in the tenth century. Developing out of the narrative tradition of pre-Tang and Tang figure painting, the carefully conceived composition is essentially didactic. In the safe haven of his pavilion, the scholar rediscovers the moral order that had been lost amid the social and political turmoil of worldly affairs. The tall pine trees on the riverbank represent Neo-Confucian *junzi*, superior gentlemen and leaders of men, steadfast in their moral uprightness. Here, they refer also to the scholar in his pavilion. As the eighth-century poet Du Fu wrote,

> *The nation is shattered, but the mountains and the rivers shall remain,*
> *Deep in the countryside the grasses and trees shall continue to grow . . .*[24]

suggesting that in time reclusion may yet lead back to active service at court. By encapsulating two central themes, reclusion and self-cultivation, *Riverbank* embodies the main concerns of the Confucian scholar-gentleman in the tenth century.

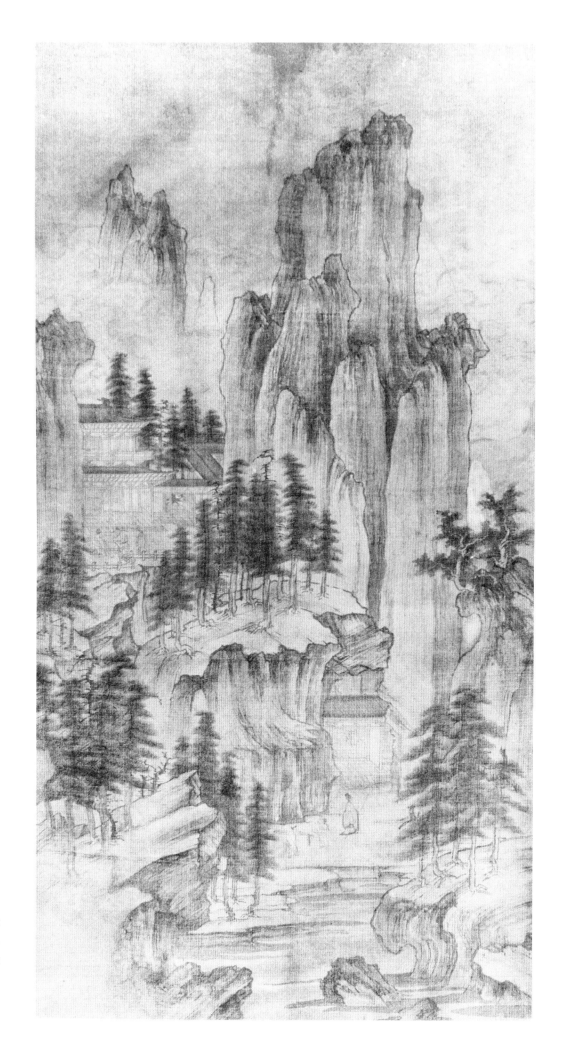

Figure 14. Unidentified
artist (10th century), *A
Chess Party in the Mountains*,
ca. 940–85, from a tomb at
Yemaotai. Hanging scroll,
ink and color on silk, 41⅞ x
25⅝ in. (106.5 x 65 cm).
Liaoning Provincial
Museum

In style and execution, *Riverbank* can be dated firmly to the tenth century. Although the authenticity of the signature (pl. 1a) is not documented, the calligraphic style, which follows that of the leading Tang calligrapher Yan Zhenqing (709–785), is typical of the tenth and eleventh centuries. It compares closely, for example, in both form and brush technique, to the calligraphy of the Northern Song scholar Ouyang Xiu (1007–1072; fig. 15), suggesting that the inscription dates to no later than the early Song period.

James Cahill, in his repudiation of *Riverbank* as tenth century, characterizes the brushwork in the painting as "fuzzy,"[25] but in fact it is precisely this brushwork that defines the tenth-century modeling technique. In his study of Jing Hao (ca. 870–930), Kiyohiko Munakata describes the tenth century as "a transitional period [between the Tang and the Song] when . . . ink-wash was still a new and developing means in painting. It is interesting to note that [Jing's] approach does not include the notion of *cun* [texture pattern] strokes, which are the typical means by which the Song artists achieved harmony between brushwork and ink-wash."[26] The modeling of the mountain forms in *Riverbank* (pls. 1c, 1d), for example, does not show clearly defined draping hemp-fiber texture patterns, seen in *Wintry Groves and Layered Banks* (fig. 5). Instead, the bulging mountain boulders are shaded naturalistically, with a softly rubbed and rather complex brushwork that blends with and disappears into a graded ink wash.[27] Two other tenth-century paintings, Wei Xian's *The Lofty Scholar Liang Boluan* (fig. 13) and Huang Jucai's (933–after 993) *Pheasant and Sparrows* (fig. 16), show similarly shaded rock forms delineated by a graded ink wash and softly brushed darker accents, and without a clearly formulated texture pattern. Jing Hao (ca. 870–930), a Neo-Confucian scholar and painter from northern Henan Province, in his "Notes on Brush Methods," has described this technique as follows:

> The higher or lower parts of an object are distinguished by a light ink wash, which makes them stand out in either shallow or deep relief. The rendering is so natural that it *does not appear to be made by a brush* [italics added].[28]

The tenth century saw the growth of Neo-Confucianism, a philosophy that advocated the reordering of society by the fusing of the spiritual with the material and by the objective study of the moral principles of nature. The first to formulate a coherent theory of monumental landscape painting, Jing Hao viewed the archetypal landscape image as a diagram of cosmic truth; a good landscape painter was someone "capable of divining the emblems [*xiang*], or archetypes, of objects and grasping their truth."[29]

Riverbank may also be seen to reflect the new tenth-century interest in naturalness and in the rich diversity of mountain forms in nature. Jing catalogues a variety of mountain forms:

> A peak has a pointed top; a head has a flat top; a hump has a round top; ranges have connected peaks; a cavern has a cave on the side; a cliff has a steep wall; a grotto is the space between two cliffs or below a cliff; a gorge is a pass going

Figure 15. Ouyang Xiu (1007–1072), colophon, dated 1064. Ink on paper, 10¾ x 67¾ in. (27.2 x 171.2 cm). National Palace Museum, Taipei

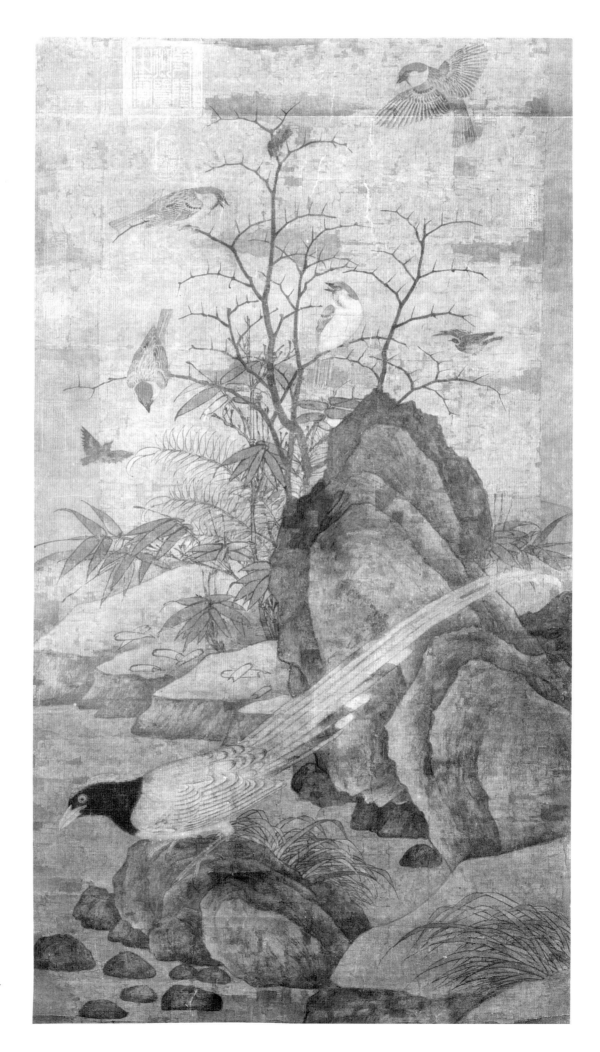

Figure 16. Attributed to Huang Jucai (933–after 993), *Pheasant and Sparrows.* Hanging scroll, ink and color on silk, 38¼ x 21⅛ in. (97 x 53.6 cm). National Palace Museum, Taipei

through the mountain; a gully is a pass blocked at one end; a ravine is a gully with running water; and a torrent is a stream running through a gorge. Although the peaks and the humps high above are separated, below them the hills and the ranges run together. The forests and springs are seen here and hidden there. The impression of far and near is thus clearly revealed.[30]

In contrast to the simple schematic mountain motifs of Tang landscape painting, as seen in *Riverboats, Storied Pavilions* (fig. 7) and *Spring Outing* (fig. 8), the complicated natural forms in *Riverbank* appear to illustrate Jing Hao's belief that "the [forms] of the mountains and rivers are mutually generative, their breath forces causing one another to grow." The interlocking mountains show a rich but naturalistic complexity unmatched by any known painted landscape after the tenth century.

Jing also describes trees and tree forms. In the tall pine tree, he discerns the human characteristics of the superior gentleman. "One must understand the archetype, the emblem of each thing":

> When a pine tree grows, it may bend but will not appear crooked. . . . As a sapling it stands upright, its budding heart already harboring noble ambitions. Once it has grown taller than all the other trees, even when its lower branches bow down to the earth, they never touch the common ground. Its layered branches spreading in the forest, it possesses the virtuous air of a superior gentleman.

And he describes other tree forms:

> When a cypress grows, it is full of movement and has many turns. It is dense but not ornate, and its trunk has many clearly marked knots. Its twisting patterns grow so as to follow the movement of the sun. Its leaves are like knotted threads and its branches are covered in hemp. . . . As for other trees, such as catalpas, paulownias, camilias, oaks, elms, willows, mulberries, and pagoda trees, each is different from the other in its form and character. By thinking deeply about them, one should be able to distinguish each and every one.[31]

Ranging laterally across the bottom of *Riverbank* are three tall pine trees (pl. 1b), a deciduous paulownia, a cypress, and another paulownia. The treatment of the trees and the rising mountain view call to mind the autumn scene from *The Four Seasons*, in the mausoleum at Qingling in eastern Mongolia, dating to about 1030 (fig. 17). In both compositions the mountain forms are additively piled up, the evergreens and deciduous trees are differentiated and carefully scaled to suggest recession in space, the pine trees in the foreground are individually delineated, and the distant firs are indicated by simplified patterns of layered foliage in ink wash.

As a transitional work between the Tang and the early Song, the visual structure of *Riverbank* remains notably additive and compartmental in the treatment of forms and spatial juxtapositions.[32] In contrast to Guo Xi's *Early Spring*, of 1072 (fig. 4), in which the complex overlapping of the trees and their three-dimensional disposition in space suggest illusionistic depth and spatial recession, the tree forms in *Riverbank* are disposed laterally, with virtually no overlapping. The far valley, with a line of geese leading the eye into the distance (pl. 1d), also shows similarities with such earlier Tang

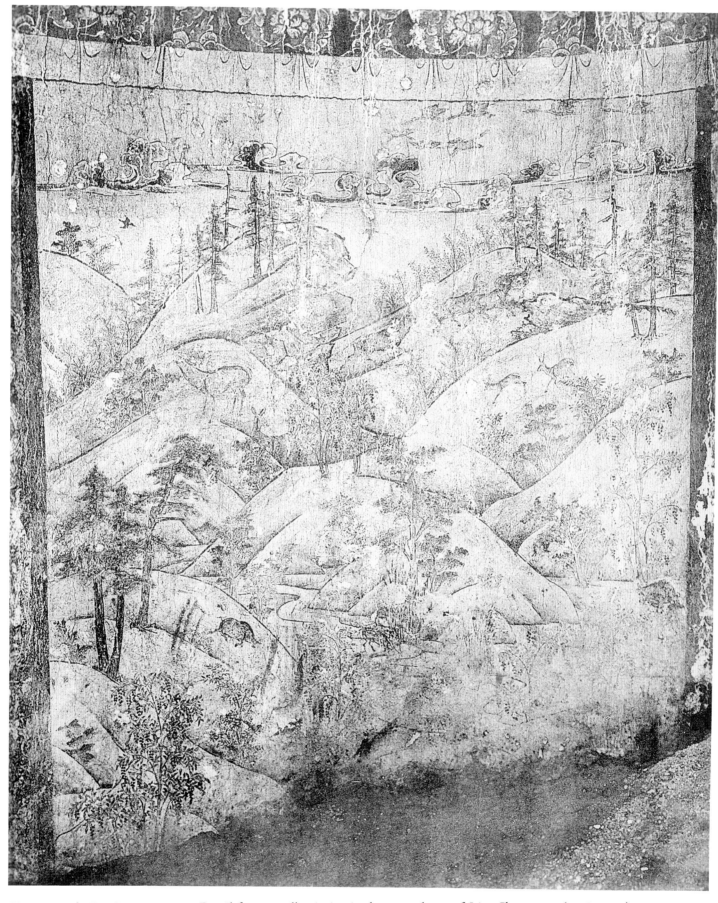

Figure 17. *The Four Seasons*, ca. 1030. Detail from a wall painting in the mausoleum of Liao Shengzong (r. 983–1031), approx. 110 x 74¾ in. (280 x 190 cm). Qingling, eastern Mongolia

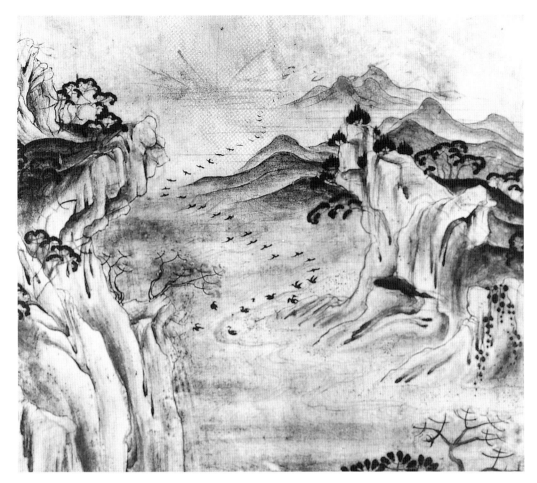

Figure 18. Unidentified artist (8th century), *Musicians Riding on an Elephant*. Detail of painting on a lute plectrum guard. Shōsō-in Treasury, Nara

examples as the deep distance in *Musicians Riding on an Elephant* (fig. 18), at the Shōsō-in, dating to the eighth century, and *Emperor Minghuang's Journey to Shu*, attributed to Li Zhaodao (active ca. 670–730), in the National Palace Museum, Taipei.[33] Compared with the distant valley scene on the left side of *Early Spring*, in which overlapping shore-lines recede in a foreshortened perspective, the zigzag shorelines in the deep distance of *Riverbank* are flat silhouettes piled up vertically and additively in the picture plane. Cahill's description of "what must be a distant river turn[ing] imperceptibly into a road with people walking on it" appears to be a misreading of the scenery. The zigzag path in the valley leads the eye into the distance, where it ends at the tiny village by water's edge. The additive, compartmentalized treatment of space reflects the conceptual approach of the tenth-century landscape masters—the approach outlined by Jing Hao, with its emphasis on "thought" (*si*) and "scenery" (*jing*).

Jing describes "thought" as a mental state through which "imagination crystallizes into forms."[34] In poetry criticism, the eighth-century poet Wang Changling describes the conception of the poetic world as passing through three successive stages: "objective description" (*wujing*), which deals with the external world, "affective state" (*qingjing*), which is concerned with emotion, and "ideational state" (*yijing*), which describes an aesthetic idea.[35] To draw a parallel to landscape painting, the narrative

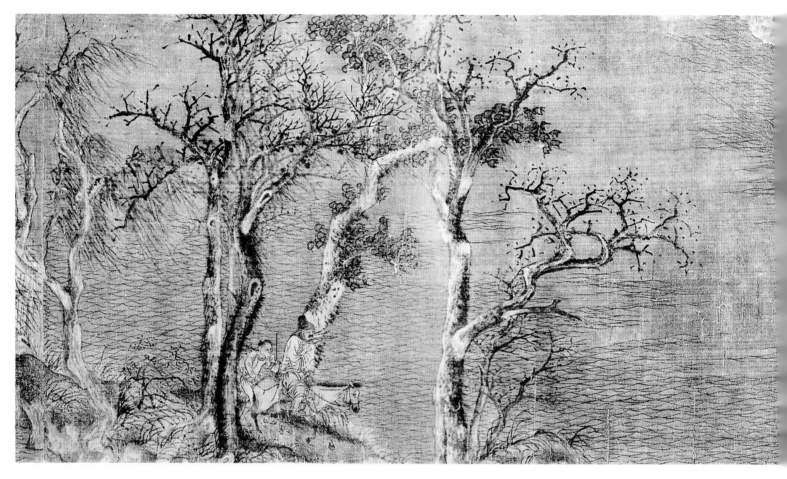

Figure 19. Zhao Gan (active ca. 960–75), *First Snow along the River*. Detail. Handscroll, ink and color on silk, 10¼ x 149¼ in. (25.9 x 376.5 cm). National Palace Museum, Taipei

description of *Riverbank*, which deals with the external world of human activity, is replaced in *Wintry Groves and Layered Banks* (fig. 5) by a symbolic monumental style that is concerned with the aesthetic idea. Unlike *Riverbank*, *Wintry Groves* has no narrative content. Rather, it is a lyrical evocation—of winter with its windswept branches, bare earth, and frozen waters. Where *Riverbank* gives descriptive detail, *Wintry Groves* offers simplified, formal abstractions. Where figures are present in *Riverbank*, there is only feeling and emotion in *Wintry Groves*. In the former, we see softly rolling earthen banks, descriptive of the Jiangnan landscape; in the latter, a clearly formulated hemp-fiber texture pattern.

Following Max Loehr (1968), Barnhart has argued that "if both *Riverbank* and *Wintry Groves* are the creations of Dong Yuan, then the former must be an early work, perhaps dating from the late 930s, and the latter a product of two or three decades later, near the end of the artist's life."[36] Barnhart shows that the trees and mountain forms of *Riverbank* relate not only to those of *Wintry Groves* but also to those in *First Snow along the River* (fig. 19), a painting by Zhao Gan (active ca. 960–75), a student at the Southern Tang Painting Academy, where Dong was the leading master. A common feature shared by *Riverbank* and *First Snow along the River* is the way the painter portrays a storm gusting across the landscape, with turbulent waves, violently stretched tree branches, and travelers struggling to withstand the elements. Like Dong Yuan in *Riverbank*, Zhao Gan employs a descriptive, rather than a lyric, symbolic style. Only in *Wintry Groves* is the later, monumental landscape style brought to realization.

The ideational state (*yijing*) is most clearly and brilliantly expressed in the two well-known masterpieces of Northern Song monumental landscape painting by Fan Kuan and by Guo Xi (figs. 3, 4). In his essay "Lofty Ambition in Forests and Streams," Guo Xi describes landscape painting in terms of *huayi*—a state of suggested ideas and meanings.[37] For both Fan and Guo, landscape painting represented a cosmic vision of the natural and the human world. The central mountain in Fan Kuan's *Travelers amid Streams and Mountains*, for example, represents, in Guo Xi's words, "a great king, seated and facing the sun, with a hundred grandees [secondary mountains] coming to court."[38]

As screen and wall decorations, early Northern Song monumental landscape painting served a symbolic and ritual function. In the early Northern Song imperial palace, the Jade Hall of the Institute of Academicians at the Imperial Chancellery was first decorated on the east, north, and west with a continuous wall painting of dragons in the vast oceans surrounding the Daoist isles of the immortals. In 992, when the expatriate Southern Tang painter Juran, a follower of Dong Yuan's, came to the Song capital Bianjing, he was ordered to paint a landscape composition on the north wall of the Jade Hall. In 1023, a six-panel landscape screen by the court painter Yan Su (d. 1040) was placed in the center of the same hall.[39] Guo Xi, who was the favorite court painter of Emperor Shenzong (r. 1068–85), decorated the screens and walls of many major imperial buildings during this period. Guo's *Early Spring* (fig. 4), dated 1072, which celebrates the ebullient spirit of the early Shenzong reign, is expressive of the occult Daoist belief in the magical powers of spring and seasonal renewal that was central to imperial ritual sacrifices.

Monumental landscape painting began its decline at the end of the Shenzong reign, in the late eleventh century. Ironically, it was through the efforts of Emperor Huizong (r. 1101–25) to improve the quality of painting through the establishment of an Institute of Painting in 1104 that the art of monumental landscape painting was brought to an end.[40] A consummate artist himself, Huizong aspired to a deeper, transcendent realism, achieved through the careful study of both nature and ancient models. According to the twelfth-century art historian Deng Chun (active ca. 1167), as soon as Huizong became emperor, he had all the wall paintings by Guo Xi removed from his palaces. When Deng's father was serving on the Imperial Privy Council, the emperor gave him a new mansion, and there he discovered that a workman from the palace was using a painting by Guo Xi as a dust cloth![41]

Beginning in the reign of Huizong, and throughout the ensuing Southern Song period, as the Painting Academy elevated painting to a fine art, Academy artists turned increasingly to the production of small-scale handscroll and album paintings, and left monumental pictorial decoration to artisan painters. Meanwhile, rare ancient works were removed from old screens and palace furnishings, remounted as scrolls and in albums, and kept in imperial collections as art treasures. Two of the tenth-century works discussed above, Wei Xian's *The Lofty Scholar Liang Boluan* (fig. 13) and Huang Jucai's *Pheasant and Sparrows* (fig. 16), found their way into the imperial collection of Emperor Huizong. These vertical compositions, both of which show original Huizong mountings, had been turned sideways, mounted, and preserved as individual handscrolls, a decision that marked their transformation from old screen decorations to ancient masterworks to be prized and collected.[42]

Reconstructing the Dong Yuan/Juran Idiom during the Yuan Dynasty

Following the Song conquest of the south in 976, Dong Yuan's southern landscape style, with its soft, subtly modeled mountain forms, was brought to the north at the Northern Song court, in Bianjing, through the work of Dong's follower the Buddhist monk Juran (active ca. 960–95), who in 992 was commissioned to decorate the Jade Hall.[43] No authenticated original work by Juran survives. Nevertheless, on the basis of stylistic analysis, we can make several attributions. In an early Northern Song hanging scroll attributed to Juran, *Xiao Yi Seizing the Lanting Manuscript* (fig. 20), the columnar mountain forms in the background, individually outlined and shaded, recall the rising peaks in *Riverbank*, while the triangular slopes in the foreground, with their continuous outlines and softly rubbed parallel texture strokes, echo those in *Wintry Groves and Layered Banks*. In two other Juran attributions stylistically datable to the late Northern Song period, *Layered Peaks and Dense Forests* (fig. 21) and *Buddhist Retreat by Streams and Mountains*,[44] rounded rocks known as alum heads (*fandou*), parallel hemp-fiber texture strokes, and tall, spindly trees covered with round foliage dots represent landscape motifs recognized as more typical of the Juran manner.[45]

For the most part, Northern Song landscape painting was dominated by the dramatic landscapes of northern China, exemplified in the work of Fan Kuan and Guo Xi. In the late Northern Song, Dong Yuan was rediscovered by the scholar-critic Mi Fu (1052–1107). Mi, rejecting the dramatic emotionalism of Guo Xi's landscapes, advocated a revival of Dong Yuan's quieter style, the simplicity of which he considered essential to good art:

> Dong Yuan's painting, plain and natural, is completely different from paintings of the Tang dynasty. . . . It is the divine class of the recent age, incomparable in its lofty character. . . . In his representations of streams, bridges, and fishing bays with overlapping islets and beaches, [Dong] depicts scenes typical of Jiangnan.[46]

During the Southern Song, when most painters turned from the monumental to a more intimate idiom, the Dong Yuan/Juran idiom was all but forgotten. One of

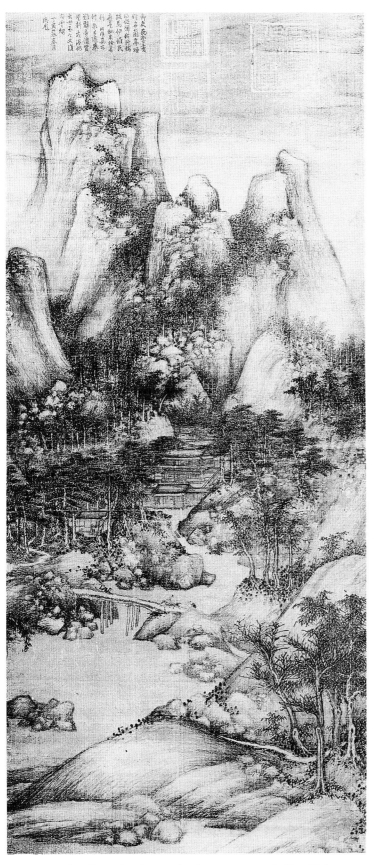

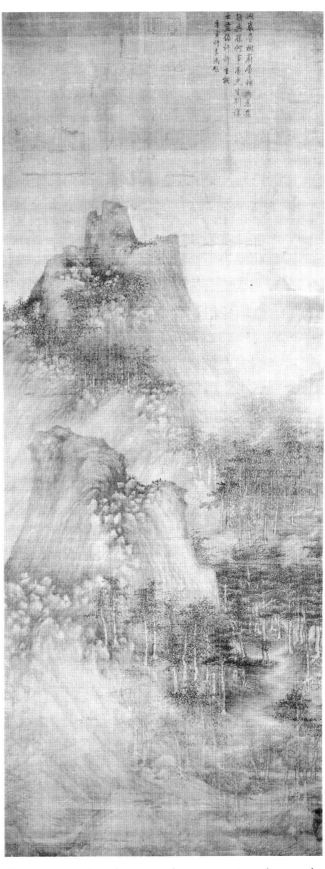

Figure 20. Attributed to Juran (active ca. 960–95), *Xiao Yi Seizing the Lanting Manuscript*. Hanging scroll, ink and color on silk, 56¾ x 23½ in. (144.1 x 59.6 cm). National Palace Museum, Taipei

Figure 21. Attributed to Juran (active ca. 960–95), *Layered Peaks and Dense Forests*. Hanging scroll, ink on silk, 56¾ x 21⅞ in. (144.1 x 55.4 cm). National Palace Museum, Taipei

the best-known chroniclers of Southern Song life and culture was Zhou Mi (1232–1298). As a supervisor of the imperial storehouse in Lin'an, he had access to all the private art collections in the capital. Among them were those of the notorious prime minister Jia Sidao (1213–1275) and the collector Prince Zhao Yuqin (late 13th century).[47] Included in the inventory of Prince Zhao's collection is the listing "Dong Yuan, *Riverbank*."[48] Apparently, the painting had passed from Jia Sidao's collection to Zhao's (as indicated by their respective seals) after Jia fell from power and his properties were dispersed in 1275. After the fall of Lin'an to the Mongol forces in 1276, the great art collections in the capital—presumably including the collection in which *Riverbank* was preserved—were scattered. Then in the 1280s, *Riverbank* resurfaced among the holdings of the early-Yuan collector Wang Ziqing (active ca. 1290–1310).[49] Sometime before he went north to present himself at the Mongol Yuan court in Beijing in 1286, the southern calligrapher and painter Zhao Mengfu (1254–1322), who was a friend of both the chronicler Zhou Mi and the collector Wang Ziqing, wrote a poem about the painting entitled "For Dong Yuan's *Riverbank*":

> *How the mountain peaks are gray and white,*
> *With gentle mists encircling their waist.*
> *Blocking the sun, the high mountains,*
> *Dark and obscure, are heavy with rain.*
> *A stream, meandering through the valley,*
> *Disappears into distant sandy marshland.*
> *Here macaques and gibbons thrive,*
> *And ducks and wild geese gather.*
> *Who is that gentleman who lives in seclusion,*
> *Keeping company with fragrant grasses?*
> *When he sings*
> *The forest quivers with the sounds of autumn.*[50]

Technically, in his own practice of early Northern Song landscape styles, Zhao Mengfu followed the hemp-fiber brush idiom of *Wintry Groves and Layered Banks* (fig. 5)

Figure 22. Zhao Mengfu (1254–1322), *Autumn Colors on the Qiao and Hua Mountains*, dated 1296. Detail. Handscroll, ink and color on paper, 11⅛ x 36⅜ in. (28.4 x 92.3 cm). National Palace Museum, Taipei

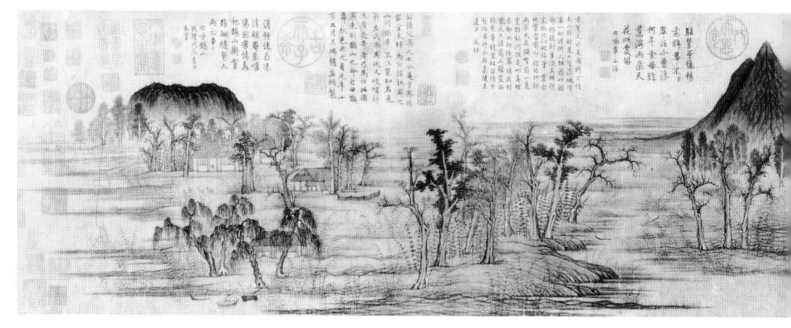

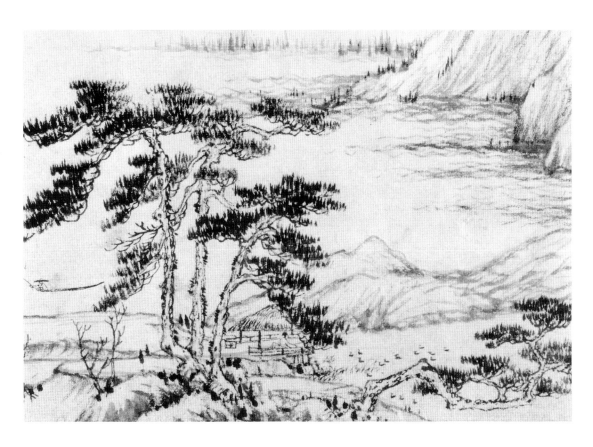

Figure 23. Huang Gong-wang (1269–1354), *Dwelling in the Fuchun Mountains*, dated 1350. Detail. Handscroll, ink on paper, 13 x 250¾ in. (33 x 636.9 cm). National Palace Museum, Taipei

Figure 24. Ni Zan (1306–1374), *Empty Pavilion in a Pine Grove*, dated 1354. Hanging scroll, ink on silk, 32⅞ x 20⅞ in. (83.4 x 52.9 cm). National Palace Museum, Taipei

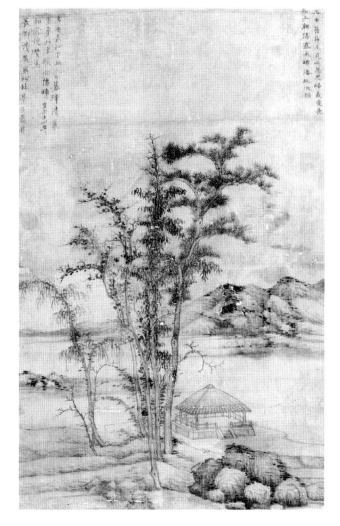

Figure 25. Wu Zhen (1280–1354), *Winter Geese amid Reedy Banks*, 1330s. Hanging scroll, ink on silk, 32¾ x 11 in. (83.3 x 27.8 cm). Palace Museum, Beijing

Figure 26. Wu Zhen (1280–1354), *Autumn Mountains*, 1330s. Hanging scroll, ink on silk, 59⅜ x 40⅞ in. (150.9 x 103.8 cm). National Palace Museum, Taipei

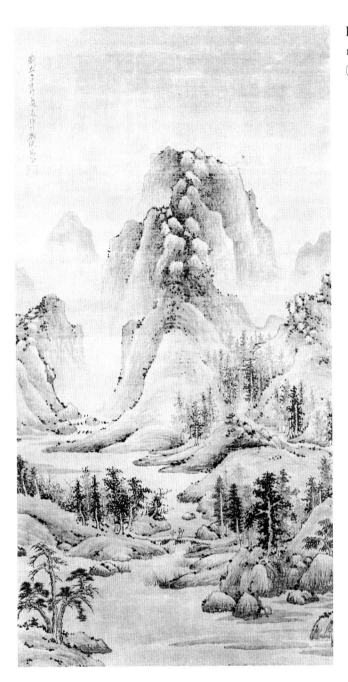

Figure 27. Li Shixing (1283–1328), *Landscape*, 1320s. Hanging scroll, ink on silk, 41⅞ x 20¾ in. (106.2 x 52.7 cm). Palace Museum, Beijing

Figure 28. Wu Zhen (1280–1354), *Central Mountain*, dated 1336. Handscroll, ink on paper, 10⅜ x 35¼ in. (26.4 x 90.7 cm). National Palace Museum, Taipei

rather than *Riverbank* as his model for the Dong Yuan style.[51] Dong Yuan had formed his style by studying the softly rolling mountain landscape of the Jiangnan region. Only in his later style did he condense his technique to a graphic formula of softly rubbed parallel texture strokes. It was from this later technique that Zhao Mengfu derived the typical Yuan painter's calligraphic hemp-fiber texture pattern, using it as a vocabulary for painting a landscape. In his *Autumn Colors on the Qiao and Hua Mountains* (fig. 22), dated early 1296 and dedicated to his friend Zhou Mi, Zhao, a native of the south, uses Dong Yuan's brush idiom to recollect a stretch of landscape in Shandong, where he had recently served as vice governor and where Zhou Mi's ancestral home was located. Across the short handscroll composition on paper, two schematic mountain forms, one triangular and the other semicircular, rise above a flat marshland; the central section recalls Dong Yuan's *Wintry Groves*. In modeling the layered sand banks with parallel texture strokes, Zhao turns Dong Yuan's naturalistic representation into a calligraphic formula: dry, centered brushstrokes, blurred and fused, are used to create a visually continuous vista, with a spatially foreshortened ground plane.

During the late Yuan, after the flooding of the Yellow River in 1344, the Yuan government embarked on a ruthless campaign to collect tax revenues from the rich lower Yangzi delta region of southeastern China, especially Suzhou and its neighboring prefectures. As rebellions against the Mongols broke out in southern China in the 1340s and 1350s, the subject of *Riverbank*—living in reclusion in the mountains—assumed a new topical meaning for scholar-artists retreating from political turmoil. Huang Gongwang (1269–1354), for example, in his handscroll of 1350, *Dwelling in the Fuchun Mountains* (fig. 23), casts himself as a recluse scholar sitting in a pavilion near three tall pine trees. And Ni Zan (1306–1374), in his *Empty Pavilion in a Pine Grove* (fig. 24), dated 1354, paints a landscape in the Dong Yuan hemp-fiber idiom with an empty pavilion that represents the artist's abandoned home in a war-torn world.[52]

Wu Zhen (1280–1354), on the other hand, seems to have been inspired more by Dong Yuan's *Wintry Groves* than by *Riverbank*. In *Winter Geese amid Reedy Banks* (fig. 25), dating to the 1330s, Wu adapts compositional elements from *Wintry Groves*, a painting he knew,[53] to paint one of his hermit-fishermen series, using a wet, blunt brushwork to create a desolate view of lonely riverbanks covered with dense, bristly reeds. In such larger landscape compositions as *Autumn Mountains* (fig. 26), also dating to the 1330s, Wu follows the Juran model (figs. 20, 21).[54] During the 1320s and 1330s, both Li Shixing (1283–1328; fig. 27) and Zhang Xun (active ca. 1295–after 1349; pl. 6) had experimented with the Juran idiom. It was Wu Zhen, however, who formulated the new calligraphic Juran idiom, with clustered alum heads, round parallel texture strokes, and round moss dots. In his *Central Mountain* (fig. 28), dated 1336, Wu reduces the landscape to an iconic image of a host peak flanked by guest peaks, with straight parallel strokes done with a round centered brushwork that represents the typical calligraphic Juran idiom.

The youngest of the four masters of the late Yuan, Wang Meng (ca. 1308–1385) was a grandson of Zhao Mengfu. Wang clearly knew *Riverbank*. Not only did he re-create the vision of reclusion exemplified in the painting, he also transformed Dong's hemp-fiber texture idiom into a new, dynamically expressive landscape style. Unlike the other

three masters, who found the life of reclusion congenial to their temperament, Wang was by nature outgoing and had an active interest in public affairs. He served for a time as a provincial prosecutor before war broke out in the 1340s, and he was forced to retire to the Yellow Crane Mountain near Hangzhou. In *Sparse Trees and Pavilion* (fig. 29), a silk fan painting datable to the 1350s, Wang paints a shorthand version of *Riverbank* and describes his own life as a recluse:

> In the quiet of empty forest and dancing foliage,
> A thatched pavilion stands alone under the noonday sun.
> In the south wind, green waves ripple through the long day.
> Wearing a gauze cap and coarse hemp, I feel no summer heat.
> My wilderness home is near Yellow Crane Peak.
> At dusk I enter an empty grotto to listen to the mountain rain.

And in *Dwelling in Seclusion in Summer Mountains* (fig. 30), dated 1354, Wang adapts *Riverbank* to his own ideas of peaceful mountain living in a lush summer setting. Seated in his pavilion shaded by tall trees, the artist looks onto an open panorama of marsh grasses; behind him, conical mountain masses verdant with growth extend into the distance. Unlike Wu Zhen's straight parallel brushstrokes, Wang Meng's hemp-fiber strokes are more complexly vibrant.

Wang Meng in the 1350s and 1360s spent much time traveling between Songjiang, Suzhou, and Wuxi, Jiangsu, making the acquaintance of famous poets and artists in the area. By 1365, he was involved with the rebel government of Zhang Shicheng (1321–1367), a salt smuggler who had occupied Suzhou since 1356 and now called himself the Prince of Wu. In 1365, Wang commemorated a gathering near Suzhou of literati notables at the Rain-Listening Pavilion of Lu Shiheng, painting a handscroll on which all those present (including Ni Zan) inscribed poems.[55] In *Reading in Spring Mountains* (fig. 31), dating to the spring of 1365, Wang brings the *Riverbank* motifs into closer focus, transforming the crowded mountains, dense, swaying pine trees, and well-hidden pavilion into a dark vision of impending doom.

In the summer of 1365 Zhu Yuanzhang, the future founder of the Ming dynasty (r. 1368–98), began his campaign against Zhang Shicheng, and by the end of 1366 Suzhou was under siege by the forces of the Ming general Xu Da. In *Fisherman's Retreat on a Flowering Stream* (fig. 32), of about 1367, Wang Meng reworks elements from *Riverbank* to represent the story of the Peach Blossom Spring, by the early-fifth-century poet Tao Qian (365–427). In the story a fisherman loses his way and finds himself in the land of peach blossoms, a realm where time has been suspended. The villagers he meets there are descendants of those who had escaped from the ravages of the war during the years of the Qin dynasty (221–206 B.C.). Hiding in the mountains by a land-locked flowering stream, Wang, during the ten-month siege of Suzhou, perhaps felt that he, like the villagers in the garden, was inhabiting a place where time had stopped.

After the establishment of the Ming dynasty in early 1368, Wang Meng went north and served for three years as the magistrate of Taian, Shandong. In *Simple Retreat* (pl. 8, page 121), dating to about 1370, he rearranges the familiar motif of a thatched

Figure 29. Wang Meng (ca. 1308–1385), *Sparse Trees and Pavilion*, 1350s. Fan mounted as an album leaf, ink on silk, 9⅞ x 11⅛ in. (25.2 x 28.3 cm). The Metropolitan Museum of Art. From the P. Y. and Kinmay W. Tang Family Collection, Partial and Promised Gift of Oscar L. Tang, 1991 (1991.438.1)

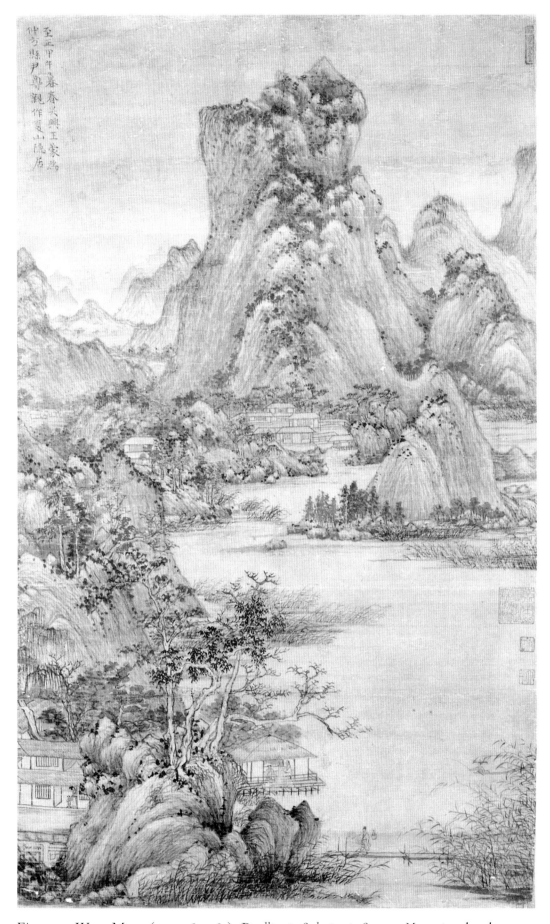

至正甲午春吳興王蒙為
仲方縣尹畫觀作夏山隱居

Figure 30. Wang Meng (ca. 1308–1385), *Dwelling in Seclusion in Summer Mountains*, dated 1354. Hanging scroll, ink on silk, 22⅜ x 13½ in. (56.8 x 34.2 cm). Freer Gallery of Art, Smithsonian Institution, Washington, D.C.

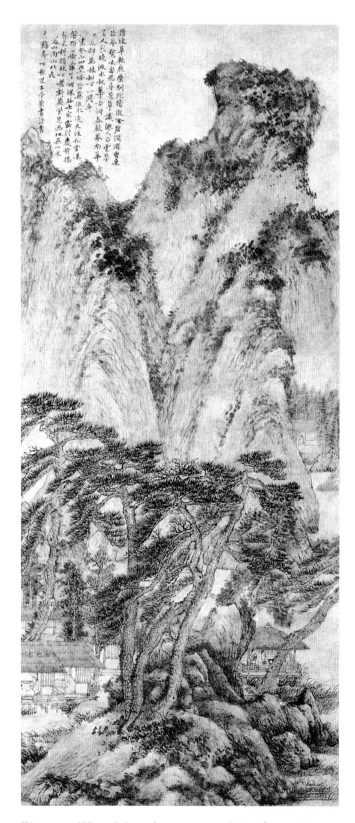

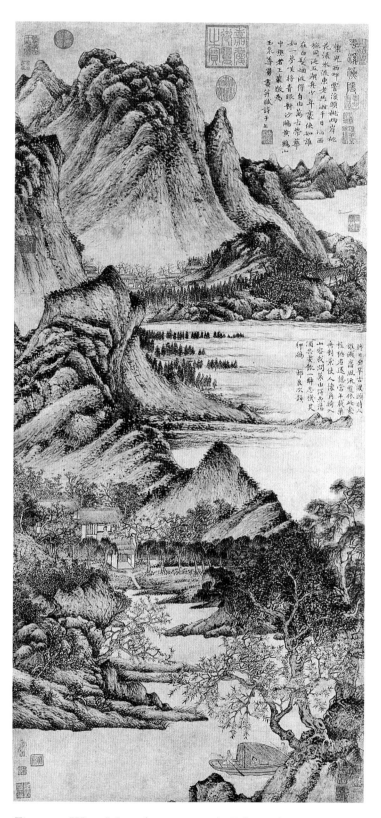

Figure 31. Wang Meng (ca. 1308–1385), *Reading in Spring Mountains*, 1365. Hanging scroll, ink and color on paper, 52 x 21⅞ in. (132 x 55.4). Shanghai Museum

Figure 32. Wang Meng (ca. 1308–1385), *Fisherman's Retreat on a Flowering Stream*, ca. 1367. Hanging scroll, ink and color on paper, 50¾ x 23 in. (129 x 58.3 cm). National Palace Museum, Taipei

hermitage nestled in the mountains into a tightly woven composition of fluttering texture strokes, dots, and bright spots of color. The restless energy and thrusting, heaving movement give an unprecedented physicality and dynamism to late-Yuan landscape painting. In his essay "Secrets of Landscape Painting," Huang Gongwang writes:

> The mountain peaks should turn and link together, change direction and turn again, with the veins of the mountains branching smoothly throughout. This method makes the mountains come alive. The myriad peaks bow, making way for one another, while ten thousand trees march like soldiers in a great army.[56]

The *Simple Retreat* shares with certain Northern Song paintings, notably *Travelers at the Mountain Pass*, attributed to Guan Tong (active ca. 907–23; fig. 33), an extraordinary expressiveness. It is possible that during his northern sojourn Wang Meng had an opportunity to see *Travelers*, which was part of the Yuan imperial collection in Beijing. In his late years Wang continued to express in paintings his own inner turmoil and complexity. In 1380, he was implicated in the alleged treason of the prime minister Hu Weiyong. He died in prison in 1385.

DONG YUAN: A PATRIARCH OF THE SOUTHERN SCHOOL OF LANDSCAPE PAINTING

In the tradition of Mi Fu and Zhao Mengfu, the literati artists of the Ming period studied ancient paintings both as painters and as critics, art historians, and collectors. They studied the works of the old masters with the eye and the feeling of a painter, and they painted to re-create and recapture art history with the experience of a connoisseur.

Because the Ming painters of the fifteenth and sixteenth centuries continued to paint in the calligraphic landscape idioms of the late Yuan masters, little critical attention was paid to Dong Yuan and Juran during this period. Once *Riverbank* entered the Ming imperial collections—as documented by the painting's official Ming half-seal dating to 1374–84—it became inaccessible to the artist-connoisseur.[57] By the early seventeenth century, when Dong Qichang was collecting the work of Dong Yuan and attempting to reconstruct his oeuvre, *Riverbank* was notably absent from the key monuments available to him.

Dong Qichang (1555–1636) began to collect important Song and Yuan paintings soon after he had earned his *jinshi*

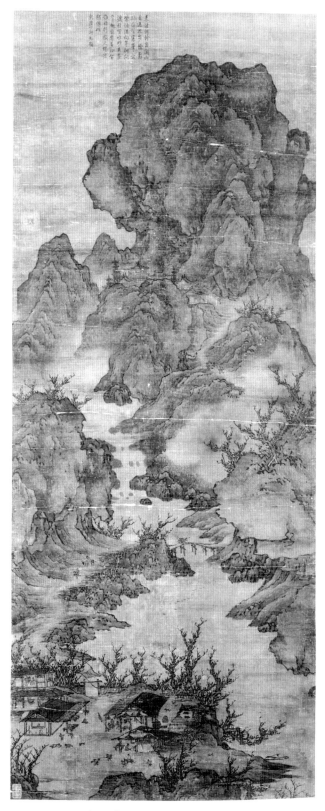

Figure 33. Attributed to Guan Tong (active ca. 907–23), *Travelers at the Mountain Pass*. Hanging scroll, ink and color on silk, 56⅞ x 22⅜ in. (144.4 x 56.8 cm). National Palace Museum, Taipei

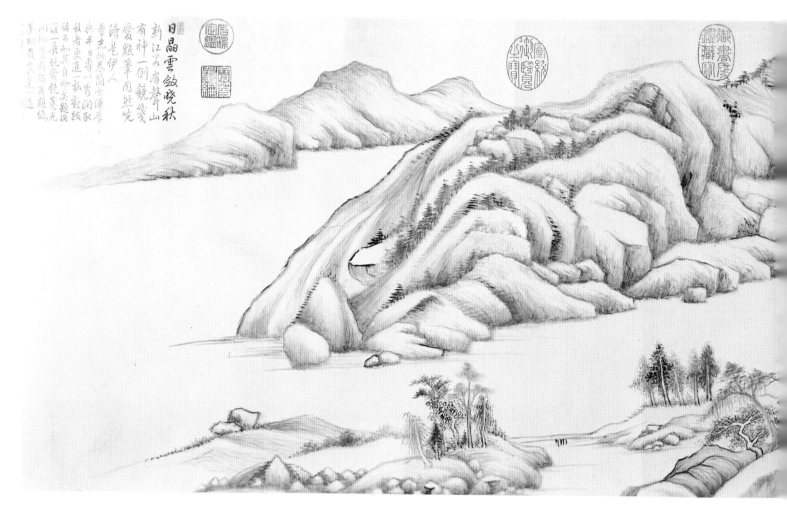

Figure 34. Dong Qichang (1555–1636), *Landscape in the Manner of Huang Gongwang*, ca. 1624–27. Handscroll, ink and Korean paper, 14⅞ x 53¾ in. (37.8 x 136.4 cm). The Cleveland Museum of Art

degree in Beijing in 1589. In 1597, he acquired the handscroll *The Xiao and Xiang Rivers* (fig. 6). And in 1635, a year before he died, he inscribed the following colophon on the handscroll *Summer Mountains*,[58] also in his collection and also attributed to Dong Yuan:

> While I was in Chang'an [Beijing], I saw [original] handscrolls by Dong Yuan on three different occasions. In 1597, I acquired *The Xiao and Xiang Rivers* for my collection; in 1624, I saw *Awaiting the Ferry at the Foot of Summer Mountains*;[59] and in 1632, I acquired the present scroll. It was formerly owned by [the Southern Song prime minister] Jia Sidao, and on it is his seal, [which reads] "Zhang." The height and the length of these three silk scrolls are about the same, but *The Xiao and Xiang Rivers* is the best. *Awaiting the Ferry* bears a colophon by [the Yuan connoisseur] Ke Jiusi; it was an imperial treasure in the collection of Emperor Wenzong of the Yuan dynasty, and is now in the collection of Zhu [Geng], the minister of Dongqang. Mi Fu, who lived not long after the time of Dong Yuan, said that he had seen only five original works by that master. How fortunate I am to have owned two of them![60]

The handscrolls, all three of which represent the rich, dense landscape of the lower Yangzi delta region in central China, show the recognized late manner of Dong Yuan, the rounded mountain forms modeled in softly rubbed, parallel hemp-fiber texture

strokes and round moss dots. *The Xiao and Xiang Rivers*, which, as noted by Dong Qichang, is indeed superior to the other two scrolls, is dated by modern scholars to the late eleventh century.[61] As noted earlier, compared with the clearly outlined mountain forms and highly representational foliage dots of the earlier *Wintry Groves and Layered Banks* (fig. 5), here the marks are fused to create a unified, impressionistic surface typical of the late eleventh century. Barnhart has demonstrated that *The Xiao and Xiang Rivers* and *Awaiting the Ferry* are sections of different versions of a lost handscroll composition.[62] In *Summer Mountains*, a work by a follower of Dong Yuan that appears to date to the first half of the thirteenth century, spatial illusion is further developed, with defined outlines obliterated in a surface pattern of dots and ink wash.

Dong Qichang's interest in Dong Yuan was motivated by his attempt to define the Southern school of landscape painting, a stylistic lineage that, according to his theory, was initiated in the Tang dynasty by the poet-painter Wang Wei (701–761) and was later

Figure 35. Dong Qichang (1555–1636), *Qingbian Mountain in the Manner of Dong Yuan*, dated 1617. Hanging scroll, ink on paper, 83⅜ x 26½ in. (224.5 x 67.3 cm). The Cleveland Museum of Art

developed by Dong Yuan and the four masters of the late Yuan. In reconstructing the stylistic tradition of the Southern school, Dong proposed the hemp-fiber texture pattern as the principal connecting element. In a colophon that he inscribed on the handscroll *Rivers and Mountains after Snow*, attributed to Wang Wei, he noted: "Beginning with Wang Wei, both texture strokes and ink washes were used in landscape painting. . . . Once the basic method was formulated, it was not difficult [for later painters] to follow and improve upon it."[63] In his own rendering of the hemp-fiber texture method, Dong Qichang created a stylistic synthesis of the Dong Yuan and Huang Gongwang idiom by reducing it to a calligraphically based "straight texture" formula:

> One begins [a landscape] by outlining the mountains, first in accordance with their outward form and momentum, and then by applying within the outlines straight texture strokes. This is the method of Huang Gongwang.[64]

The best demonstration of Dong's straight texture method is *Landscape in the Manner of Huang Gongwang* (fig. 34), dating to about 1624–27, in which cubistic mountain forms rise and fall across the picture plane creating a dynamic "breath-momentum" (*qishi*) throughout the composition.[65]

Dong Qichang was puzzled by the apparent diversity of styles found in paintings—especially large hanging scrolls—traditionally attributed to Dong Yuan:

> Both *The Xu River* and *The Xiao and Xiang Rivers*, by Dong Yuan, are in my collection. In their brushwork, they look as if they were done by two different hands. I also own several hanging scrolls by Dong Yuan. Not one of them shares a common style. [Dong] may be called the [mysterious] dragon among painters![66]

As a connoisseur and a collector, Dong Qichang kept his own counsel. In his public pronouncements, he could be less than candid—even inaccurate—wreaking havoc in the researches of later scholars.[67]

It is often difficult for us to understand what Dong Qichang had in mind when he wrote that in his own paintings he was "imitating Dong Yuan." James Cahill, for example, in his study of Dong's 1617 hanging scroll *Qingbian Mountain in the Manner of Dong Yuan* (fig. 35), writes:

> Wang Meng's depiction of the mountain [fig. 48], done in 1366, survives; Dong, although he may have had this great work in mind, does not refer to it in the inscription on his own *Qingbian Mountain* of 1617, but says rather that he is "imitating Dong Yuan." It is hard to see what he can mean by invoking that tenth-century master, whose style cannot account for much of importance in this painting.[68]

Kohara Hironobu argues that the model for Dong Qichang's *Qingbian Mountain in the Manner of Dong Yuan* was none other than Dong Yuan's *Travelers amid Autumn Mountains* (fig. 1), the work formerly in the J. D. Chen collection.[69] Kohara points to a line from the poem inscribed by Dong Qichang on the painting that seems to describe the mountain village depicted in the Chen *Travelers*:

> *Where chickens and dogs are seen on top of clouds, a village market lies.*

Kohara assumes that the J. D. Chen *Travelers amid Autumn Mountains*, whose composition is of course identical to that of Chen Lian's reduced copy of the scroll (fig. 2), was the Dong Yuan model referred to by Dong Qichang as in his collection. This is refuted by Fu Shen, who proposes, without explanation, that the J. D. Chen "Dong Yuan" is a modern forgery by Zhang Daqian.[70] We shall return to this problem later.

Another painting attributed to Dong Yuan, now in the Ogawa Collection in Kyoto, has a similar title, *Travelers amid Streams and Mountains* (fig. 36), and also shows a village market scene with chickens and dogs. Once in the collection of the fifteenth-century scholar painter Shen Zhou (1427–1509), this painting was known as "A Half-Scroll of Jiangnan." About this painting Dong Qichang wrote:

> I have in my collection the painting *Travelers amid Streams and Mountains*, by Dong Yuan. This painting was copied by Shen Zhou. Wen Zhengming [1470–1559] once wrote that in his entire life the only painting by Dong Yuan that he had seen was "a mountain in half a scroll." This is the painting [Wen] was referring to.[71]

It would now appear that rather than the Chen *Travelers amid Autumn Mountains*, it is the Ogawa *Travelers amid Streams and Mountains* that was the model for Dong Qichang's *Qingbian Mountain in the Manner of Dong Yuan*. Painted in heavy parallel hemp-fiber texture strokes, the Ogawa *Travelers* dates stylistically to the early fifteenth century. In his painting, Dong Qichang applies the simplified Dong Yuan/Huang Gongwang straight texture pattern. A complex exercise in the study of rock and tree forms rendered calligraphically, the composition represents the breath-momentum of the artist's physical movements with abstract, volumetric mountain forms that writhe and turn in a new, dynamically expressive kinesthetic landscape style.

When we examine Chen Lian's copy of Wang Meng's *Travelers amid Autumn Mountains* (fig. 2), we realize that unlike the Ogawa *Travelers amid Streams and Mountains*, the mountain village

Figure 36. Attributed to Dong Yuan (active 930s–60s), *Travelers amid Streams and Mountains*. Ogawa Collection, Kyoto

in Wang Meng's painting is placed in a landscape setting very much like that of *Riverbank*. The modeling, done in a fine parallel hemp-fiber pattern, recalls that of Wang's earlier *Dwelling in Seclusion in Summer Mountains* (fig. 30), except that the mountain forms have been simplified and transformed into a serpentine, or dragon-vein, movement.[72] Dong Qichang was therefore very much on the mark when he observed that *Travelers amid Autumn Mountains* was "a masterwork done before Wang Meng transformed

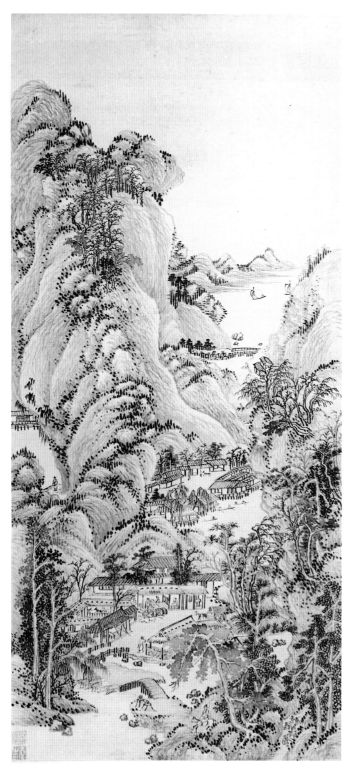

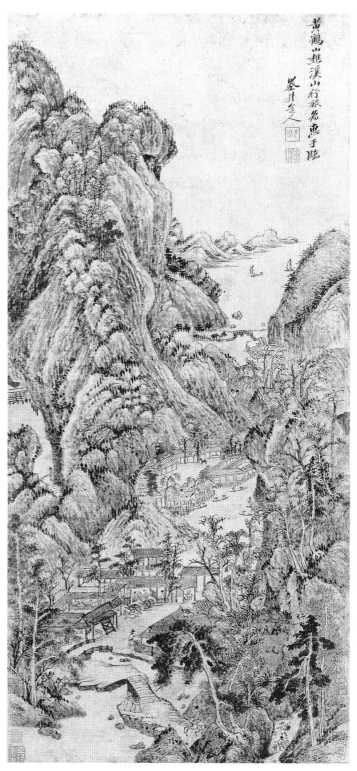

Figure 37. Wang Hui (1632–1717), *After Chen Lian's Reduced Copy of Wang Meng's "Travelers amid Streams and Mountains,"* 1680s. Hanging scroll, ink on paper, 23⅛ x 10½ in. (88 x 65 cm). Private collection

Figure 38. Wu Li (1632–1718), *After Chen Lian's Reduced Copy of Wang Meng's "Travelers amid Streams and Mountains,"* 1680s. Hanging scroll, ink on paper, 23½ x 10¾ in. (59.7 x 27.2 cm). The Metropolitan Museum of Art. Ex. Coll.: C. C. Wang Family, Edward Elliott Family Collection, Purchase, The Dillon Fund Gift, 1981 (1981.285.6)

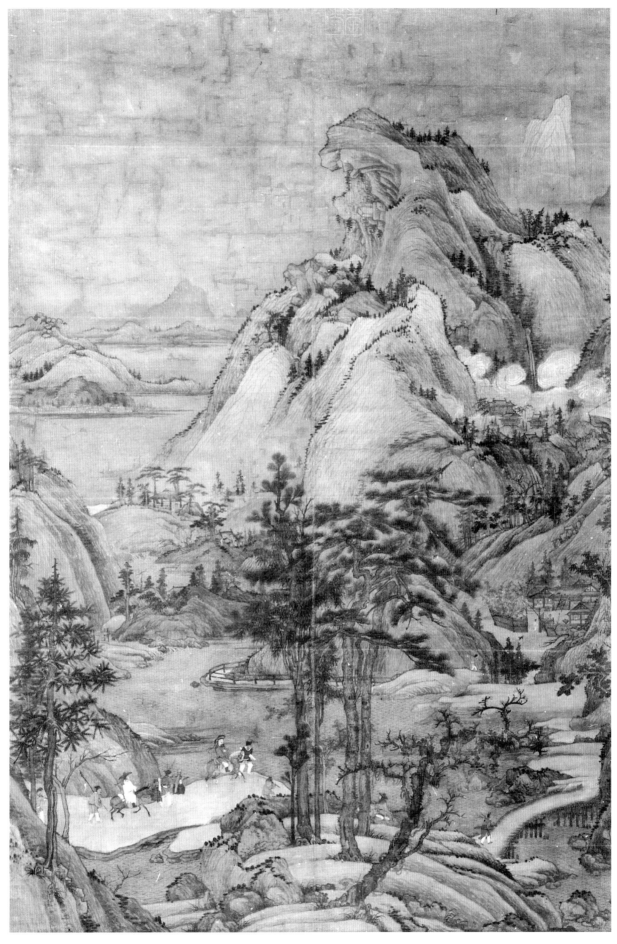

Figure 39. Unidentified artist (14th century), *Along the Riverbank at Dusk*. Hanging scroll, ink and color on silk, 70½ x 45⅞ in. (179 x 116.5 cm). National Palace Museum, Taipei

the earlier master's style." The statement is remarkable in that Dong himself appears not to have had any direct knowledge of Dong Yuan's *Riverbank*, which was of course Wang's model.

Stylistically, Wang Meng's fine hemp-fiber brushstrokes, a calligraphic idiom of the fourteenth century, are very different from the subtly shaded mountain forms of *Riverbank* (pl. 1c), which show the more representational modeling technique of the tenth century. By the seventeenth century, while Dong Yuan's representational shading technique had been relegated to obscurity, his texture pattern continued to be re-created through Wang Meng's calligraphic method. In the 1680s, both Wang Hui (1632–1717; fig. 37) and Wu Li (1632–1718; fig. 38) made exact copies of Chen Lian's reduced copy of Wang Meng's *Travelers amid Autumn Mountains* (fig. 2).[73] Working in Dong Qichang's kinesthetic landscape style, both painters used Chen Lian's straight parallel texture strokes to build up the composition, the whole dramatically expanding in a dragon-vein movement.

ZHANG DAQIAN AND MODERN FORGERIES

According to Fu Shen, sometime between 1936 and 1938 the modern painter and collector Zhang Daqian (1899–1983) saw in Beijing a painting then attributed to Dong Yuan, a colored landscape entitled *Along the Riverbank at Dusk* (fig. 39). It was a work that haunted him for many years.[74] Living in Sichuan and Dunhuang during the Second World War, Zhang returned to Beijing in 1945 and acquired the painting. It was donated to the National Palace Museum, Taipei, by Zhang's family after his death in 1983. Painted in the archaic blue-green idiom of Zhao Mengfu, with elegant calligraphic hemp-fiber strokes and bright mineral colors, *Along the Riverbank at Dusk* dates stylistically to the fourteenth century or later.

Seven years prior to his acquisition of this painting, in wartime Guilin, Guangxi Province, Zhang had acquired *Riverbank* from the painter Xu Beihong (1895–1953), who had discovered the painting in Guilin.[75] In a letter dating from late 1938 or early 1939 sent from Singapore (fig. 40), Xu wrote the following:

> I have acquired a large hanging scroll, *The Water Village*, by Dong Yuan, perhaps the preeminent Dong Yuan under heaven. [Zhang] Daqian saw the painting and was so enamored of it that he insisted on taking it with him to Sichuan. So I invited him to research and authenticate the painting. The work includes a line of signature [by Dong Yuan], a Song palace seal, and the collectors' seals of Jia Sidao and Ke Jiusi. Although the silk of the painting is abraded, the painting itself is quite legible. All the details—figures, houses, mountains, trees, water—are wonderfully executed.[76]

From this letter we learn that when Xu first acquired *Riverbank*, the painting was known, mistakenly, as *The Water Village*. The line of signature and the various collectors' seals on the painting had already been deciphered. By 1957, when the painting was

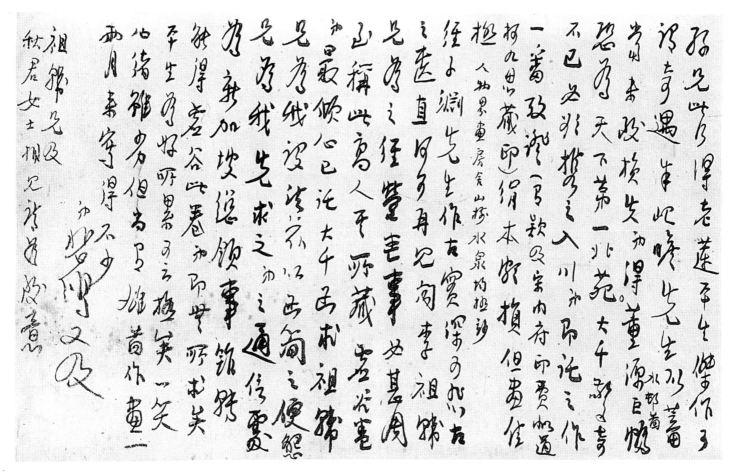

Figure 40. Xu Beihong (1895–1953). Letter sent from Singapore, late 1938 or early 1939. Private collection, Japan

published by the connoisseur Xie Zhiliu, it had recovered its proper title, *Riverbank*.[77] When C. C. Wang acquired the painting from Zhang Daqian in the late 1960s, he had it restored and remounted in Tokyo by the renowned conservator Meguro Sanji.

In the late 1940s and early 1950s, Zhang Daqian labored to recapture Dong Yuan's style (fig. 41), copying and recopying his favorite Dong Yuan model, *Along the Riverbank at Dusk* (fig. 39). Fu Shen writes:

> Zhang was so impressed with *Along the Riverbank* that after learning how to copy its imposing foreground trees he used their likeness in some thirty paintings. He also made at least three copies of the complete composition: the first in spring 1946 and two, or possibly more, copies in fall 1950, in Darjeeling, India.[78]

It would appear that Zhang Daqian did not recognize the importance of *Riverbank*. His own collecting activities were inspired by Dong Qichang. In a colophon dated 1947 he wrote,

> According to [Zhang Zhou's] "The Calligraphy and Painting Barge" [1616], Dong Qichang was obsessed with Dong Yuan. In his lifetime he owned four works [by Dong Yuan], *The Xiao and Xiang Rivers* being the finest. . . . Last winter [1946], I myself finally acquired *The Xiao and Xiang Rivers*. . . . I had earlier obtained *Along the*

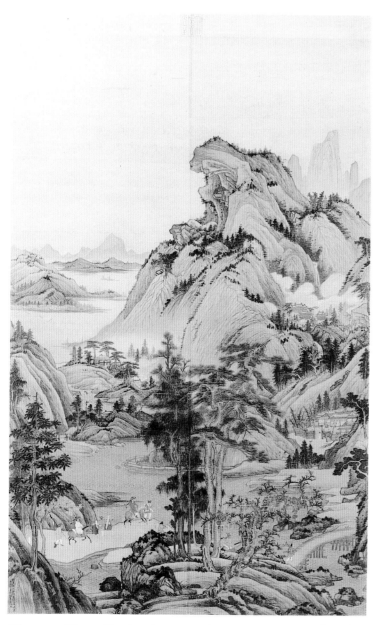

Figure 42. *Mustard Seed Garden Manual of Painting* (1679), illustration for the manner of Juran (active ca. 960–95)

Figure 41. Zhang Daqian (1899–1983), *After Dong Yuan's "Along the Riverbank at Dusk,"* dated 1950. Hanging scroll, ink and color on silk, 78 x 46¼ in. (198 x 117.5 cm). Zhang Xu Wenbo, Taipei

> *Riverbank at Dusk* and *Wind and Rain [The Dragon] Rising after Hibernation,* so that I now own three Dong Yuans. If some day I should acquire one more, I will have put a stop to old Dong's monopoly![79]

And in another colophon, dated 1949:

> Dong Yuan has a grand and elegant manner, which is difficult to imitate. After I acquired *Along the Riverbank at Dusk* and *The Xiao and Xiang Rivers,* I began to understand [Dong's] brush methods.[80]

It is possible that because *Riverbank* does not show the typical Dong Yuan/Juran hemp-fiber idiom, Zhang simply did not know how to respond to the attribution.[81] As Fu Shen has noted:

Figure 43. Zhang Daqian (1899–1983), *Water and Clouds at the Xiao and Xiang Rivers*, dated 1946. Hanging scroll, ink and color on paper. Private collection

Figure 44. Zhang Daqian (1899–1983), *Peach Blossom Spring*, dated 1983. Hanging scroll, ink and color on paper, 82⅜ x 36⅜ in. (809.1 x 92.4 cm). Cemac Ltd., Edmonton, Alberta

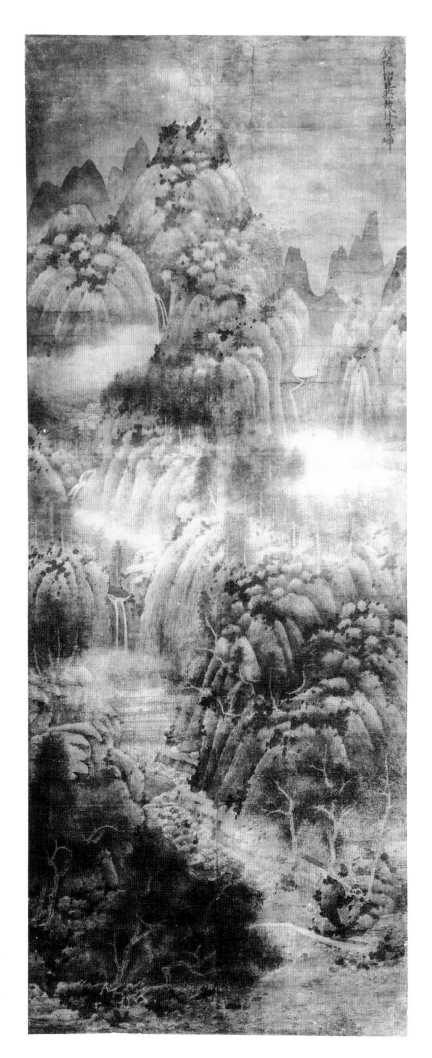

Figure 45. Zhang Daqian (1899–1983), forgery of Juran's *Dense Forests and Layered Peaks*, ca. 1951. Hanging scroll, ink and color on silk, 72¾ x 29 in. (184.7 x 73.8 cm). British Museum, London

The hanging scroll *Riverbank* did not have much influence on Zhang. There is no evidence of his ever having made any copy of this work, nor have we found any discussion of this work by him. A possible reason for this is the way the mountain forms in this painting are done with a shading technique, without a clearly defined linear, *cun* texture method. Neither does the linear pattern of its trees, architecture, or human figures seem extraordinary, so Zhang made no effort to copy or learn from it.[82]

The key concept here is the phrase "linear, *cun* texture method," which defines Zhang Daqian's technical approach to landscape painting. Earlier we discussed the development of Chinese landscape painting from Song naturalism to the calligraphic expression of the Yuan. By the late Ming and early Qing, landscape modeling techniques had been codified and catalogued into an elaborate set of graphic formulas known as *cun* texture methods. The *Mustard Seed Garden Manual of Painting* (1679; fig. 42), for example, lists "draping hemp fiber" (*pima*), "disorderly hemp fiber" (*luanma*), and "cow hair" (*niumao*) among a repertoire of sixteen texture patterns, relating them to historical styles of well-known masters.[83] This was Zhang Daqian's technical inheritance.

In his copies of the Dong Yuan attributions *Along the Riverbank at Dusk* and *The Xiao and Xiang Rivers* (figs. 41, 43; cf. figs. 39,

Figure 46. Unidentified artist (late 17th century), *After Juran's "Living in the Mountains."* Hanging scroll, ink on silk. Saito Collection, Japan

6), Zhang starts with the hemp-fiber *cun* patterns. In the former, his brushwork is sleek and sharp; in the latter, round, straight, and flat. There is a crucial difference between Zhang's hemp-fiber *cun* method and those of the late Ming and early Qing masters, such as Dong Qichang, Wang Hui, and Wu Li (figs. 34, 35, 37, 38): whereas the energetic and richly varied brushwork of the seventeenth-century masters builds forms into a smoothly flowing serpentine, or dragon-vein, movement, Zhang's linear patterns, which derive from Qing copybooks, are static, flat, and lifeless.

To remedy the flatness of his *cun* method, Zhang turned to ink wash to model

his forms in a Western chiaroscuro manner. He began to experiment in a new splat-tered-ink (*pomo*) blue-and-green landscape style, combining late-Qing linear *cun* pat-terns with Western chiaroscuro modeling techniques. In his *Peach Blossom Spring*, dated 1983 (fig. 44), the grandeur of the scenery and the dynamic impact of natural forces are powerfully conveyed by both traditional Dong Yuan/Juran motifs and imposing abstract blobs of black ink and color.

Of Zhang Daqian's large output of paintings now in collections around the world, *Dense Forests and Layered Peaks* (fig. 45), a forgery of a work by Juran, has received much critical attention. Fu Shen writes:

> When closely examined, the brushwork bears traits of Zhang's hand. The contrast between light and dark, which is harsher than in early paintings, gives Zhang's landscape a flatter appearance than *Seeking Dao in the Autumn Mountains*.[84] The contours of the rocks and especially the hard edge of the distant mountains in *Dense Forests and Layered Peaks* are stiffer and more slick.[85]

In addition to *Seeking Dao in the Autumn Mountains*, a painting attributed stylistically in the early Ming to Juran,[86] *Dense Forests and Layered Peaks* also builds on another Juran attribu-tion, *Living in the Mountains* (fig. 46), a work whose dragon-vein composition dates it to the late Ming and early Qing. Compared with its models, the modern forgery shows every hallmark of a painting by Zhang Daqian: fluent but flat brushwork, static moun-tain and tree forms, and smooth, heavy, Western-style chiaroscuro modeling.

In the early twentieth century, many modern forgeries of early Chinese paint-ings were made by copying photographic facsimiles. The J. D. Chen *Travelers amid Autumn Mountains* (fig. 1) is a case in point, unfortunately now known only in repro-duction.[87] Without close examination of the work itself, it is not possible to deter-mine whether it is actually by Zhang Daqian. From the poor reproduction, one can deduce only that it shares many of the same characteristics of a twentieth-century forgery: lifeless brushwork, flat forms, and heavy Western-style modeling.

Much can be learned, however, from a close examination of the modern forgery of Wang Meng's *Hermitage in the Qingbian Mountain* (fig. 47), also formerly in the J. D. Chen collection, which is based on a facsimile reproduction of the original, now in the Shanghai Museum (fig. 48). In the original, dated 1366, one of the most famous paintings of the Yuan period, the convulsive mountain forms and electrically charged trees are built with layers of pulsating, overlapping, dark and light inkstrokes, their swirling rhythms creating violent eddies and counter-eddies in a composition that, in the words of Max Loehr, "seems not so much to describe a passage of mountain scenery as to express a terrible occurrence . . . an eruptive vision."[88] By contrast, the

Figure 47 (opposite left). Modern forgery of Wang Meng's *Hermitage in the Qingbian Mountain*. Hanging scroll, ink on paper, 38¾ x 11 in. (97.3 x 28 cm). Formerly the Edward L. Elliott Family Collection

Figure 48 (opposite right). Wang Meng (ca. 1308–1385), *Hermitage in the Qingbian Mountain*, dated 1366. Hanging scroll, ink on paper, 55⅜ x 16⅝ in. (140.6 x 42.2 cm). Shanghai Museum

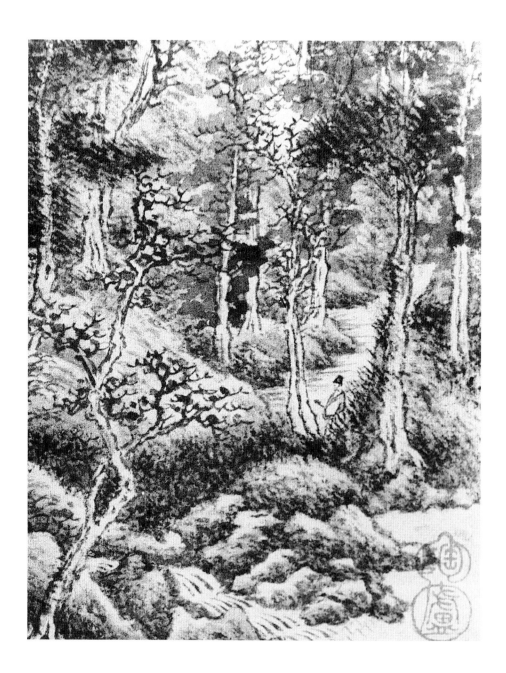

copyist, though attempting to be faithful to his model, is heavy-handed and incoherent. In a close-up view of two comparable details, one from the forgery (47a) and one from the original (48a), where the calligraphic brushwork in the original is both fluent and representationally expressive, in the forgery the copyist merely conceals his awkwardness with aimless daubing and heavy ink-wash modeling. In focusing on individual motifs and surface patterns, the forger grasps the proverbial trees but not the forest of Wang Meng's composition.

In studying *Riverbank* and the history of the Dong Yuan tradition in Chinese landscape painting, we have related the style of the painting to the social and artistic milieu of tenth-century China, in which it was produced; we have reconstructed its history and its influence on Yuan painting in the fourteenth century; and we have noted its inaccessibility to scholars and collectors during the Ming dynasty, from about 1380 to 1644, and its eventual rediscovery in the early twentieth century. The ramifications of the story we have told are manifold. As the product of a pivotal period in Chinese history, *Riverbank*

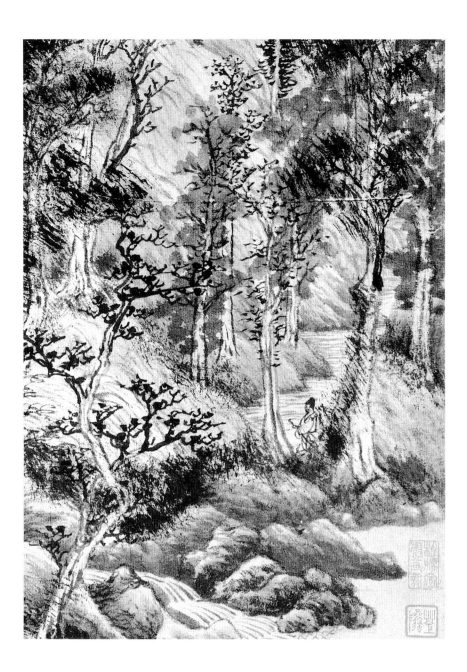

exemplifies the rise of monumental landscape painting, one of the most important developments in Chinese art. Its true significance, however, was soon forgotten. Later painters nevertheless tried to re-create Dong Yuan in their own works. At the heart of Chinese artistic endeavor is the traditional practice of copying works by ancient masters and imitating their styles. In copying, the exceptional artist studies the original, intently and perceptively, but he uses it only as a point of departure for his own creativity.

The Chinese painter's tool, a pliant yet resilient brush that tapers to a point, was compared by the seventeenth-century master Wang Yuanqi (1642–1715) to Indra's diamond club, an invincible weapon that bestowed upon the Hindu god his powers of creation.[89] A good painting, like good calligraphy, is considered a "heart print" (*xinyin*) that graphically expresses the artist's psychic identity. So how, one might ask, can a forgery, however clever, masquerade as an ancient masterpiece?

A successful forgery is not only a technical triumph, it is a psychological coup. Writing about forgeries of European masterworks, Hans Tietze once remarked that a good fake "must be served hot on the plate."[90] One of the first rules of a good

imitator or forger is to re-create a work in an idiom he has so mastered and internalized that the end product appears naturally inspired. So while Zhang Daqian may have been capable of creating forgeries of works by Dong Yuan by successfully imitating *Along the Riverbank at Dusk* and *The Xiao and Xiang Rivers*, in whose styles he was thoroughly conversant, he could never have painted *Riverbank*, whose ancient and forgotten forms and techniques were alien and incomprehensible to him.

1. J. D. Chen 1955.
2. For the album "To See Large Within Small" (*Xiaozhong xianda*), see Fong, Watt, et al. 1996, pp. 474–76.
3. See Fong et al. 1984, pp. 33–35.
4. Barnhart 1983a, pp. 30–37.
5. Ibid.
6. These attributions are *Xiao Yi Seizing the Lanting Manuscript* (fig. 20), *Layered Peaks and Dense Forests* (fig. 21), and *Buddhist Retreat by Streams and Mountains*, The Cleveland Museum of Art (Fong et al. 1984, fig. 39). Barnhart makes this observation in Barnhart 1983a, p. 37.
7. For a detailed study of the seals, see K. Yang 1998.
8. Zhao Mengfu, *Songxuezhai ji* (Collected Works of the Songxue Studio), *juan* 2, pp. 12a, b, in *Lidai huajia shiwenji*, vol. 2.
9. Barnhart 1983a, p. 30.
10. Cahill 1980, p. 48.
11. Cahill 1997, p. 5.
12. I have discussed the need for defining period styles in Chinese painting history with James Cahill in my review of his book *The Compelling Image* (1982) in Fong 1986, pp. 507–8.
13. Cahill 1997, p. 5.
14. David Sensabaugh, Curator of Asian Art, Yale University Art Gallery, brought to my attention the recent discovery of a painted six-paneled landscape screen in a Tang tomb in Fuping County, Shaanxi Province, dating from the middle Tang period; see *Kaogu yu wenwu*, no. 4 (1997), with a color illustration of two panels of the screen. For a discussion of early textual evidence for landscape screens, see Wu Hung 1996, pp. 134–44; see also Sullivan 1980, p. 47.
15. See Fu Xinian 1978, pp. 50–52.
16. Wakasugi 1985, pp. 173–75.
17. Guo Xi, *Linquan gaozhi* (Lofty Ambition in Forests and Streams; compiled 1117), in *Zhongguo hualun leibian* 1973, vol. 1, p. 639.
18. See Loehr 1968; and Egami and Kobayashi 1994.
19. For paintings attributed to Zhou Wenju, see Fong 1992, pp. 34–42; for *The Night Entertainment of Han Xizai*, attributed to Gu Hongzhong, see pp. 70–71 and fig. 59 in this volume, and Wu Hung 1996, pp. 29–71.
20. See Kang-i Sun Chang 1980.
21. Zhang Yanyuan, *Lidai Minghua ji* (Record of Famous Paintings in Successive Dynasties; 847), in *Huashi congshu* 1963, vol. 1, p. 23; see Acker 1954, p. 185.
22. *Xuanhe huapu*, juan 8, p. 83. See Barnhart (1983) 1984, p. 63.
23. The scholar's renunciation of worldly affairs in *Riverbank* echoes the episode in the life of the Buddha, Prince Siddhartha, when, in his Great Going Forth in search of enlightenment, he entered—always at the left of a composition—a forest in the mountains. Another example of a westward journey moving toward the left of a composition is *Emperor Minghuang's Journey to Shu*, which depicts the Tang emperor's flight from the capital along the mountainous roads of Sichuan. See Fong 1992, pp. 26–31.
24. Du Fu 1972, p. 38.
25. As quoted by Carl Nagin (1997, p. 26).
26. Munakata 1974, p. 7.
27. For an analysis of the forms and techniques of the rocks and trees in *Riverbank*, see Shih Shou-chien 1997, pp. 82–87.
28. Jing Hao, *Bifaji* (Notes on Brush Methods), in *Zhongguo hualun leibian* 1973, vol. 1, p. 606; see also Munakata 1974, p. 12.
29. Jing Hao, *Bifaji*, p. 605; see also Munakata 1974, p. 12.
30. Jing Hao, *Bifaji*, p. 607; see also Munakata 1974, p. 14.
31. Ibid.
32. For a description of three discernible stages of compositional development in Chinese landscape painting, see Fong et al. 1984, pp. 20–22.
33. Illustrated in Sirén 1956–58, vol. 3, pl. 83.
34. Jing Hao, *Bifaji*, p. 606; see also Munakata 1974, p. 12.
35. Yu-kung Kao 1991, p. 74. Wang Changling is depicted as the host of a literary gathering in Nanjing in the handscroll *Scholars of Liuli Hall*, attributed to the Southern Tang court painter Zhou Wenju; see Fong 1992, pp. 39–42, pl. 6.

36. Barnhart 1983a, p. 34.

37. Guo Xi, *Linquan gaozhi*, in *Zhongguo hualun leibian* 1973, vol. 1, pp. 640–41.

38. Ibid., p. 635; also Bush and Shih 1985, p. 153.

39. See Ogawa 1981, pp. 23–85; and Jang 1992, pp. 83–84.

40. See Fong 1992, pp. 174–87.

41. Deng Chun, *Huaji* (A Continuation of the History of Painting; preface dated 1167), in *Huashi congshu* 1963, vol. 1, p. 76.

42. See Barnhart (1983) 1984, pp. 62–63, 69.

43. See Ogawa 1981, pp. 22–23.

44. See note 6 above.

45. See Fong et al. 1984, pp. 36–40.

46. Mi Fu, *Huashi* (History of Painting), in *Zhongguo hualun leibian* 1973, vol. 2, p. 653.

47. See the biography of "Chou Mi" by Chu-tsing Li, in Franke 1976, vol. 1, pp. 261–68.

48. Zhou Mi, *Yunyan guoyan lu* (Record of What Was Seen as Clouds and Mists; 1280s), in Zhang Chou, *Qinghe shuhuafang* (The Painting and Calligraphy Barge at Qinghe; preface dated 1616), *juan* 1, p. 15.

49. See ibid.

50. Zhao Mengfu, *Songxuezhai ji, juan* 2, pp. 12a, b, in *Lidai huajia shiwenji* 1970, vol. 2.

51. Dong Yuan's *Wintry Groves and Layered Banks* was also well known to Yuan painters. See Wu Zhen, *Meidaoren yimo* (The Ink Legacy of Wu Zhen), in *Meishu congshu* 1964, vol. 2, p. 230.

52. See Fong 1992, p. 485.

53. See note 51 above.

54. Two other Wu Zhen compositions in the Juran manner are found in the album "To See Large Within Small"; see Fong et al. 1984, p. 37, fig. 37, p. 179, fig. 147c.

55. See Bian Yongyu, *Shigutang shuhua huikao* (Compilation of Writings on Calligraphy and Painting; 1682), vol. 4, painting section, *juan* 22, pp. 283–88.

56. Huang Gongwang, *Xie shanshui jue* (Secrets of Landscape Painting), in *Zhongguo hualun leibian* 1973, vol. 2, p. 697.

57. Both the *Tiewang shanhu* and the *Qinghe shuhuafang* note the fact that *Riverbank* was found in the imperial collection. See Zhu Cunli [Zhao Qimei], ed., *Tiewang shanhu* (Coral Treasures in an Iron Net; postscript dated 1600), 12/8, p. 8v; and Zhang Chou, *Qinghe shuhuafang, juan* 1, p. 15, *si*/38.

58. Illustrated in Barnhart 1970, fig. 3.

59. Liaoning Provincial Museum; illustrated in ibid., fig. 4.

60. Ibid., p. 15.

61. See Suzuki 1962–63, vol. 2, pp. 61–63; and Fong et al. 1984, p. 34, n. 41.

62. See Barnhart 1970.

63. Fong 1976–77, pp. 17–18.

64. Dong Qichang, *Huayan* (The Eye of Painting), in *Yishu congbian* 1967, ser. 1, vol. 12, p. 21.

65. For Dong Qichang's discussion of breath-momentum, see ibid., p. 19.

66. Dong Qichang, *Huachanshi suibi* (Miscellaneous Notes of the Huachan Studio; compiled 1720); see *Hualun congkan* 1958, vol. 2, p. 84.

67. For a study of Dong's connoisseurship, see Kohara 1992, pp. 81–103.

68. Cahill 1982b, p. 100.

69. Kohara 1992, pp. 100–101.

70. Fu Shen 1991, p. 308.

71. Dong Qichang, *Huaji*, in *Huashi congshu* 1963, vol 1, p. 84.

72. For a discussion of dragon-vein movement, see Fong, Watt, et al. 1996, p. 488.

73. Interestingly, Wu Li titled his painting, now in the Metropolitan Museum, *Copy after Wang Meng's "Travelers amid Streams and Mountains."*

74. Fu Shen 1991, p. 186; see also Fu Shen 1994, pp. 67–122.

75. Ding Xiyuan 1998a, pp. 101–2.

76. The letter is preserved in Japan. A photograph of the letter was made available, through Mr. Wang Shoukun of New York City, by Professor Ding Xiyuan. The letter is published in Ding 1998a.

77. See Xie Zhiliu 1957, pl. 2.

78. Fu Shen 1991, p. 191. Fu Shen (1994) reproduces three copies of the composition by Zhang, dated 1949 (pl. 4), 1950 (pl. 5), and 1950 (pl. 6).

79. Fu Shen 1994, p. 83.

80. Ibid., p. 86.

81. Zhang published three attributions to Dong Yuan in the 1954 edition of his collection. Two paintings appear in volume 1 (pls. 3, 4); *Riverbank* appears in volume 4 (pl. 1). See Zhang Daqian 1954.

82. Fu Shen 1994, p. 77.

83. See also March 1935, pp. 33–37.

84. National Palace Museum, Taipei; illustrated in Fong et al. 1984, fig. 35.

85. See Fu Shen 1991, p. 191.

86. The round calligraphic texture strokes of *Seeking Dao* date the painting to after Wu Zhen's *Central Mountain* of 1336 (fig. 28); see Fong et al. 1984, pp. 36–37.

87. It is now known only through J. D. Chen's publication *The Three Patriarchs of the Southern School of Chinese Painting*, 1955.

88. Loehr 1939, p. 273–90.

89. Wang Yuanqi, *Yuchuang manbi* (Jottings Done Beside a Rain-Splashed Window), in *Zhongguo hualun leibian* 1973, part 1, p. 173.

90. Tietze 1948, p. 55.

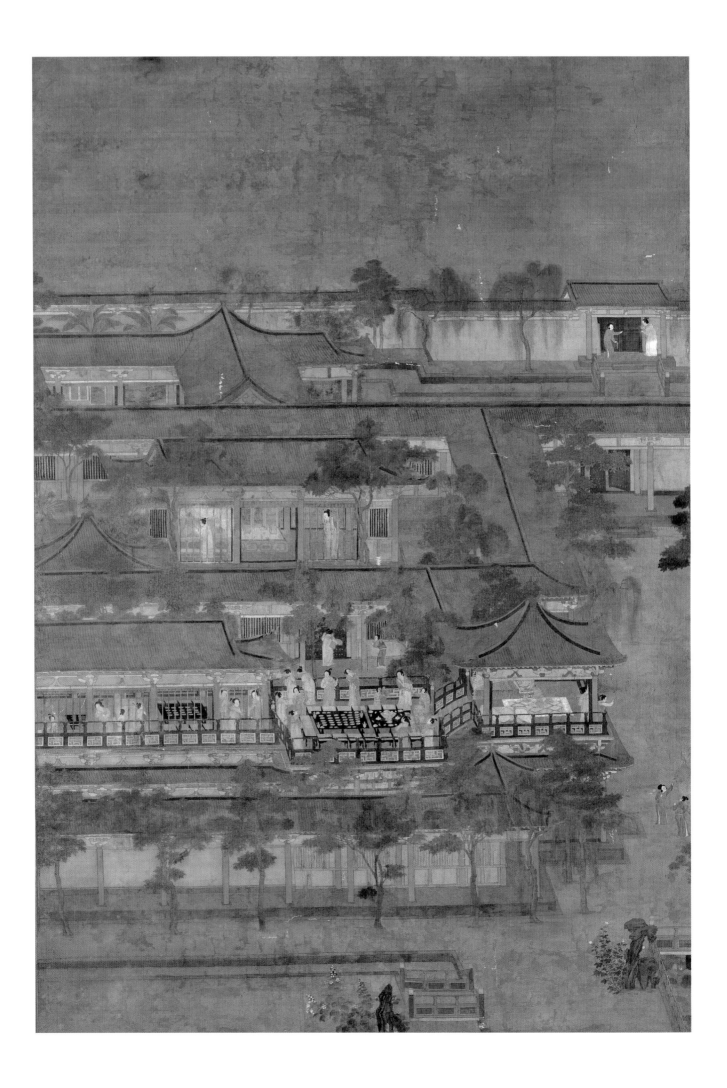

Along the Riverbank

Maxwell K. Hearn

Devoted to ancestor worship, the Chinese have long described their art in terms of schools and traditions and master-pupil lineages. The tenth-century master Dong Yuan, for example, to whom the monumental landscape painting *Riverbank* (pl. 1, page 2) is attributed, was later regarded as a founding patriarch of the Southern school of Chinese landscape painting. Leading landscape painters of later centuries, from the four masters of the late Yuan (1279–1368) to Dong Qichang (1555–1636) and both the orthodox and individualist masters of the early Qing dynasty (1644–1911), were all said to be Dong's followers. But as Wen C. Fong has demonstrated in the preceding essay, while works attributed to Dong have inspired landscape painters from the Yuan period onward, these later artists re-created the master's idiom after their own styles.

We can approach the history of Chinese painting by thinking of it as a great river formed by the confluence of many tributaries, cross-currents, and directional shifts. This essay explores some of these meandering currents, these ever-changing directions. The twelve works from the C. C. Wang Family Collection that are discussed in this volume have been acquired for the Metropolitan Museum by Oscar L. Tang and his family to extend and strengthen the Museum's holdings. Spanning nearly eight centuries of painting history, from about 950 to 1702, the group comprises major examples of court and scholar painting from the three principal genres of Chinese pictorial art: figural narrative, landscape, and flower-and-bird subjects. While twelve works cannot encompass the breadth and variety of this great tradition, they illuminate major changes in Chinese art history; in particular, they illustrate how later painters continued to reflect upon and transform the images and styles inherited from earlier masters.

PALACE BANQUET

The two earliest paintings in the Tang family promised gift are rare tenth-century works that may be associated with the Southern Tang dynasty (937–75). *Palace Banquet* is by an unidentified Academy painter, and *Riverbank* is attributed to Dong Yuan (active 930s–60s).

A time of political turmoil, the tenth century was also an era of artistic innovation. During the chaotic years between the collapse of the Tang dynasty in 907 and the founding of the Song dynasty in 960, a time known as the Five Dynasties and Ten Kingdoms period, centralized rule was shattered and China splintered into competing states. North China was ruled by a succession of short-lived military regimes, each

2a. Detail, plate 2

intent on achieving political hegemony, and South China fragmented into small regional states that showed little interest in conquest.

The Southern Tang dynasty, which governed much of the lower Yangzi River delta region from its capital at Nanjing, was among the most stable and prosperous of these southern kingdoms. The arts flourished, particularly under the patronage of the last two rulers, Li Jing (r. 943–61) and Li Yu (r. 961–75), both of whom supported talented artists at their courts, including the figure painters Zhou Wenju and Gu Hongzhong, the architectural specialist Wei Xian (all three active ca. 943–75), and the originators of a distinctive southern idiom of landscape painting, Dong Yuan (active 930s–60s) and Juran (active ca. 960–95).[1]

The elegant life-style of the Southern Tang court is vividly evoked in *Palace Banquet* (pl. 2), a large-scale image executed in ink and mineral colors on silk that epitomizes the descriptive richness and narrative complexity of tenth-century figure painting. Measuring nearly five feet in height, the painting, now mounted as a hanging scroll consisting of two joined vertical lengths of silk, originally may have formed part of a much larger multipanel screen. The painting presents a bird's-eye view of the women's quarters of an imposing palace in which richly furnished rooms look out onto a series of private courtyards graced with willows, plantains, bamboo, palms, and other ornamental trees. At the heart of the complex is a second-story terrace where ladies and female servants stand expectantly around tables set with dishes and serving vessels, waiting for an elaborate banquet to begin. What is the occasion? Where is the emperor? Only on close examination do we discover the subtle narrative structure that guides us through the picture space, providing answers to our questions.

At the top of the picture, a broad expanse of empty silk defines the separation of these private quarters from the world beyond the palace, whose only point of entry is the gate at the upper right corner. Beginning with the gateway, both the architecture and the gestures of the figures lead us from the exterior world to the increasingly intimate interior space of the royal harem. The path, like that in a Chinese garden, is not a direct one; it follows a circuitous route that only gradually reveals the layers of meaning that the painting holds.

Inside the gate, a servant girl helps a lady lift off the massive wooden beam that bars the double doors—signaling the emperor's imminent arrival (pl. 2a). The servant holds a padlock that she has just removed from a second gate, the open door of which beckons the viewer to enter a wide yard where two girls—one holding a fan, the other a pair of lotus—chase after a butterfly, oblivious to the calls of the ladies who look down on them from a two-story pavilion (pl. 2b). The butterfly and the paired lotus are images often linked with romantic love, but they also function as temporal markers indicating the summer season.

2b. Detail, plate 2

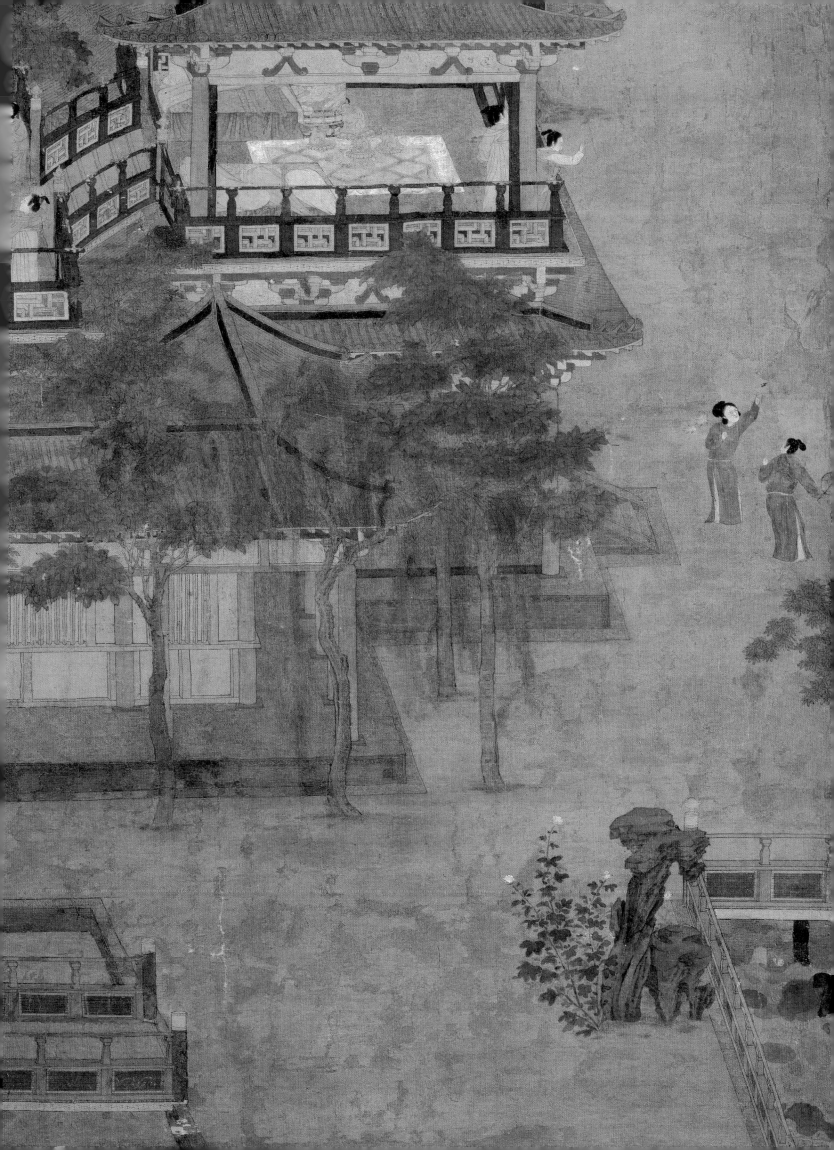

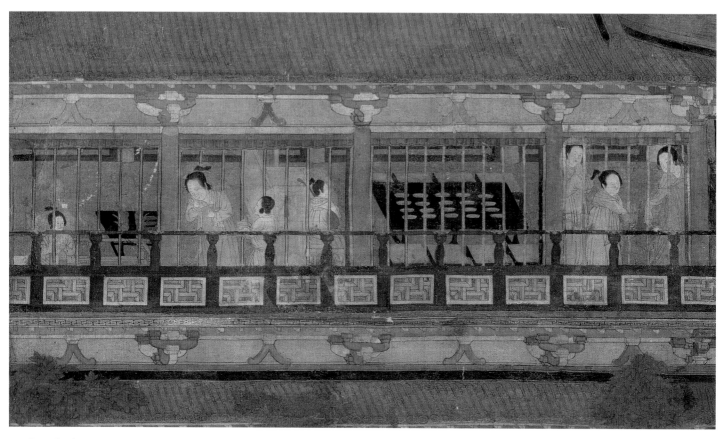

2c. Detail, plate 2

The girls stand beside a stone stairway that is the only visible access to the seraglio. Broad avenues, a moat, and garden rocks like sentinels encircle the tree-shaded cloister, emphasizing its physical isolation. At the left, in a spacious hall, five ladies look out expectantly (the one on the far left is shown just emerging from a stairway leading from the first floor), while another plays a lute beside a large table surrounded by cushioned stools (pl. 2c). More tables set with wine cups, plates, and ewers have been moved onto the adjacent terrace (pl. 2d), and a sideboard nearby holds an array of gold serving vessels. In a detached pavilion to the right of the terrace, an elaborate incense burner in the form of lions on lotus thrones has been placed on a carpet, while musical instruments still wrapped in brocade have been set out for a concert (pl. 2e).

Everything has been readied for an elaborate party, but the imperial guest has yet to arrive. Among the waiting women, two standing at the rear left of the central banquet table are particularly noteworthy. One points skyward, while her companion licks a strand of silk in preparation for threading the needle that she holds in her raised left hand. A lady on the balcony at the far left also threads a needle (pl. 2c). It is these unusual activities that provide the key to the subject of the painting.

On the seventh day of the seventh lunar month, the Weaving Maid and the Herd Boy, legendary lovers immortalized as stars at either end of the Milky Way, meet in a lovers' tryst.[2] The occasion, still celebrated as Lovers' Day (*Qingrenjie*), was known in traditional China as the Seventh Evening Festival (*Qixijie*), or the Entreating Skills Festival (*Qiqiaojie*), a day when women decorated the household, set out platters of food, drank wine, and competed in needle threading.[3] If the theme of *Palace Banquet* is indeed the celebration of Lovers' Day, the absence of its principal participant

2d. Detail, plate 2

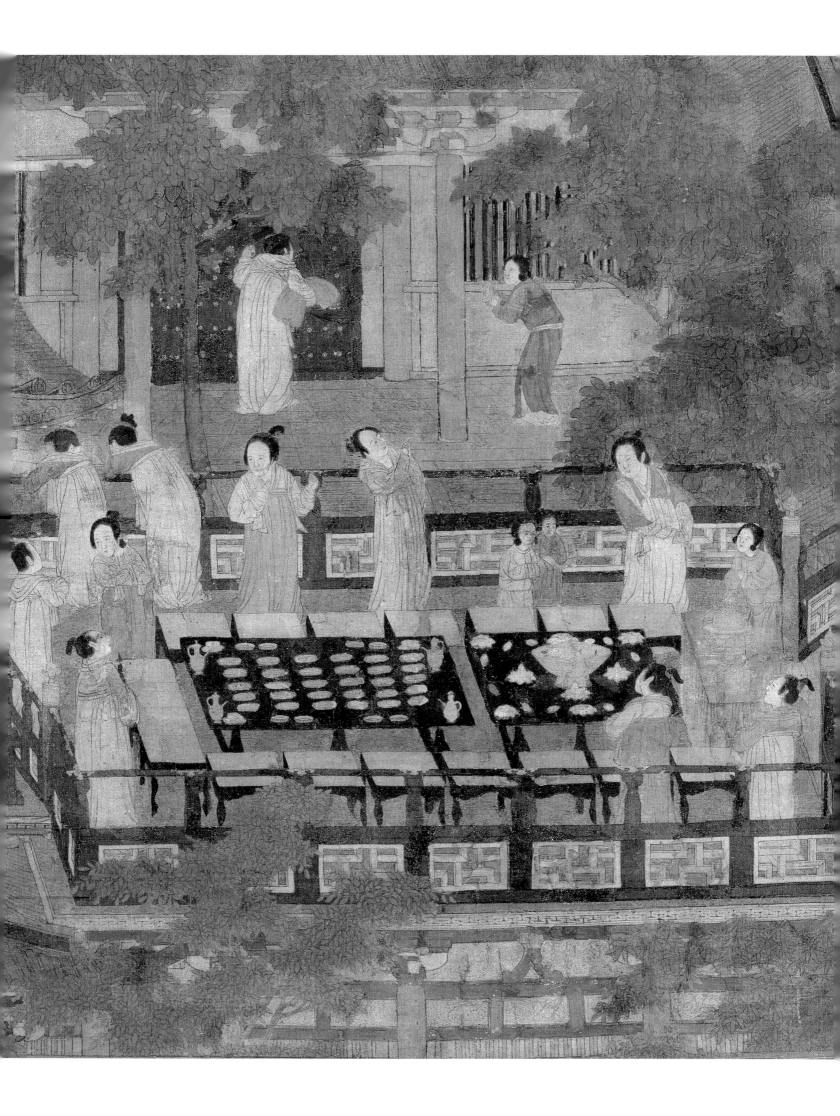

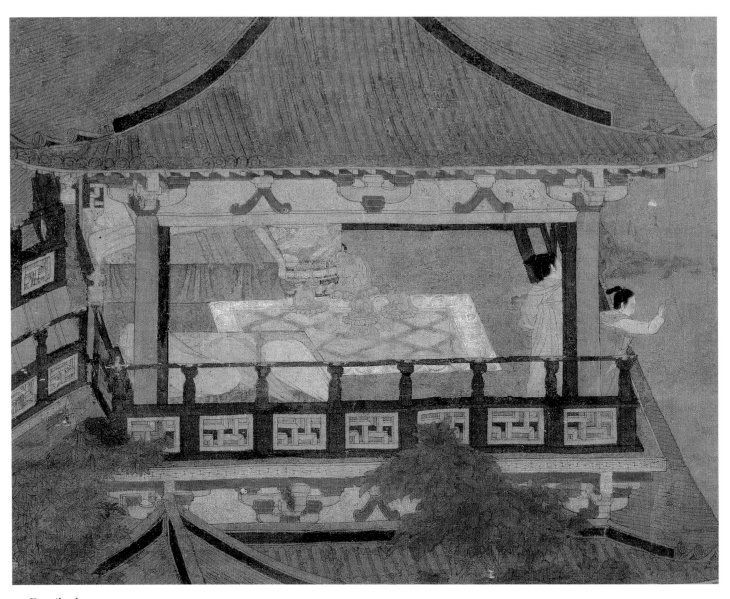

2e. Detail, plate 2

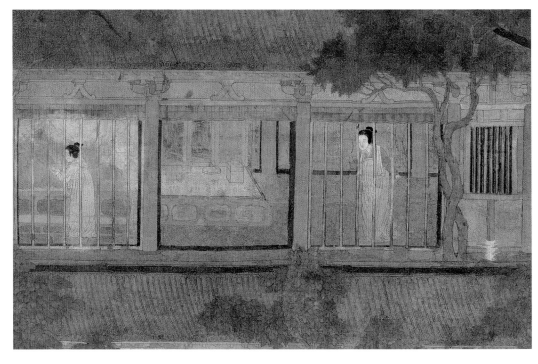

2f. Detail, plate 2

2g. Detail, plate 2

intensifies the picture's narrative suspense. In seeking out the emperor, we are inevitably led beyond the banquet scene to the inner chambers of the royal harem, where the amorous nature of the festival is made more explicit.

Entry to these private apartments lies directly behind the terrace through yet another gate, where a lady and her servant are about to enter (pl. 2d). Beyond this doorway is a three-bay hall (pl. 2f), the central room of which holds a dais backed by a multipanel landscape screen (pl. 2g). If this were the emperor's study, the dais might be set with an inkstone and writing materials; instead, we see a mirror case and a cosmetics box, clear indications that this is a feminine space. In the right chamber, a woman lights a standing lamp—a reminder of the evening hour. The left chamber is a bedroom. Viewed through a transparent blind, we glimpse a bed with curtains pulled back to reveal its occupant, concealed beneath a disheveled bedcover. The sleeping figure, presumably the emperor's favorite, is interrupted in her reverie by a lady who claps her hands, to rouse her in preparation for his arrival. Uncovered by our voyeuristic gaze, the scene explicitly suggests the possibility of a later romantic encounter and makes us conscious of ourselves as the unseen observers for whom the vignette was created.

The artist has led us on a path of gradual discovery. But if the scene in the bedroom represents a dramatic culmination, it does not occur in the innermost space of

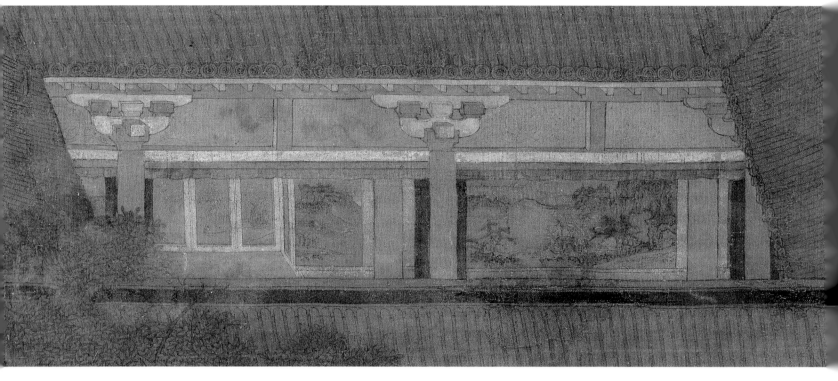

2h. Detail, plate 2

the compound and so cannot be the narrative's final chapter. Behind the bedroom suite lies another hall aligned along the same axis but set perpendicular to it, its massive roof shielding the interior from our view. Here, no doubt, are the emperor's private apartments. The corridor to the left of the royal chambers is lined with a large screen and several wall hangings that depict a palatial complex surrounded by rugged peaks and tall pines, a blue-green image of layered hills along a shoreline, and a three-panel composition showing fishermen boating by a reed bank (pl. 2h).

These paintings within the painting remind us of the many levels on which illusion functions in this work. By the tenth century, painters had begun to reflect on the very act of painting itself, both through the revival of earlier styles and through a recognition of the artifice involved in representing a three-dimensional space on a two-dimensional surface. The paintings within the painting serve to persuade us that the space we have entered is a real one. This illusion, however, is contradicted by our relation to the action depicted, since we view the narrative from outside the picture space. Like other works created at the Southern Tang court, *Palace Banquet* explores the tension between our world and the world of the painting, offering, like a theatrical performance, only a momentary suspension of disbelief before leading us back to a heightened awareness of ourselves.[4]

Another aspect of the painting's artifice is its revival of Tang-dynasty architectural motifs, costumes, and figure types to indicate that this is not a record of contemporary life but a historical narrative. The most famous lovers associated with the seventh day of the seventh month are Tang emperor Xuanzong (r. 712–56) and his consort Yang Guifei. It was Xuanzong's infatuation with Yang Guifei and his neglect of the affairs of state that led to the rebellion of An Lushan in 755, which forced the emperor to flee the capital to Shu (present-day Sichuan Province). En route,

Xuanzong's palace guard mutinied, refusing to accompany the emperor until Yang Guifei was put to death. Several generations later, the poet Bai Juyi (772–846) memorialized the tragic romance in his "Song of Unending Sorrow" (*Changhenge*). *Palace Banquet*, with its elegant ladies, elaborate banquet, and in particular the dilatory concubine still sleeping in her bedchamber recall similar images in Bai Juyi's poem:

> *There were other ladies in the inner palace, three thousand of rare beauty,*
> *But [the emperor's] favors to three thousand were focused on one.*
> *By the time she was dressed in her Golden Chamber, it was nearly nightfall;*
> *In the Jade Tower at the banquet's end, her drunkenness was mellow as springtime.*

Other details in the painting may also allude to images from the poem. The blossoming hibiscus and willow trees recall the poem's Lake Taiyi hibiscus and Weiyang Palace willows, which are compared to Yang Guifei's "petal-like countenance" and "willow-leaf eyebrow," while the tree formed of intertwined trunks (pl. 2f) alludes to the lovers' unfulfilled vow, recounted in a dreamlike sequence:

> *And she sent him, by his envoy, a verse reminding him*
> *Of vows known only to their two hearts:*
> *"On the seventh day of the seventh month, in the Palace of Long Life,*
> *We told each other secretly in the quiet midnight world*
> *That we wished to fly to heaven, two birds with the wings of one,*
> *And to grow together on earth, two branches of one tree."*[5]

Other details in the painting are also based on Tang prototypes. The blue-green color scheme of the architecture and the inverted V-brackets set between the columns (pl. 2e), an ornamental device that disappears after the Tang dynasty, parallel structures depicted in Tang murals (fig. 51). The costumes, coiffures, and full proportions of the

Figure 51. Unidentified artist (early 8th century), *Gateway Towers*. Detail of a mural from the tomb of Prince Yide (d. 701). Shaanxi Provincial Museum

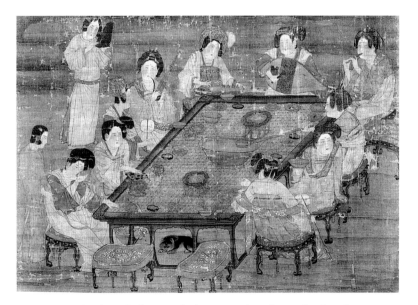

Figure 52. Unidentified artist (8th century), *Palace Ladies Drinking*. Hanging scroll, ink and color on silk, 19⅛ x 27⅜ in. (48.7 x 69.5 cm). National Palace Museum, Taipei

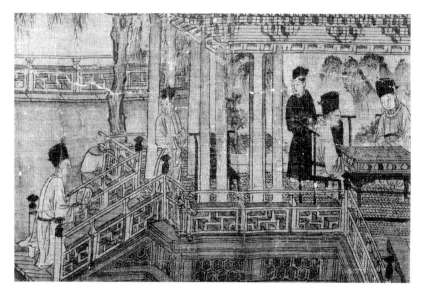

Figure 53. Zhang Xian (990–1078), *Ten Poems Celebrating a Gathering at the South Garden*, dated 1064. Detail. Handscroll, ink and color on silk, 20½ x 70⅜ in. (52 x 178.7 cm). Palace Museum, Beijing

Figure 54. Unidentified artist (11th century), *Buddha Vikirnoshnisha*, ca. 1056. Detail. Ink and color on paper, 37 ¼ x 19¾ in. (94.6 x 50 cm). Yingxian County Office for Cultural Relics, Shanxi Province

Figure 55. Unidentified artist (9th century), *Paradise of Bhaisajyaguru*. Detail. Ink and color on silk, 81⅛ x 65¾ in. (206 x 167 cm). British Museum, London

palace ladies are based on eighth-century fashions and standards of beauty later associated specifically with Yang Guifei, while the furnishings of the palace, including the couches and beds with box construction and the elaborate ogival cutouts and large banquet tables with stools, all follow Tang styles (fig. 52). But while these details derive from Tang models, they are not clearly Tang.[6] The inverted V-brackets have fanciful upturned ends, while the ladies' high-waisted dresses, short jackets, and scarves do not precisely match a Tang model. Other details also suggest a later date. The latticework on the railings, while it derives from Sui and Tang prototypes, is closer in proportion and in the spacing of the railing posts to the example depicted in Zhang Xian's (990–1078) *Ten Poems Celebrating a Gathering at the South Garden*, dated 1064 (fig. 53).[7] Similarly, the incense burner (pl. 2d) resembles a censor found in the *Buddha Vikirnoshnisha*, of about 1056 (fig. 54).

The complex spatial setting of *Palace Banquet* also argues against a Tang date. In paradise scenes depicted in ninth-century silk

paintings recovered from Dunhuang (fig. 55), figures appear out of scale in relation to their setting; shifts in scale are schematic; and perspective is disjointed, with the main hall represented as if viewed from below, the side halls viewed from above. By the twelfth century, this kind of grand architectural panorama had become highly complex, as seen in the late-eleventh-century handscroll *Going Up the River at the Qingming Festival* (fig. 56), or in the murals of the Yanshan Temple, dating to 1167 (fig. 57).[8] In the Yanshan murals, a multiscene narrative is woven together across a vast space with architecture providing the spatial framework. But while certain motifs such as the ornamental railings with lattice-work inserts are close to those in *Palace Banquet*, the use of foreshortening is far more advanced; the technique of drawing the bracketing system has also become more mechanical, with a grid of ruled lines used to block out the placement of the individual components. The same lowered ground

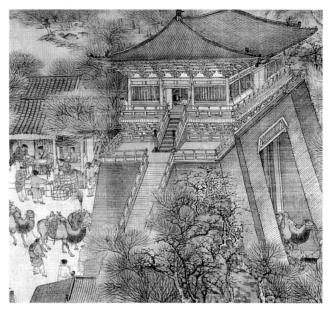

Figure 56. Zhang Zeduan (active 11th century), *Going Up the River at the Qingming Festival*. Detail. Handscroll, ink and color on silk, 9¾ x 208 in. (24.8 x 528 cm). Palace Museum, Beijing

Figure 57. Wang Kui (active 12th century). Detail of a mural on the west wall of Manjusri Hall, dated to 1167. Yanshan Temple, Fanzhi County, Shanxi Province

Figure 58. Unidentified artist (late 11th century). Detail of a mural on the north wall of Kaihua Temple, rebuilt 1073–98. Gaoping County, Shanxi Province

Figure 59. Gu Hongzhong (active ca. 943–75), *The Night Entertainment of Han Xizai.* Detail. Handscroll, ink and color on silk, 11¼ x 132⅛ in. (28.5 x 335.5 cm). Palace Museum, Beijing

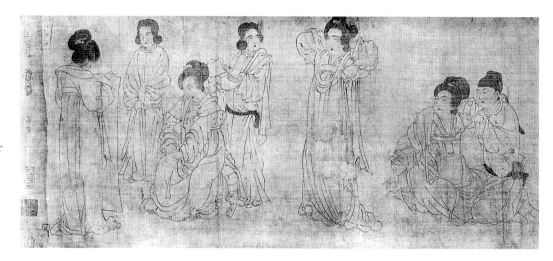

Figure 60. Unidentified artist (active early 12th century), after Zhou Wenju (active ca. 943–75), *In the Palace,* before 1140. Detail. Handscroll, ink and touches of color on silk, 10⅜ x 57½ in. (26.5 x 146 cm). The Metropolitan Museum of Art. Purchase, Douglas Dillon Gift, 1978 (1978.4)

plane and use of ruled lines to render the brackets appear in Zhang Xian's painting of 1064 (fig. 53). A closer parallel to *Palace Banquet* is found in the murals of the main hall of the Kaihua Temple in Shanxi Province, painted about 1098 (fig. 58), which show similar Tang-style architectural archaisms such as inverted V-brackets between columns, though the more highly integrated spatial setting in the Kaihua mural indicates a somewhat later date. In spite of the painting's elevated perspective, which enables us to look over the walls into neighboring courtyards and chambers, *Palace Banquet* does not exhibit a unified spatial structure. Instead, the composition is constructed additively, with the architecture forming register-like internal divisions as a structure for a sequential narrative. The sharply tilted ground plane, the minimal diminution in the size of objects from foreground to background, and the expanses of blank silk with no suggestion of atmosphere all suggest a date prior to the eleventh century.

Difficult to date because of the dearth of comparable works and the absence of any clear record of transmission, *Palace Banquet* fits most comfortably into the later tenth century, when "ruled-line" (*jiehua*) architectural renderings developed into a specialized genre and the Tang tradition of depicting the daily life of palace ladies came into vogue.[9] The painting's intimately detailed evocation of the inner palace also relates it to two of the most famous compositions associated with the Southern Tang court, *The Night Entertainment of Han Xizai,* by Gu Hongzhong (fig. 59), and *In the Palace,* by Zhou Wenju, a composition preserved in an early-twelfth-century copy now divided

into four parts, the final section of which is at the Metropolitan Museum (fig. 60). Like *Palace Banquet*, *In the Palace* focuses on the women's quarters and depicts figures wearing Tang-style costumes. *Night Entertainment*, which depicts the promiscuous private life of the Southern Tang minister Han Xizai (908–970), similarly features banqueting, musical instruments, and bedroom scenes comparable to those in *Palace Banquet*, though the costumes and furniture reflect contemporary tenth-century tastes.

Palace Banquet may also be read as a subtle political commentary directed at the Southern Tang ruling house. In the painting, the failure of the concubine to treat the imminent arrival of the emperor with the properly respectful attitude not only recalls the excesses of Yang Guifei's relationship with Emperor Xuanzong, whose love affair was a disaster for the Tang empire, but would also have been understood as a warning against similar excesses at the Southern Tang court. There, its last ruler, Li Yu, sensing the inevitability of his own dynasty's demise and the futility of resistance, is said to have given himself over to an indulgent life among the ladies of his harem.

There is of course a major difference in the format of *Palace Banquet* compared with that of *Night Entertainment* and *In the Palace*. Both *Night Entertainment* and *In the Palace* are painted as handscrolls; by contrast, *Palace Banquet* is a rare survivor of the large-scale screen format—perhaps the central section of a panoramic architectural structure comparable to those seen in later wall paintings (figs. 57, 58). The screen paintings depicted in *Palace Banquet* offer important evidence of how such works functioned within an architectural setting. In *Night Entertainment*, paintings are shown as screens or panels set within pieces of movable furniture. In *Palace Banquet*, however, paintings are integrated into an architectural framework. Large panels (made up of joined pieces of silk) are mounted against the partition walls between columns, while screens with individual silk panels framed by a cloth border are displayed either flat, as behind a dais, or folded into a nichelike configuration. Five such compositions are visible in the painting: two in the bedroom suite of the emperor's consort and three in the emperor's apartments. The couch in the central bay of the consort's chambers (pl. 2g) is backed by a three-panel composition that shows a blue-green landscape. Behind this screen is a series of much larger panels that fill the spaces between columns along the rear wall of the hall. Only the panel behind the lady lighting the lamp is readable; it shows a wintry lowland landscape with bare trees and rocks visible along its right edge. Three more compositions are visible in the corridor adjacent to the emperor's apartments (pl. 2h). The multipanel composition at the left, which shows two figures in a skiff beside a shore lined with tall reeds, resembles a scene from *First Snow along the River*, a handscroll composition by the Southern Tang Academy painter Zhao Gan (active ca. 960–75; fig. 19). Adjacent to this screen are two other landscape compositions, one a blue-green mountainscape, the other an image of a temple framed by a rugged range of mountains and tall foreground pines—a composition that became even more evocatively rendered in eleventh-century handscrolls. The dominance of landscape imagery in these paintings is striking; while *Palace Banquet* emphasizes the worldly pleasures of the royal harem, at the heart of this man-made paradise withdrawal into nature remains the ultimate ideal.

As so often happens in art history (as in political history), once a certain development or style has reached its apogee or a level of mastery is achieved, it is replaced by its opposite. Thus, at about this time, when figure painting had attained a highly sophisticated complexity, it was superseded by monumental landscape, which had been evolving as an independent genre since at least the eighth century. While the depictions by Southern Tang figure painters of the decadent pleasures of palace life alluded to the increasingly perilous position of the rulers for whom they labored, another group of artists working at the court drew inspiration from the natural world, finding in mountains and rivers a permanence and place of sanctuary that the human realm increasingly lacked. The images of landscape that these men created were not descriptions of specific sites; rather, they were idealized conceptions of man's place within the natural order.[10]

One of the striking features of the genre was its predominantly monochromatic palette. Whereas Tang landscapes were often brilliantly colored with mineral pigments, tenth-century artists increasingly relied on graded tones of ink to capture the spirit of the landscape, not merely its outward appearance. Although darkened with age, *Riverbank* (pl. 1, page 2), the tallest of all surviving early Chinese landscape paintings, marks the majestic inception of the monumental landscape tradition. With the absence of contour lines and the use of subtle ink washes to describe the rounded hills and earthen slopes of southeastern China, the painting is distinct in appearance and style from images attributed to northern masters of the late tenth and early eleventh centuries (fig. 3). Its tenth-century date and southern regional character are supported by the partially effaced signature inscribed along its lower left margin: "Painted by the Assistant Administrator of the Rear Park, Servitor Dong Yuan" (pl. 1a, page 6). The presence of a signature on a Chinese painting is never a guarantee of its authorship, as signatures were often added long after the painting was made, but the antique style of the writing makes it equally inadvisable to ignore.

Dong Yuan, revered by later scholar-artists as a patriarch of the Southern school of landscape painting, had perhaps a greater impact on the development of later Chinese painting than any other artist, yet the details of his life remain largely unknown. His name is absent from the art-historical record for more than a century after his period of activity, and even such details as his given name, place of birth, and date of death are in dispute.[11] What is known is that Dong was active in the Southern Tang capital (present-day Nanjing, Jiangsu Province) under the second Southern Tang ruler, Li Jing (r. 943–61), and that he held the minor position of assistant administrator of the North or Rear Park.[12] In 947, Dong and several court artists were ordered to collaborate on a painting that would depict Li Jing and several of his officials celebrating a heavy snowfall on New Year's Day. Dong was to contribute the snow-covered bamboo and wintry groves.[13] That he was asked to participate in an imperial commission such as this suggests that Dong was already an established artist, active for some time

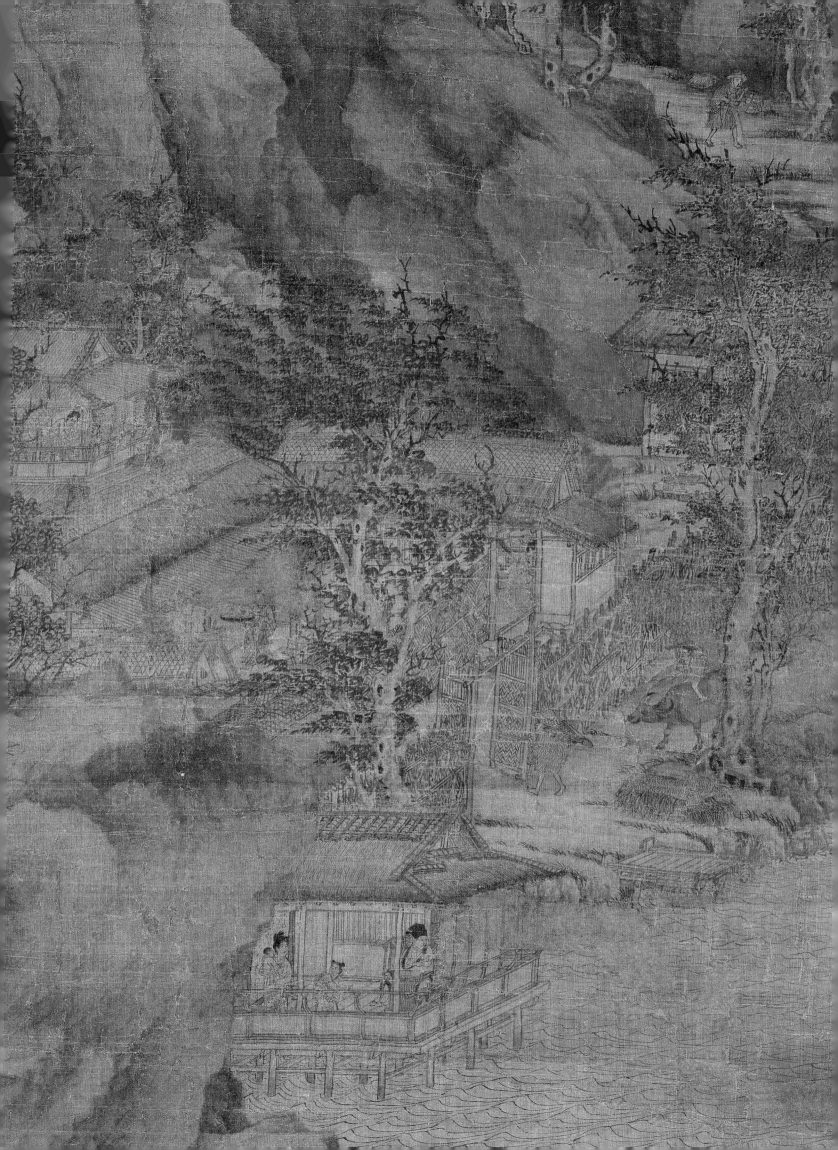

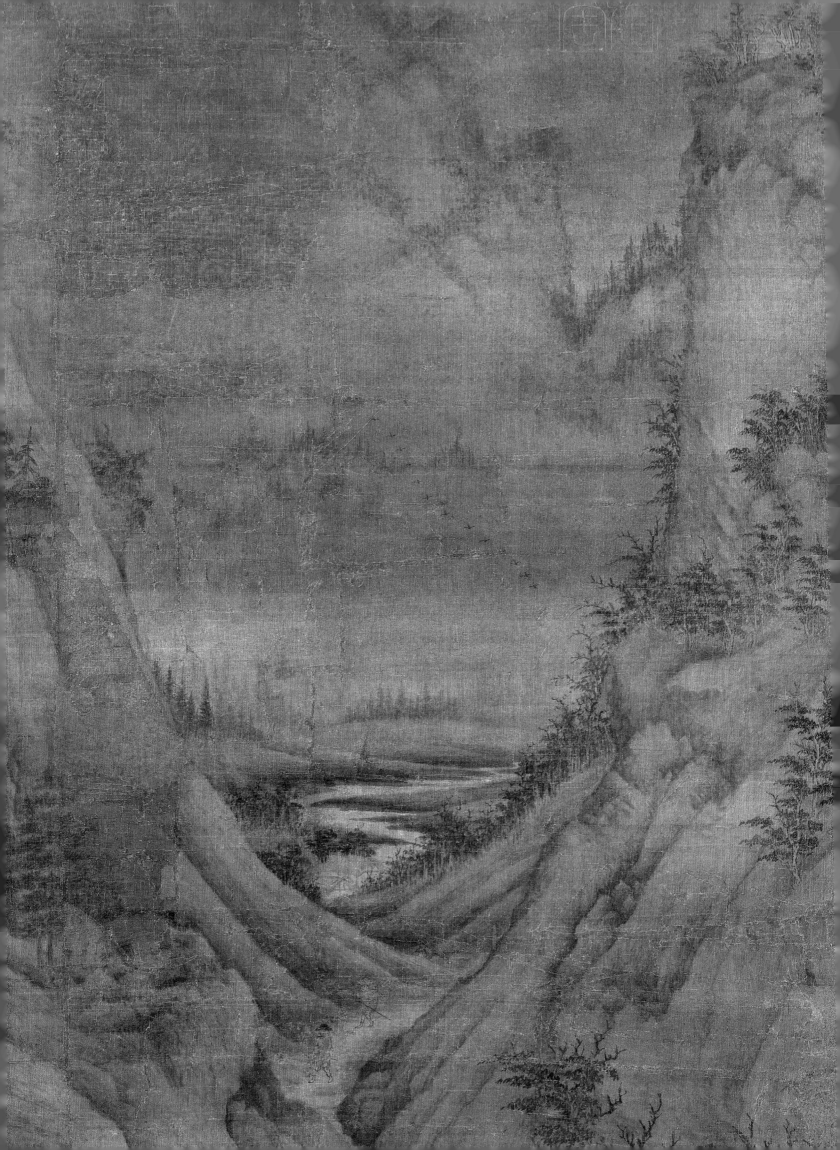

prior to the commission. While he was not a member of the Southern Tang Painting Academy, Dong's period of activity placed him in the circle of a remarkable constellation of artists working at the Southern Tang court, including the figure painters Zhou Wenju and Gu Hongzhong, the flower-and-bird painter Xu Xi, the architectural specialist Wei Xian (all active ca. 943–75), and the landscapist Juran (active ca. 960–95). With the exception of Juran, none of these artists is recorded as having continued to work during the Song dynasty, so their periods of activity presumably came to an end prior to 975, when the Southern Tang state was extinguished and its last ruler, Li Yu (r. 961–75), and members of his court were relocated to the Song capital of Kaifeng.[14]

The nature of Dong Yuan's art has remained as elusive as the facts of his life. Guo Ruoxu, writing about 1070, records that Dong mastered both the colored landscape style of Li Sixun (651–716) and the monochrome ink-wash landscape style of Wang Wei (701–761), but that he was also a proficient painter of water buffalo and tigers.[15] The *Xuanhe huapu* (preface dated 1120), the Song catalogue of imperially owned paintings, records an even wider range of subject matter among the seventy-eight examples of Dong's art in Emperor Huizong's (r. 1101–25) collection, including landscapes, dragons, water buffalo and herdboys, and various figural subjects.

To ascertain whether *Riverbank* has a place within this diverse oeuvre, we must begin with a careful examination of the painting itself. Large in scale, the painting is formed of two vertical lengths of silk that, while they have been trimmed during the course of repeated remountings (see the Appendix for a description of the painting's condition), still preserve a coherent composition of deeply sculpted mountains framing a distant vista. As we enter the composition from the bottom edge of the picture frame, a screen of trees arrayed along a foreground spit of land serves as a repoussoir separating the pictorial space from the picture surface (pl. 1b, pages 8–9). The tallest of the trees leads us across a wide river to a middle-ground promontory. To the right, a river flows beside an elegant hermitage whose geomantically optimal siting between mountains and river emphasizes its harmonious integration with the natural world (pl. 1e, page 73). To the left, the river recedes to a waterfall that pours forth from a mountain in a series of cascades (pl. 1c, page 10), further enhancing the importance of water in the artist's conception of landscape, or *shanshui* (mountains and waters). Behind the waterfall a succession of thrusting escarpments and deeply eroded ridgelines topped with clusters of trees builds layer upon layer into a towering peak that disappears into the background as it climbs toward the top of the picture frame.

Many aspects of the painting suggest a dating to the tenth century. First, the artist achieves his complex vision simply and schematically through the additive buildup of overlapping motifs across a steeply tilted ground plane. Following the archaic convention that more distant elements are rendered higher and smaller on the picture plane, the painting's step-by-step recession is complemented by a progressive diminution in the scale of trees and other landscape features. Second, the artist's efforts to convey the monumental grandeur of the mountains is rivaled by his painstaking delineation of the landscape's spaces: the shadowy clefts and hollows of

1f. Detail, plate 1

the mountain, the sheltering courtyards and halls of the hermitage, the contained curves of the stream, and the winding valley that connects the foreground space to the broad river basin and distant mountains—all reflect an early stage in the depiction of volume and the illusion of recession on a two-dimensional surface through the use of primitive space cells.[16]

A third key to the dating of this landscape is the way in which the surfaces of the rocks and mountain forms are modeled through the use of alternating areas of light and dark ink wash. There is no evidence of a brush or of the artist's hand, and there is a general absence of contour lines, both of which constitute an approach to landscape not unlike that of artists of the Tang dynasty. An eighth-century painting on a leather lute plectrum guard (fig. 18, page 25), for example, shows mountains defined not by texture strokes but by alternating bands of light and dark wash with no sense of a brush as an animating presence. In a landscape composition excavated from a mid-tenth-century Liao-dynasty tomb (fig. 14, page 20), the alternating areas of dark and light shading are defined by distinctive dragged strokes that reveal traces of the brush—a characteristic already in advance of what we see in *Riverbank*.[17] By the early eleventh century, the texturing of landscape forms through the use of individual brushstrokes in such works as Fan Kuan's (active ca. 990–1030) *Travelers amid Streams and Mountains* (fig. 3, page 4) had become both more prominent and more systematic: texture strokes and dots that vary in both length and direction now define the planes of rock surfaces. By the second half of the eleventh century, in works such as *Early Spring* (fig. 4, page 4), a painting by Guo Xi (ca. 1000–ca. 1090) dated 1072, an even more complex array of texture strokes, washes, and contours is used not only to evoke the tactile qualities of rock forms but to suggest the blurring effect of a moisture-laden atmosphere.[18]

Another indication that *Riverbank* represents an early moment in the development of monumental landscape is its narrative content, for here human activity still vies with nature as the principal subject, each of the fourteen figures in the painting contributing to the complex narrative structure. The figures thus appear to be relatively large in scale, especially when compared to the minute stature of the figures in the landscapes of Fan Kuan and Guo Xi. Indeed, the painting's unusual height may reflect the artist's desire to present the mountain as monumental while retaining a human scale comparable to that found in other figure paintings of the period. In spite of its increased importance, landscape in *Riverbank* thus continues to function as the framework for human activity.

As with *Palace Banquet* (pl. 2), the narrative unfolds from background to foreground. Having peered deep into the distance, the viewer is again brought back to the foreground in a winding course that follows the river in its forward movement from the top right of the composition, passing by two thatched dwellings before disappearing behind a mountain ridge (pl. 1f, page 74). The dwellings stand at the convergence of the river and a pathway that leads into the foreground through an opening in the mountains. In the gathering gloom four travelers scurry through the narrow defile, sustaining the forward movement until it is arrested by the broad stream and hermitage.

Following the travelers, the viewer encounters a series of narrative clues that establishes the painting's temporal as well as physical setting. The darkening sky announces the approach of evening; the formation of geese seeking shelter in the valley heralds the changing season. Trees bend in the wind, and the travelers wear thatch cloaks and hats as protection against the approaching storm.

The hermitage at the center of the composition (pl. 1e) offers shelter. It is protected on three sides by the encircling mountains, while the fourth side is enclosed by a wattle palisade. A man carrying a plow and the boy on the water buffalo have just arrived at the villa's outer gate after a day in the rice paddies.[19] Entering the rustic compound one finds a central hall and side buildings that form a courtyard with a woven bamboo fence. Through the open doorway of the building at the right a woman is visible preparing the evening meal. Another servant carries a tray of food. Behind the kitchen area are the servants' quarters, separated from the main household by a yard. On the balcony of the two-story tower behind the central hall a woman comforts a child who appears frightened by the rising storm. Stalks of bamboo, windswept branches of trees, and the choppy waves of the river indicate the intensity of the squall.

Our visual journey through the picture space culminates at the hermitage's most distinctive structure, an imposing pavilion that projects over the river on stilts (pl. 1g). It is here that the master of the household, seated in an elegant yoke-back chair, contemplates his surroundings, his scholarly status underscored by his tall hat, the writing table upon which he leans, and the calligraphic screen at the back of the pavilion.[20] Joined by his wife and two children and protected by a transparent bamboo blind, the gentleman serenely faces the storm—a vivid metaphor for the tenth-century ideal of finding in nature sanctuary from political chaos.

The theme of the scholar-recluse living in rustic retirement was common in later Chinese painting, but its appearance here is more complex and less self-conscious than the stereotyped images seen in fourteenth-century and later interpretations of the subject, all of which derive from tenth-century precedents. Here, the artist has given careful attention to many details of the household and the lives of its inhabitants. This delight in describing everyday life through a rich accumulation of material detail, which finds parallels in popular fiction and poetry of the time, reached its zenith between the late tenth and the early twelfth century, in such works as *The Water Mill* (fig. 61) and *Going Up the River at the Qingming Festival* (fig. 56), but it was already a salient feature in tenth-century works associated with the Southern Tang court.[21]

One such painting, which shows many parallels to *Riverbank*, is a small hanging scroll entitled *The Lofty Scholar Liang Boluan* (fig. 13, page 18). Orginally part of a six-panel screen, it is attributed to the tenth-century artist Wei Xian.[22] A contemporary of Dong Yuan, Wei Xian came from Chang'an, the former Tang capital (present-day Xi'an), but worked at the court of the Southern Tang ruler Li Yu. When we compare *The Lofty Scholar* with *Riverbank*, we see the same sharply inclined ground plane, a schematic, tripartite division of space, pronounced contrast in scale between foreground figures and

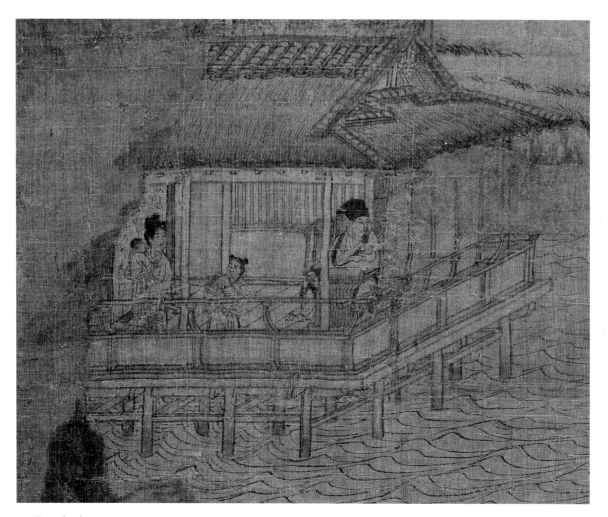

1g. Detail, plate 1

Figure 61. Unidentified artist (late 10th–early 11th century), *The Water Mill*. Detail. Handscroll, ink and color on silk, 21 x 47 in. (53.2 x 119.3 cm). Shanghai Museum

Figure 62. Wei Xian (active ca. 960–75), *The Lofty Scholar Liang Boluan*. Detail. Hanging scroll mounted as a handscroll, ink and color on silk, 53 x 20⅝ in. (134.5 x 52.5 cm). Palace Museum, Beijing

landscape setting, and compositional juxtaposition of tall mountains to the left with a deep recession into space on the right. Descriptive details and brushwork techniques are also analogous. The mountains and rocks in *The Lofty Scholar* are modeled by contrasting light and dark areas rendered by an unsystematic mix of washes and texturing marks. In particular, the deeply eroded recesses and mountain cavities, defined with progressively darker washes, recall similar passages in *Riverbank*, notably the area of the waterfall (pl. 1c). Tree trunks are similarly modeled with light and dark contrasts to enhance the illusion of roundness and are pocked with knotholes that add form and texture. Both paintings also share the same meticulous representation of water, the entire surface delineated by a netlike pattern of waves.

Parallels in the architecture of *Riverbank* and *The Lofty Scholar* are equally striking. The pavilions in the two paintings exhibit the same hip-and-gable roof structure, with interlocking convex and concave tiles surmounted by a raised roof spine and raised corner ridges that emphasize the gable ends and hips (pl. 1g; fig. 62). In both structures the junction of the gable with the roof skirt is trimmed with raised tiles that are indented inside the rafter beams, helping to frame the ornamental cloud-scroll centered in the gable. Both have gated fences that use similar construction

3a (opposite). *Entering the mountains*

3b (above). *Discovering a peach tree*

techniques and materials. And the scholars in both paintings lean on writing tables having the same kind of curved, slatted legs.[23] A similar yoke-back armchair and bent-leg table appear in the late-tenth- or early-eleventh-century *The Water Mill* (fig. 61).[24]

Another painting accepted as having been made at the Southern Tang court is a long handscroll entitled *First Snow along the River* (fig. 19, page 26) by Zhao Gan (active ca. 960–75), a student at the Southern Tang Painting Academy.[25] Zhao's painting displays the same uptilted ground plane, layered division of space, netlike pattern of waves, and figures that appear large relative to landscape details seen in *Riverbank*. As in *Riverbank*, the earthen embankments in *First Snow along the River* are modeled in soft ink washes with no texture strokes, while the foreground trees, arrayed in screenlike fashion parallel to the picture plane, show the same sticklike branches and trunks modeled with arbitrary light and dark shading.

In both paintings narrative content is prominent. *First Snow along the River* is notable for its sharp observations of daily life, in particular the activities of the fishermen living along the river and the official and his family seen traveling through the landscape on muleback, all of whom are subjected to the discomforts of winter weather. If *Riverbank* is the confident image of a scholar who faces a gathering storm unperturbed, Zhao Gan's image shows the hardships shared by scholar and commoner alike as the winter cold intensifies. It is not implausible that the distinction reflects a shift in political circumstances. While *Riverbank* still holds out hope for an idyllic life in reclusion, Zhao Gan's image may reflect the imminent demise of the Southern Tang dynasty, which led scholars at court to contemplate the consequences of dynastic collapse and the harsh reality of survival outside the court.

劉晨阮肇剡縣人也家世業儒
尤留意扵醫嘗飄然有霞表
之氣味漢明帝永安十五年二
人攜鋤筥往天台山採藥焉

入山既深尋藥方醫筥少惄
將返迷失來路且粮糗俱盡

LIU CHEN AND RUAN ZHAO IN THE TIANTAI MOUNTAINS

With the fall of the Southern Tang dynasty in 975 and the Wu-Yue kingdom in 978, the Song dynasty (960–1279) completed its consolidation of the core of the former Tang empire, becoming the largest and most prosperous state in East Asia. In spite of its great wealth, however, the Song state was militarily weak. The Song founder, Emperor Taizu (r. 960–76), believing that the fall of the Tang had resulted from the excessive independence and power of the aristocracy and the military, concentrated authority in the hands of a civil bureaucracy selected through a system of civil service examinations. The resulting shift in power, based on scholarship rather than birthright or force of arms, gave rise to a new meritocracy of scholar-officials. Success in the government examinations, achieved through literary brilliance and a command of history and the arts rather than any specific technical skill, became the enduring ideal of later Chinese society and the pinnacle of cultural attainment.

This shift in priorities from military prowess to literary achievement may have contributed to the Song inability to subdue the non-Chinese states along its northern borders. In 1127, armies from one of these states, the Jurched Jin (1115–1234), seized the Song capital of Bian (present-day Kaifeng, Henan Province) and occupied all of Song China north of the Huai River. The remnants of the Song government fled south, eventually establishing a new capital at Hangzhou. Buying peace with annual payments of silver and silk to the Jin state, the so-called Southern Song dynasty prolonged its existence another 170 years until the Mongols, a warlike nomadic people, succeeded in overrunning Song defenses, capturing Hangzhou in 1275, and replacing the Song with their own Yuan dynasty (1279–1368), the first non-Chinese state to rule all of China.

Plate 3. Zhao Cangyun (active late 13th–early 14th century), *Liu Chen and Ruan Zhao in the Tiantai Mountains.* Handscroll, ink on paper, 8½ x 222¼ in. (21.5 x 564.4 cm). The Metropolitan Museum of Art. Ex. coll.: C. C. Wang Family, Promised Gift of the Oscar L. Tang Family

81

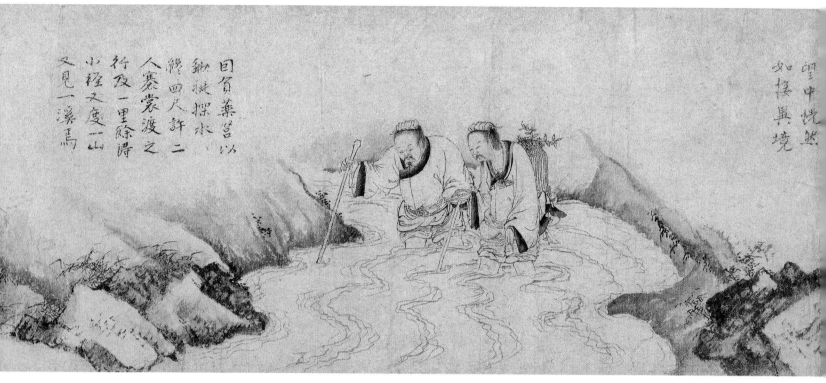

望中恍然
如接異境

目貢藥苗以
鋤挑探水以
鞭四尺許二
人褰裳渡之
行及一里餘得
小徑又度一山
又見一溪焉

3d. *Wading through the stream*

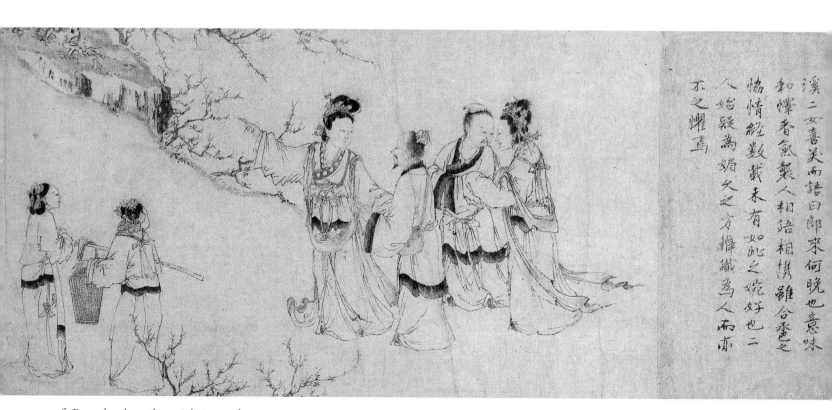

溪二女喜笑而語曰郎來何晚也意味
和懌香氣襲人相語相攜雖合巹也之
愜情經數載未有如此之婉好也二
人始疑為娟父之方雜織為人而而
不之懼焉

3f. *Escorted to the residence of the immortals*

82

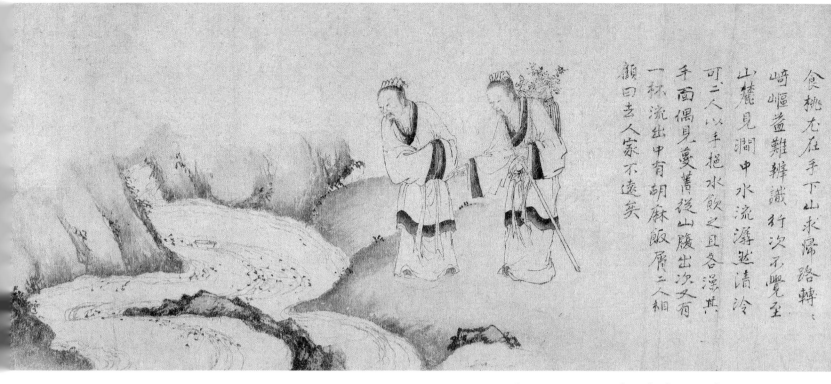

食桃尤在手下山求歸路轉
崎嶇益難辨識行次不覺至
山麓見澗中水流潺湲清泠
可二人以手挹水飲之且各澡其
手面偶見蔓菁從山腹出次女有
一杯流出中有胡麻飯屑二人相
顧曰去人家不遠矣

3c. Coming upon a stream where a bowl of rice is floating

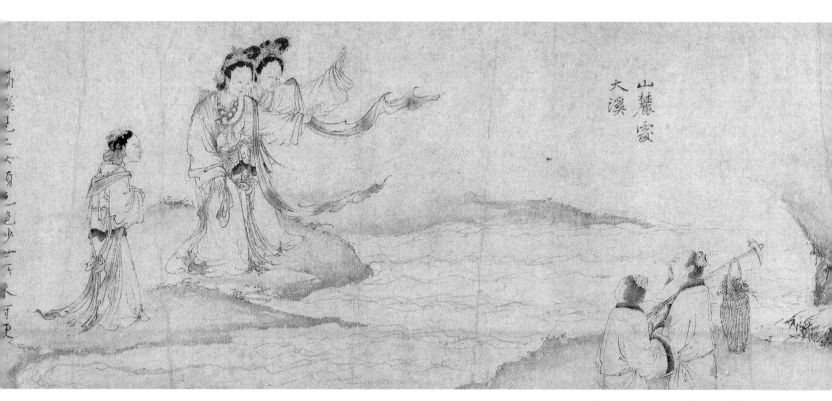

山麓靄
大溪

3e. Encountering two female immortals

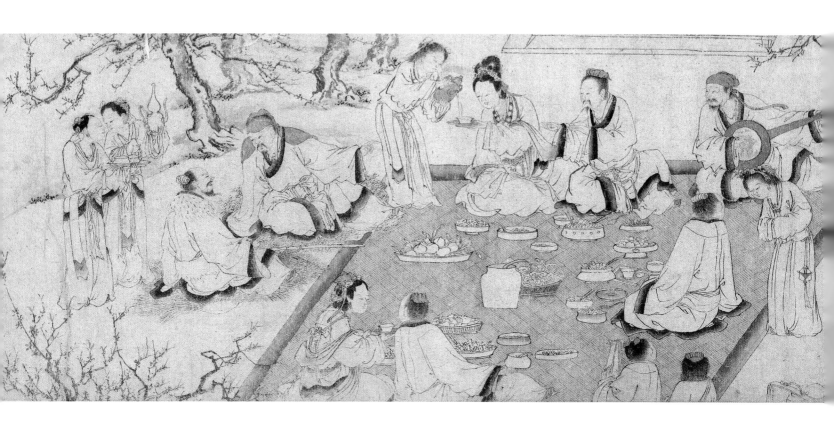

二子出洞口行至大道回首惟桃花燦

二女邀劉阮偕止宿絕半月餘二子求還女答曰全來此皆汝宿福所招得至于仙館此之流傮宿福遂懸留住及半年天氣常如三春山鳥忘喧二子求還甚切女曰業根未滅使令子心如此於是嗟嘆仙女共作頹送劉阮偣遂告之曰此山洞口出去不遠至大道全家易矣

3i. *A farewell drink*

二女因邀歸家飛過山徑崎嶇淵山
挑花爛熳行及三里餘到其飛店
廳館朴殿服飾非如人間頗有左右
女侍息青衣皆端正莊觀爛然如
雲少頃貴胡麻飯山羊脯食之甘
美二人食方畢不覺饑歆訊家世
二女但相與談笑亂之器不之告二
人來不敢固問知其為異人又之亦
不見其家有男子也

3g. At the banquet

既而又當庭設席陳酒肴為二人
壽方飛觴次有數仙客持三五仙
挑至女家云未慶女婿各至席
二人禮之數仙客皆各出樂
器奏之肅難和鳴暢飲適二三
時候二女親各舉巵勸二人酒歆
曲之情春氣可挹二子悅邈如在
天上也日向暮仙客各邈去

3h. Escorted to their lodgings

3k. *Final text passage and signature of Zhao Cangyun (right) and colophons by Hua Youwu (middle) and Yao Guanxiao (left)*

The Mongol conquest imposed a harsh new political reality upon China. Civil service examinations were discontinued, leaving most of China's educated elite disenfranchised. Southern Chinese, having long resisted the Mongol invasion, were subjected to a concerted policy of discrimination. Encountering absolutist policies and prejudicial treatment, many scholars living in the south withdrew from government service and lived in humbled circumstances or semiretirement, a life-style that afforded them the time and impetus to pursue self-cultivation and self-expression through the arts.

An early reflection of the trauma of dynastic change is captured in *Liu Chen and Ruan Zhao in the Tiantai Mountains* (pl. 3), a long narrative handscroll by Zhao Cangyun (active late 13th–early 14th century), a member of the Song royal family who lived through the Mongol conquest. The painting and its accompanying text chronicle the well-known legend of Liu Chen and Ruan Zhao, two gentlemen of the Later Han dynasty who enter the Tiantai Mountains of Zhejiang Province in search of medicinal herbs and stumble upon a magical realm of immortals.[26] Returning home after what had seemed like half a year's time, they discover that seven generations have come and gone. Alone in the world, they retrace their steps, only to find that the cave from which they had so recently emerged has vanished. In the painting, the only known illustrated version of the story, the loss of home and paradise—both situated close to the Southern Song capital of Hangzhou—evokes the disorientation and alienation felt by many of the Chinese elite following the fall of the dynasty in 1279.

Painted in rich shades of monochrome ink on paper, the story unfolds as an episodic narrative, with individual scenes set off from one another by blank spaces inscribed with text. The handscroll opens at the right with the two men entering the mountains (pl. 3a). One carries a hoe and a basket; the other points to a trail. The

爛鄉邑堆青而已甫至家鄉並無相
識鄉里姓異乃聞得七代子孫傳上祖
入山不出不知今何在

二子出洞口行至大道回首惟桃花燦

3j. Exit from the realm of the immortals (right) and the solid stone wall (left)

accompanying text serves to introduce the protagonists:

> Liu Chen and Ruan Zhao were from Shan County [in Zhejiang Province]. Although they came from old Confucian families, they were particularly interested in medicinal herbs and were accustomed to remaining aloof from the world. Thus did they, in the fifteenth year of the Yongan [fifth year of the Yongping] reign era of Han emperor Mingdi [A.D. 72], take up hoe and basket and set off for the Tiantai Mountains to gather herbs.[27]

In the second episode (pl. 3b) the men, close to starvation after having lost their way and exhausted their supplies, discover a tree laden with ripe peaches—symbol of immortality—which they eagerly devour. The next four scenes follow Liu and Ruan as they come upon the realm of the immortals. The third episode (pl. 3c) depicts the two men at a

3l. Colophon by Song Yong

stream where they discover a bowl filled with sesame rice floating with the current. In the following scene (pl. 3d), they are shown wading through the stream to find its source. In the fifth episode (pl. 3e), Liu and Ruan encounter two elegantly dressed women who greet them by name. "What took you so long?" they coyly inquire. The sixth episode shows the two men being escorted to the immortals' residence (pl. 3f). The accompanying text describes the succulent meal they are offered of sesame rice and mutton. They inquire about the women's families, but the women are evasive, and Liu and Ruan begin to suspect they are supernatural seductresses.

The seventh episode (pl. 3g), the largest and most detailed scene in the painting, shows Liu and Ruan as guests at an elaborate outdoor banquet. Zhao's text, embellished with a great many details not found in other extant versions, complements the painted image:

> In the courtyard a banquet was arranged, with wine and food set out to wish the men long life. After a few cups, guest immortals arrived at the ladies' residence bringing peaches of longevity and announcing, "We have come to congratulate the grooms." The two men paid their respects to the immortals, each of whom wore magical clothes and carried a musical instrument which they played in perfect harmony. For two or three hours the two men drank happily, while the two female immortals personally served them cups [of wine] and urged them to drink more. The beguiling melodies evoked an almost tangible sensation of spring, and the two men felt as if they were in paradise. The guests departed as the sun set.

In the accompanying illustration, Liu and Ruan occupy the seats of honor at the head and foot of a large mat that has been laid out in a grove of blossoming peach trees. They are attended by the two female immortals who offer them cups of wine. Four male immortals have joined the party; one plays a four-stringed *ruanqin*, while a flute and *sheng* (mouth organ) lie on the ground.[28] Spread out on the mat are serving dishes, one filled with peaches, another with *lingzhi* (magic fungi). Servants wait upon the two men. Yet Liu and Ruan are reluctant guests in spite of this lavish entertainment:

> The two women persuaded Liu and Ruan to remain for more than half a month, but then the men asked to return home. The women responded: "Coming upon us and living here is your good fortune. How can the herbal elixirs of the common world compare to this immortal dwelling?" So they begged the men to stay for half a year. Every day was like late spring, but the mournful cries of the mountain birds caused the two men to plead even more to return home. The women said: "Traces of your karma have remained here, which is why you still feel this way." So they summoned the other female immortals to bid them farewell with music, saying, "Not far from the mouth of this cave is a roadway that will lead to your home."

This passage is illustrated in two sections on either side of the text. In the eighth scene (pl. 3h), the female immortals and two attendants escort Liu and Ruan back to their lodgings along a cobblestone path that winds between flowering trees. While the two men maintain the dignified manners of Confucian gentlemen, clasping their hands in gestures of respect, the women are less restrained; one urges them on by

pointing the way, while the other pulls at one of the men's sleeves. In the ninth scene (pl. 3i), the two female immortals share with Liu and Ruan a last drink of wine, while attendants serenade them with clappers, *sheng*, flute, and *ruanqin*.

The final scene (pl. 3j) brings the pictorial narrative to an abrupt conclusion, juxtaposing a view of the cave entrance seen from the immortal realm on one side with a view of the two men standing helplessly before a solid stone wall on the other side. The text is again split into two sections to maximize the impact of the concluding lines. To the right of the cave opening the text describes what happens when Liu and Ruan return to their home:

> The two men exited the cave and reached the roadway. They looked back, but saw only the brilliant glow of peach blossoms and the layered greens of the mountain. When they arrived home, they recognized no one. Greatly perplexed, they made inquiries until they realized that [the villagers] were their seventh-generation descendants.

The narrative concludes at the left:

> Finding that their homeland held neither close relations nor a place to live, the two men decided to reenter the Tiantai Mountains and seek out the roadway that they had just followed. But the way was obscured, and they became lost. Later, in the eighth year of the Taikang reign era of Jin Wudi [A.D. 287], the two again entered the Tiantai Mountains. What became of them remains unknown.

In other versions of this story, the narrative ends with the two men unable to find their way back to the cave. Zhao Cangyun, by contrast, has them return again to the mountains, never to reappear. This final withdrawal recalls the Confucian tale of Boyi and Shuqi, two loyal subjects of the Shang dynasty (ca. 1600–ca. 1050 B.C.) who, rather than live under the rule of the usurping Zhou dynasty (ca. 1050–256 B.C.), prefer to enter the mountains, where eventually they starve to death. Zhao's version adds a reference to the Jin dynasty (A.D. 265–317) as the time of the men's final return to the mountains, making explicit the fact that Liu and Ruan, originally subjects of the Han (206 B.C.–A.D. 220), found no place for themselves in a world governed by another ruling house. An additional detail not found in other versions is the identification of the men in the opening passage as coming from Confucian families. As Zhao's images make clear, in spite of their interest in medicinal herbs, Liu and Ruan were not practicing Daoists seeking immortality. On the contrary, when they stumble upon the enchanted world inhabited by beguiling female immortals, they maintain the decorum and bearing of Confucian gentlemen and repeatedly ask to return home. Finding neither family nor friends in their homeland and unable to retrace their steps to the lost paradise, they elect to withdraw into the mountains, never to be heard from again.

What little we know of Zhao Cangyun's life suggests that this painting and the accompanying text are a highly personal reflection of Zhao's state of mind as a Song loyalist living under Mongol rule. In his signature following the last text passage, the artist identifies himself as Cangyun Shanren (Gathering Clouds Mountain Man). It is the colophon by Hua Youwu (1307–after 1386), the first of three colophons mounted

Figure 63. Zhao Mengfu (1254–1322), *Two Odes on the Red Cliff*, dated 1301. Detail, portrait of Su Shi (1037–1101). Album of 1 painting and 21 leaves of calligraphy, ink on paper, each leaf 10¾ x 4⅜ in. (27.2 x 11.1 cm). National Palace Museum, Taipei

Figure 64. Liang Kai (active first half 13th century), *Daoist Deities*, ca. 1200. Detail. Handscroll, ink on paper, 10⅛ x 29⅛ in. (25.7 x 74 cm). Collection of Mr. and Mrs. Wan-go H. C. Weng

after the painting (pls. 3k, 3l), that identifies Cangyun Shanren as Zhao Cangyun, a descendant of the Song royal clan.[29] Hua describes Zhao as an artist known for bone-less ink-wash landscapes and delicate figure paintings. Hua also states that in his youth Zhao Cangyun was more famous than his fellow clansmen Zhao Mengjian

Figure 65. Attributed to Fanlong (12th century), *The Sixteen Luohans*. Detail. Handscroll, ink on paper, 12 x 418 in. (30.5 x 1062.5 cm). Freer Gallery of Art, Smithsonian Institution, Washington, D.C.

Figure 66. Unidentified artist (late 12th–early 13th century), *Odes of the State of Bin: The Seventh Month*. Detail. Handscroll, ink on paper, 11¾ x 540 in. (29.7 x 1371 cm). The Metropolitan Museum of Art. John M. Crawford Jr. Collection, Gift of The Dillon Fund, 1982 (1982.459)

(1199–before 1267) and Zhao Mengfu (1254–1322). Because he never married and never served as an official, however, but withdrew to the mountains and lived as a recluse, no documentation—save for this scroll—survives.[30]

The second colophon is by Yao Guangxiao (1335–1418), a noted Buddhist monk who, from 1382 onward, served in Beijing as a key adviser to Zhu Di (1360–1424), the prince of Yan and subsequently the Yongle emperor (r. 1402–24).[31] The final colophon is an undated poem by Song Yong (unidentified) that recapitulates the painting's narrative. Yao's inscription, dated 1386, when he was still a monk using the name Daoyan, praises Hua Youwu's connoisseurship and Zhao Cangyun's art and offers another title for the painting: *Princely Grandsons in the Tiantai Mountains*. It is hard to understand why Yao would assign this title to the story unless he intended to link the painting's subject to the fate of its creator, Zhao Cangyun, a descendant of the Song royal house, who, like the subjects of his painting, withdrew from society to live a solitary life in the mountains.[32]

Art historically, the painting is a rare example of late-thirteenth-century narrative art and the early Yuan revival of *baimiao*, the monochrome drawing style heralded by the painter Li Gonglin (ca. 1041–1106). Zhao Mengfu is most often credited with this revival as part of his more general investigation of pre-Southern Song pictorial and calligraphic sources, but Zhao Cangyun's painting attests to the ongoing interest in monochrome drawing throughout the Southern Song period. Zhao Mengfu's contribution was to introduce an even more extreme austerity and calligraphic abstraction to Li Gonglin's style. In Zhao Mengfu's depiction of the Song poet Su Shi, of 1301,

for example (fig. 63), the lines of Su Shi's robe are shorn of all decorative embellishment or bravura brushwork.³³ Zhao Cangyun, by contrast, delights in his drawing in rhythmic flourishes and assertive hooks which have a visual appeal that is often independent of the drawing's representational function. This kind of bravura brushwork is typical of late-Song figure painting, as seen in a monochrome depiction of Daoist deities by Liang Kai (active first half 13th century; fig. 64). Zhao Cangyun's more relaxed drawing style is much closer to that seen in *The Sixteen Luohans*, attributed to the Buddhist monk Fanlong (12th century; fig. 65) or in the *Odes of the State of Bin*, by an unidentified scholar-artist of the late twelfth or early thirteenth century (fig. 66).³⁴ As in Zhao Cangyun's work, the figures in these two scrolls are placed within a landscape setting rendered in an ink-wash style derived from academic painting of the Southern Song.

In spite of the obvious differences in format and style, the imagery of Zhao Cangyun's painting recalls that of *Palace Banquet* (pl. 2). While Zhao eschews the brilliant mineral colors and elaborate architectural setting of the earlier painting, his pictorial narrative nonetheless leads the viewer into a protected world from which men are largely absent and the principal focus is a decadent life of music, wine, and banqueting. Liu Chen and Ruan Zhao's rejection of that life-style suggests Zhao's own disapproval of the excesses depicted in such paintings and, by extension, of the Southern Song court which, like the Southern Tang court before it, was fatally weakened by an indulgent and self-absorbed way of life. Finding himself in a homeland that had become foreign to him, Zhao was nostalgic for the lost paradise of the Song, but he was not uncritical of its flaws. Like the protagonists of his story, he rejected both worlds and sought sanctuary in the anonymity of the landscape. But for this painting, he very nearly succeeded.

Lofty Virtue Reaching the Sky

The early fourteenth century marked a watershed in Chinese painting as Yuan artists rejected the artistic precedents of the morally discredited Southern Song Academy and sought to express a new moral purpose through a revival and exploration of archaic styles. This revolution was led by Zhao Mengfu, who not only revived the use of antique models but shifted the focus of painting away from representational verisimilitude toward a greater emphasis on the calligraphic qualities of brushwork. Inscribing his own *Elegant Rocks and Sparse Trees* (fig. 67), he declared that one should "'write' rocks with flying-white cursive script, trees with seal script, and bamboo with clerical script." Zhao concluded that "only when a person is capable of understanding this will he know that painting and calligraphy are basically the same." Thenceforth, the process of painting and the physical experience of the medium became, as it had been for calligraphy, part of the artist's purpose and subject matter. Painting as practiced by the Yuan scholar-artist was no longer understood as merely the representation of reality or the poetic evocation of a particular theme; its primary purpose became calligraphic self-expression.

Figure 67. Zhao Mengfu (1254–1322), *Elegant Rocks and Sparse Trees*. Handscroll, ink on paper, 10¾ x 24¾ in. (27.3 x 63 cm). Palace Museum, Beijing

Nowhere is the application of calligraphic principles to painting more evident than in monochrome depictions of bamboo, old trees, and rocks—often combined into a single composition—in which the imagery is reduced to a limited repertoire of motifs, brushstroke types, and compositional variations. The symbolic and expressive potential of this subject matter was first explored by Northern Song scholar-artists such as Wen Tong (1019–1079; fig. 68) and Su Shi (1037–1101). Focusing on individual trees, bamboo plants, and rocks, paintings by these artists were metaphors for the life cycle and for the personality traits of men.[35] Old trees that had withstood the frost of many winters were emblems of survival. Bamboo, with its "empty heart"—signifying the ideal of a mind freed from the illusions of material existence—and its capacity to bend but not break in the winds, symbolized integrity and resilience. Distinctive rocks stood for endurance and individuality. For Chinese scholars living under the alien rule of the Mongol Yuan dynasty, such images became a potent metaphor for survival in the face of political discrimination.[36]

It was Zhao Mengfu and his slightly older contemporary and friend Li Kan (1245–1320) who were responsible for renewing the Northern Song theme of old tree, rock, and bamboo, but it was Wu Zhen, later canonized as one of the four masters of the late Yuan, who gave this traditional imagery a new expressive power by integrating painting, poetry, and calligraphy into unified works that embodied these "three perfections."

Figure 68. Wen Tong (1019–1079), *Bamboo*. Hanging scroll, ink on silk, 52 x 41½ in. (132.6 x 105.4 cm). National Palace Museum, Taipei

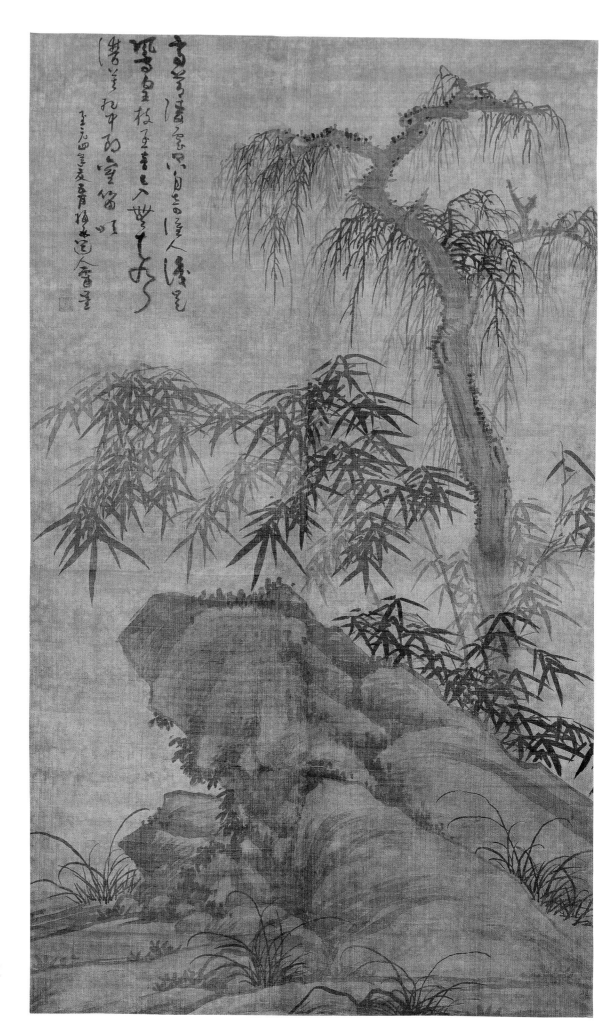

Plate 4. Wu Zhen (1280–1354), *Lofty Virtue Reaching the Sky*, dated 1338. Hanging scroll, ink on silk, 65 ½ x 38 ½ in. (166.4 x 98 cm). The Metropolitan Museum of Art. Ex. coll.: C. C. Wang Family, Promised Gift of the Oscar L. Tang Family

Wu Zhen (1280–1354) was born one year after the fall of the Southern Song dynasty in Jiaxing, Zhejiang Province, and lived there all his life in relative obscurity.[37] Most likely he came from a scholarly family, for he received a good education, though he remained aloof from government service and other professions traditionally pursued by Confucian scholars, choosing instead to live in reclusion, calling himself Meihua Daoren (Plum Blossom Daoist), and making a humble living through the practice of divination.

Lofty Virtue Reaching the Sky (pl. 4), dated 1338, is Wu Zhen's earliest extant example of the theme of old tree, rock, and bamboo. A large-scale hanging scroll executed in monochrome shades of ink on two joined widths of silk, it presents a powerful image of tightly knit picture elements whose overlapping forms carve out a shallow space that is anchored to the foreground by the barest indication of a ground plane. A massive rock modeled in dense ink washes dominates the composition, while bamboo caresses the surface, its overlapping leaves distinguished from one another by graded ink tones that effectively suggest recession. Behind the bamboo stands a spare willow tree, its twisted, lichen-covered trunk shorn of many limbs, but its continuing vigor attested to by the many smaller branches that spring from its upper reaches.

Painted in saturated ink tones, each of these elements appears weighed down: the precariously undercut rock, the bowed bamboo, the drooping branches of the willow, even the moss hanging off the rock's down-turned face and the pliant blades of grass—all bend over as if laden with moisture from a recent rain. While the bedraggled protagonists of the painting hardly project a noble image of survival, Wu's boldly brushed poem reminds us that appearances may be deceptive. Describing the bamboo, he writes:

> *Tall stalks pierce the clouds.*
> *Perhaps you find it strange,*
> *Not recognizing the wings of a phoenix.*
> *A pure sound enters the realm of the soundless,*
> *Don't let Zhonglang blow his long-necked flute.*[38]

The multiple levels of meaning embedded in Wu Zhen's imagery are immediately apparent in the first words of the poem, with the reference to the bamboo as "tall stalks" (*gaojie*), a phrase that may also be read as "lofty virtue" (hence the title of the painting). Thus, despite its bowed form, "the wings of a phoenix"— symbol of nobility—are concealed within and its silent stillness constitutes a state of transcendence. The reference to Zhonglang, a general during the Han dynasty, in the last line of verse relates directly to the circumstances of Wu's own life under Mongol rule. Known also as Su Wu (139 B.C.–after 60 B.C.), Zhonglang was sent

4a. Detail, plate 4

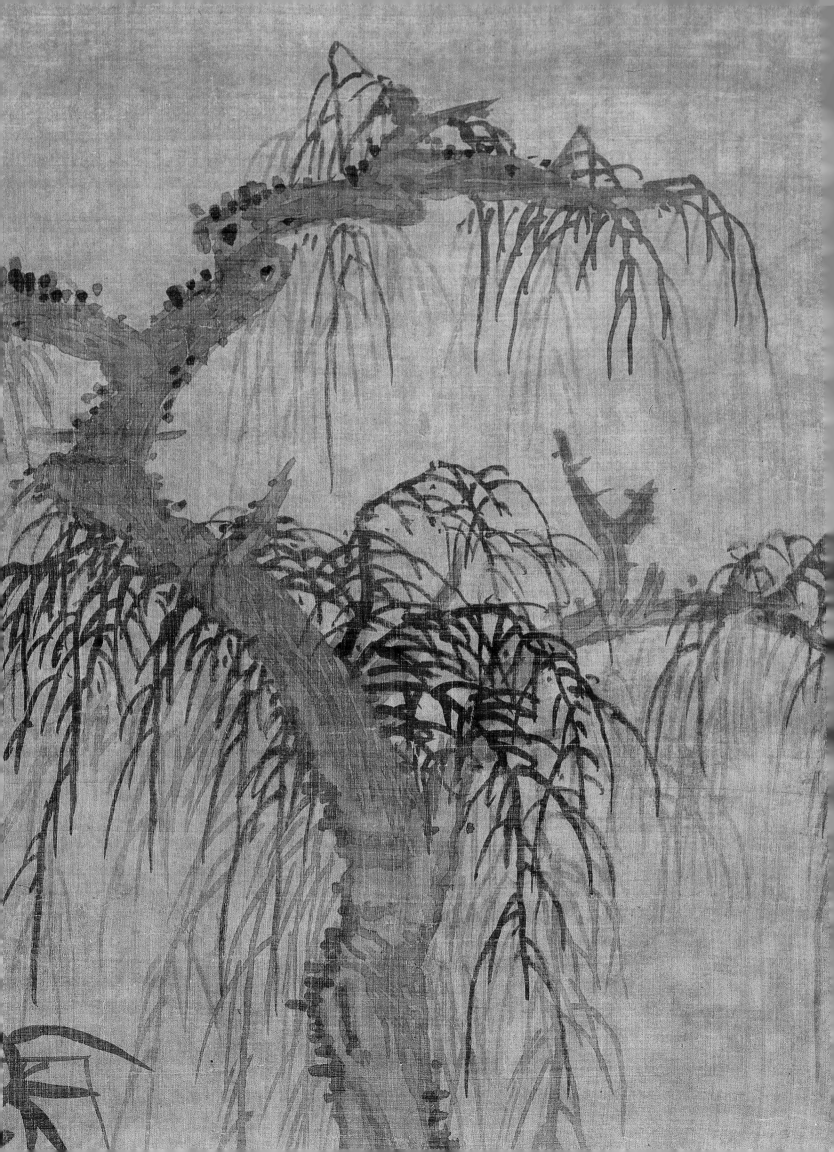

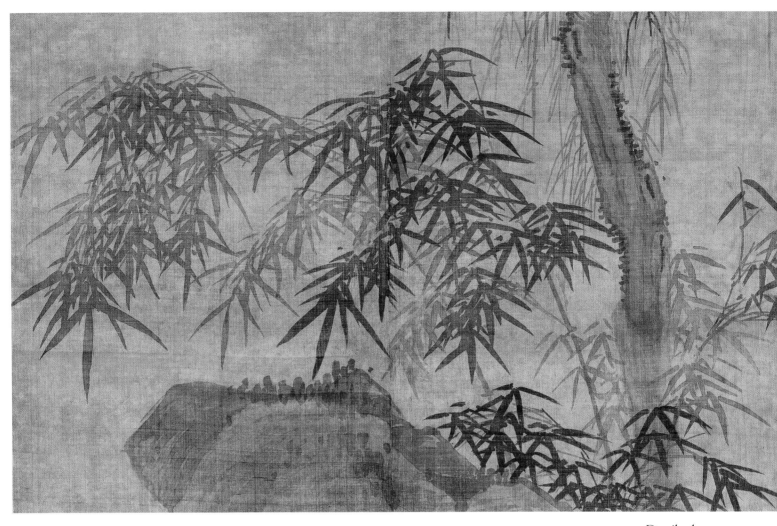

as a special envoy to improve relations with the Xiongnu, a nomadic people who were constantly threatening the northern borders of Han China. The Xiongnu detained Su and sought his collaboration, first offering him position and power, and then, when he refused their overtures, torturing him. But Su remained steadfast. Enduring nineteen years of captivity before the Han secured his release, he became a model of unbending loyalty.[39] In saying that Su Wu should not "blow his flute" (in Western parlance, "blow his horn"), Wu Zhen implies that Su's heroism is no more worthy of fanfare than the humble bamboo, which, though unnoticed—like Wu Zhen himself—requires no trumpeting; its virtue is its own reward (it has entered "the realm of the soundless").

The same indomitable spirit is conveyed by Wu Zhen's defiantly individualistic calligraphy (pl. 4a). In its spontaneity, asymmetry, and irregularly sized characters, Wu's inscription recalls the wild cursive (*kuangcao*) writing of the Chan (Zen, in Japanese) Buddhist monk Huaisu (725–785).[40] But while Huaisu often linked characters with fluid ligatures, Wu Zhen prefers the squatter, simplified forms of draft cursive (*zhangcao*), which derives from clerical script and exhibits few such linkages. Another distinctive feature of Wu's writing is his emphatic alternation of heavy, thick brushstrokes with lighter, thinner strokes, which lends to the calligraphy a pulsing, rhythmic quality. But the most striking attribute of Wu's brushwork is his centered

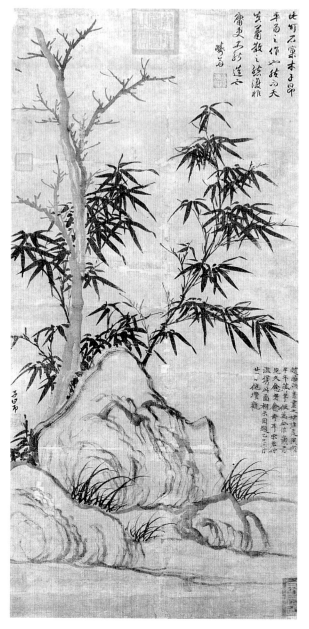

Figure 69. Zhao Mengfu (1254–1322), *Old Tree, Bamboo, and Rock*, ca. 1319–22. Hanging scroll, ink on silk, 39⅛ x 19 in. (99.4 x 48.2 cm). National Palace Museum, Taipei

Figure 70. Wu Zhen (1280–1354), *Crooked Pine*, dated 1335. Hanging scroll, ink on silk, 65⅜ x 32⅜ in. (166 x 82.3 cm). The Metropolitan Museum of Art. Purchase, The Dillon Fund Gift, 1985 (1985.120.1)

brush. By keeping the brush tip concealed within the center of each stroke, Wu imparts a roundness and substantiality to the lines that charge them with barely contained energy. This same characteristic is fundamental to the linear strokes of his painting, as seen in the branches of the willow (pl. 4b), the contours of the rock, the leaves and stalks of the bamboo.

Wu Zhen's signature, "Meihua Daoren playing with ink," signals that his painting partakes of a long tradition of highly personal "ink plays" that extend back to Su Shi and Wen Tong (fig. 68). Wu's use of silk rather than paper also follows a Song prototype, as does the painting's large scale and the use of overlapping forms and graded ink tones to create the illusion of mass and recession.[41] But Wu has moved beyond the descriptive naturalism of Song precedents. Whereas each leaf in Wen Tong's image

Figure 71. Wu Zhen (1280–1354), *Bamboo and Rock*, dated 1347. Hanging scroll, ink on paper, 35⅝ x 16¼ in. (90.6 x 42.5 cm). National Palace Museum, Taipei

is painstakingly individuated to give a rich sense of natural growth, Wu Zhen's bamboo leaves have been reduced to a calligraphic formula of repeating, patternlike clusters, while the conspicuous texture strokes and foliage dots used to describe his rock surfaces have become emphatic mannerisms (pl. 4c).

The calligraphic assertiveness of Wu's image was inspired by Zhao Mengfu's treatment of the same subject (fig. 69). In both images brushwork is overtly assertive and reduced to a set of brush conventions, while forms are flattened and frontally arrayed, creating an impenetrable space. The dark rock anchors Wu's composition in a dynamic *yin-yang* relationship with the predominantly uninked upper portions of the painting and provides an effective counterbalance to the dark lines of the inscription, the prominence of which points to the new expressive purpose of his art. While Zhao Mengfu's painting bears two inscriptions by later admirers, his own signature along the lower left margin is neither conspicuous nor informative of his state of mind.[42]

Wu Zhen's inscription, on the other hand, forms a significant part of the composition, and its bold cursive script echoes the graphic energy of the bamboo. Zhao leaves his image to explain itself; Wu's poem extends and deepens the meaning of the painting, encouraging the viewer to read the image not merely as a pictorial design but as a personal credo.

It was during the 1330s that Wu Zhen developed a new balance in his work between symbolic imagery, calligraphic execution, and poetic, highly personal expression. In *Crooked Pine* (fig. 70), a large-scale composition on silk painted in 1335, three years before *Lofty Virtue*, the new style is still evolving.[43] The painting focuses on the idiosyncratic form of a single tree, and the way one branch appears dramatically to defy gravity, projecting upward and outward toward the viewer. Wu's inscription tells us that he made the picture "to record what I saw [on an outing,] a crooked and twisting

ancient tree." Aside from the riveting form of the pine, the rest of the image has a somewhat perfunctory quality, as if an afterthought. Compared with the inscription on *Lofty Virtue*, the inscription here is less conspicuous; nor does it extend the meaning of the image through poetry. In *Lofty Virtue* the pictorial and calligraphic elements are visually and expressively integrated, providing a tension between the visual and the poetic imagery that gives the painting its remarkable power.

By the 1340s, Wu Zhen's work had reached a further stage of distillation. *Bamboo and Rock* (fig. 71), of 1347, is more intimately scaled. Pictorial details are simplified, enhancing the painting's expressive impact. The inscription, framed by rock and bamboo, here plays an even more prominent role, both in the composition and in the meaning of the painting.[44] *Lofty Virtue* thus represents the first stage in the development of a new art form, one in which painting, poetry, and calligraphy are integrated in one work, while in format and descriptive technique Song prototypes are still followed. In his subsequent shift from silk to paper, from a large to a smaller scale and to ever-sparer compositions, Wu brought his art to its quintessential form. In *Lofty Virtue*, we see the complex sources of his inspiration.

Bamboo after Wen Tong

During the first half of the Yuan dynasty, Chinese scholar-officials made a concerted effort to transform their Mongol conquerors into orthodox Confucian rulers. This effort met with growing success through the early 1330s as Mongol khans, in their capital city of Dadu (present-day Beijing), relinquished control over central and western Asian domains and increasingly assumed the role of Chinese emperors. By far the most Sinified of the Yuan rulers was Wenzong (r. 1328–32), who was not only fluent in the Chinese language but developed a keen appreciation for ancient works of calligraphy and painting.[45] Wenzong used his patronage of Chinese culture and his recruitment of Chinese scholars into the Yuan government as a means of bolstering his legitimacy, and it was during his brief reign that Chinese from the south received their greatest recognition and advancement.[46] One of the southern scholars most closely associated with Wenzong was Ke Jiusi (1290–1343), a distinguished poet, painter, and calligrapher who became the official connoisseur of the imperial art collection.

Ke Jiusi was born in Taizhou, Zhejiang Province, into a family with a history of official service dating back to the Northern Song era (960–1127).[47] His father, Ke Qian (1251–1319), held posts under three Mongol emperors, helping to compile the *Veritable Records* of Emperor Shizu (Khubilai Khan; r. 1260–94) and rising to the rank of vice supervisor of Confucian studies in the Jiang-Zhe provincial government. Because of his father's rank, at the age of twenty-four Ke Jiusi was offered a minor post as district defender of Huating, an offer he declined. Five years later, however, in 1319, he traveled to Beijing in the company of the scholar-artist Zhu Derun (1294–1365) and, using his skills in literature and painting, gained service in the residence of the heir apparent, the future emperor Yingzong (r. 1321–23). After Yingzong's assassination Ke Jiusi returned to the south, but in 1325 he was brought to the attention of a Mongol

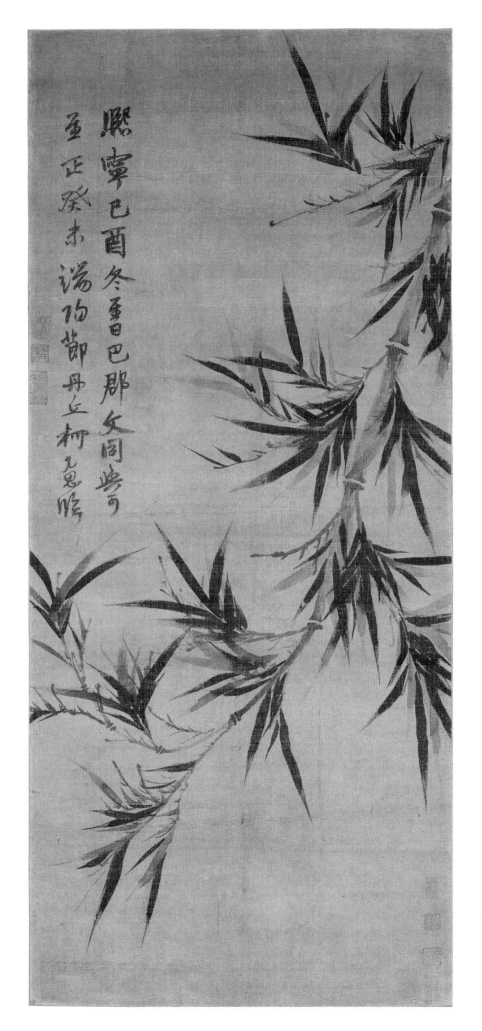

Plate 5. Ke Jiusi (1290–1343), *Bamboo after Wen Tong*, dated 1343. Hanging scroll, ink on silk, 42⅛ x 18¾ in. (107 x 47.5 cm). The Metropolitan Museum of Art. Ex. coll.: C. C. Wang Family, Promised Gift of the Oscar L. Tang Family

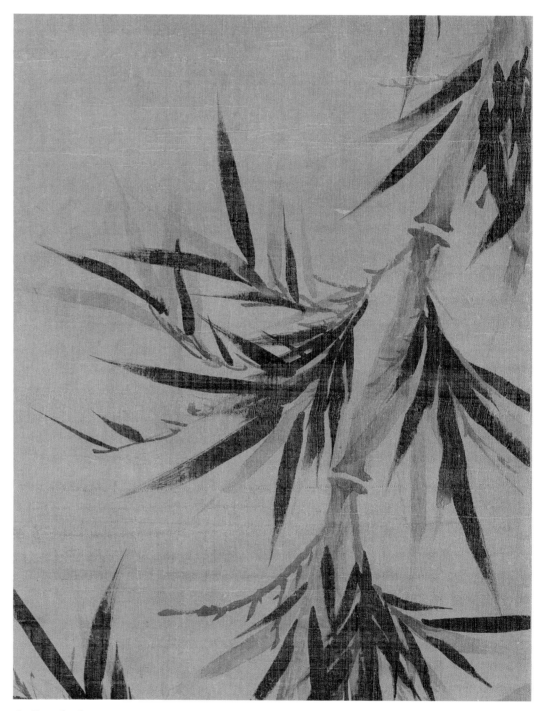

5a. Detail, plate 5

5b. Detail, plate 5

prince, the future emperor Wenzong, who maintained a residence in Nanjing. Shortly after Wenzong ascended the throne, in 1328, Ke was awarded a post in the capital, and the following year he was among the first officials appointed to the newly established Pavilion of the Star of Literature (Kuizhang Ge), a scholarly academy created by Wenzong for the transmission of Chinese artistic and literary culture at court.[48] Chinese and Mongol scholars attached to the Pavilion translated Chinese texts into Mongolian, offered instruction in the Confucian classics to the sons of the emperor and his high-ranking courtiers, and supervised the imperial library and art collections. Among Ke Jiusi's duties was the composition of formal poems that compared

Figure 72. Detail, figure 68

Wenzong's rule to that of traditional Chinese rulers.[49] In 1330, Ke was promoted to the rank of erudite connoisseur of calligraphy with the responsibility of evaluating all the model calligraphies and famous paintings in the palace. In addition to inscribing laudatory colophons on many of these works, Ke also served as adviser-curator for the imperial collection.[50]

In 1332, Ke Jiusi's close relationship with Wenzong precipitated a jealous attack by a member of the censorate who sought his impeachment on the grounds that he "lacked good character, was devious in conduct, and, making the most of an insignificant skill, was a sycophant of the powerful."[51] Wenzong reassured Ke, but took the precaution of appointing him to a provincial post. Wenzong died, however, before the appointment was put into effect, and Ke Jiusi had little choice but to retire from office and return to the south. There he devoted himself to the arts in the company of many of the leading painters and calligraphers of the day.[52]

Ke established a residence in Eastern Wu (near Songjiang, Jiangsu Province), but frequently traveled around the region, visiting friends and collectors who sought him out for his skill as a connoisseur. Ke's lesiurely pursuit of the arts came to a sudden end on November 12, 1343, when, after traveling by boat with friends in the Suzhou area, he was taken ill and died at the age of fifty-three.

In addition to his renown as a connoisseur, Ke Jiusi had gained a reputation as a specialist in monochrome depictions of bamboo, helping to establish the subject as one of the most important genres in Yuan scholar-painting.[53] His early interest in the genre was undoubtedly inspired by scholar-artists such as Li Kan, who composed a *Manual on Bamboo* (author's preface dated 1299) to which Ke's father contributed a preface in 1319.[54] Like Li Kan, Ke Jiusi sought inspiration from the originator of the monochrome bamboo genre, the Northern Song master Wen Tong, whose works were scarce even in the fourteenth century, but whose reputation enjoyed a near-legendary status thanks to the praise of his friend the poet-painter Su Shi.[55] Throughout his career Ke sought out paintings by Wen Tong, as well as calligraphies by Su Shi, Huang Tingjian, and other Northern Song literati in an effort to model his own art after theirs. Once, while visiting Ni Zan (1306–1374) at his Pure and Secluded Pavilion, he made a paint-

ing of ink bamboo after viewing one by Wen Tong. On another occasion he was invit-
ed to "repair" a painting (i.e., to paint in a missing branch) of an old tree attributed
to Wen Tong using "antique [brush] methods."⁵⁶

While Ke took Wen Tong as a source of inspiration and sought to master the
"antique methods" of the Northern Song master, he also adopted the principles first
articulated by Zhao Mengfu (1254–1322) of applying calligraphic techniques to paint-
ing. According to his biographer and friend Xu Xian:

> [Ke Jiusi] was adept at drawing rocks and bamboo. At first he followed the brush
> method of Wen Tong. Later he said that in painting the stalks of the bamboo one
> employs the seal script [*zhuan*] style [of calligraphy], in painting the branches one
> employs the cursive [*caoshu*] style, in painting the leaves one employs the clerical
> [*bafen*] or scattered brush [*sabi*] style of Lu Gong [Yan Zhenqing; 709–785], and
> that [in the case of] trees and rocks one employs [brushstrokes] which recall bent
> hairpins [*jinchaigu*] or the old stains from a leaky roof [*gulouhen*]. He never explained
> why these styles were beautiful, yet the life and movement [of his brushwork]
> suggests the hovering of dragons and the soaring of phoenixes.⁵⁷

Bamboo after Wen Tong, dated 1343 (pl. 5), pays homage to the patriarch of mono-
chrome bamboo painting while giving Ke Jiusi the opportunity to display his many
talents—as connoisseur, painter, and calligrapher. A copy of a purported original by
Wen Tong, the painting implies Ke's broad knowledge of antique masterpieces and his
ability to identify an original work by Wen Tong. His willingness to compare himself
directly with the older master by creating his own spirited reinterpretation of the com-
position reflects his confidence as a painter. And his dynamic inscription demonstrates
his skill as a calligrapher.

The dramatically cropped composition reveals neither the base of the bamboo
stalk nor its tip. It is the densely foliated branches, many reaching toward the artist's
two-column inscription that vividly links the calligraphic brushwork of the painting
to the writing, which command our attention. The inscription shows off Ke's callig-
raphy at its most expressive (pl. 5a). In contrast to the highly disciplined small regu-
lar script that he customarily employed at court and when inscribing colophons, this
writing is larger in scale and bolder in design, capturing something of the freer, more
asymmetrical brush manner of the Northern Song masters.⁵⁸ Faithful to his model, Ke
in the right column transcribes the text of Wen Tong's original: "The first day of
winter in the *jiyou* year of the Xining reign era [1069], Wen Tong, Yuke, of Bajun." In
the left column he adds his own date and signature: "On the Duanwu Festival of the
guiwei year of the Zhizheng reign era [May 28, 1343], Ke Jiusi, Danqiu, made this copy."

Ke's model no longer survives, but the composition recalls that of Wen Tong's
best-known attribution (fig. 68). Both paintings show a single stalk of pendant bam-
boo with subsidiary branches and dense clusters of leaves defined in varied ink tones.
Ke's work, however, reveals a significant departure from the representational intention
of the Northern Song example. In the earlier painting, each joint of the stalk and its
subsidiary branches is securely anchored into its socket and each twig grows convinc-

ingly from one of these junctions (fig. 72). In Ke's work (pl. 5b) the joints of the stalk abut without interlocking, twigs emerge illogically from the outside lip of the joints rather than from the joints themselves, and the smaller branches are drawn quickly, in "cursive-script" strokes, without an articulation of the individual segments. More interested in making beautiful strokes, Ke reduces the range of ink tones and the rich variety of leaves and twigs to a limited repertoire of graphic conventions.[59] Imitating Wen Tong's brush mannerisms rather than describing nature, his bamboo is a vehicle for demonstrating his command of a new calligraphic idiom.[60]

The formal nature of Ke's bamboo painting becomes apparent when compared with Wu Zhen's nearly contemporaneous image (pl. 4c). Although Wu Zhen's bamboo exhibits an even greater degree of calligraphic abstraction, it is charged with more expressive power, evoking both temporal conditions and the artist's state of mind, the idiosyncratic calligraphy and poem drawing the viewer into a private world. Ke Jiusi, trained in the etiquette of the court, remains the self-effacing courtier. His painting, formal and reserved, has none of the emotion-charged immediacy of Wu Zhen's treatment, while his terse inscription reveals nothing about his inner state.

ROCKY LANDSCAPE WITH PINES

By the 1340s the Yuan dynasty was descending into anarchy. The extensive employment of foreigners in government administration encouraged exploitation and fiscal corruption, while factionalism in the increasingly bloody struggle for imperial succession fatally weakened the already noncentralized Mongol governmental structure. Between 1320 and 1333 seven different candidates, all under the age of thirty-five, occupied the throne before the thirteen-year-old Shundi was installed as emperor (r. 1333–67). Although Shundi remained on the throne for the remainder of the dynasty, his rule was that of a figurehead. The court was fragmented by power struggles, and regional authority was divided among contending warlords. Large sections of the countryside were beyond the control of the central government, which was further undermined by a series of natural disasters. In 1344 the Yellow River overflowed its banks, causing widespread devastation and resulting in famine, epidemics, and the massive dislocation of the population. The dikes remained unrepaired for seven years before an army of 170,000 corvée laborers was assembled to rechannel the river. Although the work was successful, thousands of workers were incited to rebel, overrunning a dozen cities in the upper Huai River basin by 1351. Uprisings occurred in nearly every province, and by 1353 several rival warlords had emerged in the contest that would determine the inheritance of the Mandate of Heaven.[61]

Literati painters living through this period of turmoil found parallels to their own lives in those of tenth-century recluse scholars attempting to escape the chaos at the end of the Tang dynasty and drew inspiration from the visions of cosmic order presented in their monumental landscape paintings. In the fourteenth century, as belief

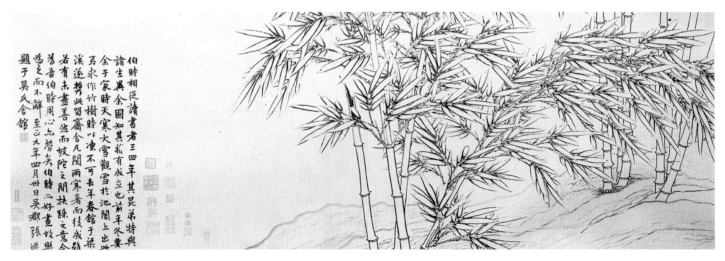

Figure 73. Zhang Xun (ca. 1295–after 1349), *Outline Bamboo and Rocks*, dated 1349. Detail. Handscroll, ink on paper, 17⅛ x 263 in. (43.4 x 668 cm). Palace Museum, Beijing

in cosmic renewal waned, images of the natural world became more introverted and personal. In contrast to earlier representations of an all-embracing natural order, Yuan landscapes become temporary havens for the artist's emotions.[62]

Zhang Xun (ca. 1295–after 1349) was one of the scholar-artists who followed tenth-century prototypes. Zhang left no collection of poetry and his surviving works are few, but he was known to the leading literati of the late Yuan, and it is through the brief biographical notices that appear in their writings that a sketchy outline of his career may be reconstructed.[63]

A native of Suzhou, Zhang Xun maintained a peripatetic existence from an early age, supporting himself through tutoring and painting. He must have had a striking appearance, as he is often referred to by his nickname, "whiskered Zhang." His contemporary Xia Wenyan wrote of him: "Widely learned, good at literary compositions, and excellent in both calligraphy and painting, [Zhang] excelled at painting bamboo in the outline drawing method, [a style in which] he was unsurpassed during his lifetime. In his landscapes he studied Juran [active ca. 960–95], but these were not as distinctive as his bamboo."[64]

The exceptional nature of Zhang's bamboo painting is borne out by his masterpiece in this genre (fig. 73), a long handscroll painted in 1349 that shows clusters of bamboo, a pine tree, and an eroded garden rock in a landscape of earthen hummocks delineated by hemp-fiber texture strokes "in the manner of Dong Yuan."[65] In an age when many artists produced paintings of bamboo, Zhang distinguished himself by specializing in delineating the bamboo in fine outlines rather than in ink wash or color, a method that Zhang Shen (active late 14th–early 15th century), in an undated colophon to this scroll, compared with the style of such early masters as Wang Wei (701–761) and Huang Quan (10th century).[66] Ni Zan, in his own colophon to the scroll, dated 1362, also lauds Zhang's talents:

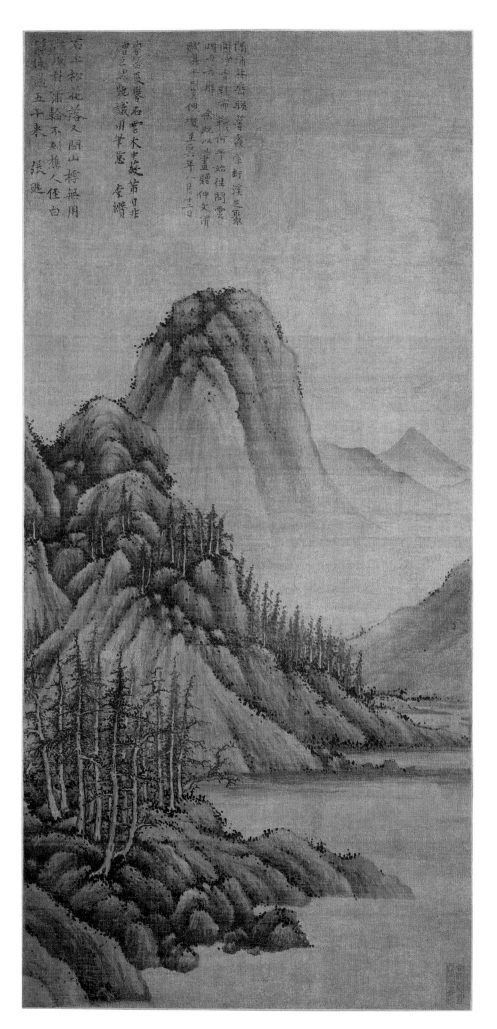

Plate 6. Zhang Xun (ca. 1295–after 1349), *Rocky Landscape with Pines*, ca. 1346. Hanging scroll, ink on silk, 35½ x 16½ in. (90 x 42 cm). The Metropolitan Museum of Art. Ex. coll.: C. C. Wang Family, Promised Gift of the Oscar L. Tang Family

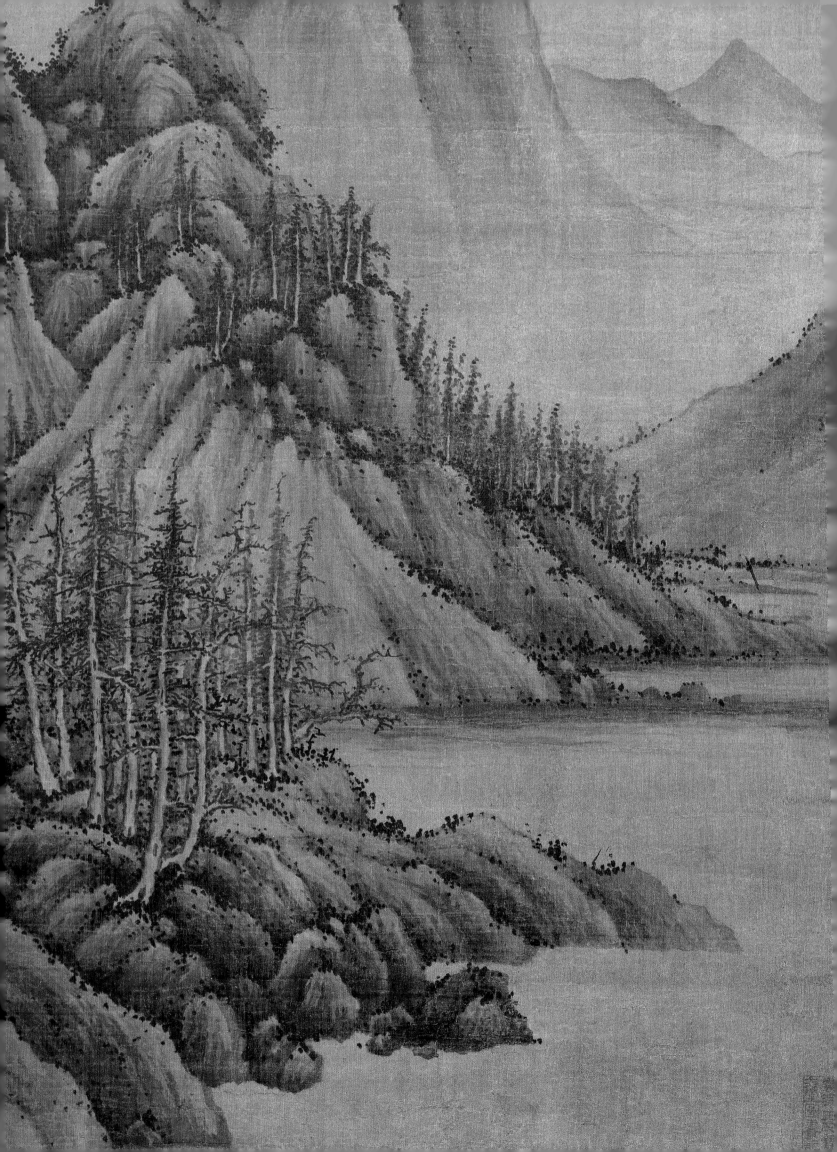

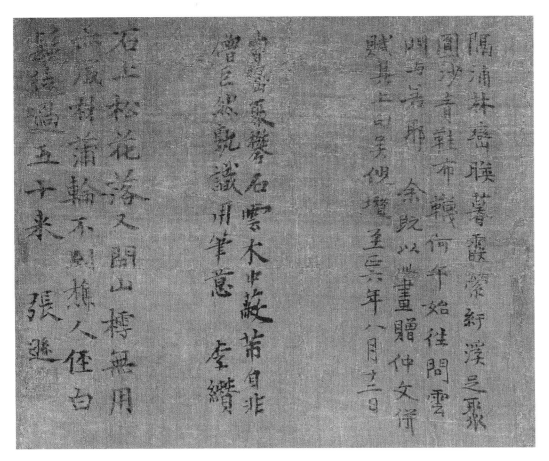

6b. Detail, plate 6

Whiskered Zhang [put his pictorial] ideas into iron-wire
outline drawings [of bamboo];
His calligraphy was uncommon, his poetry proficient.
How one grieves that in his noble suffering he was poor to the bone,
Since when he wielded his brush, he attained the style of the ancients.[67]

Rocky Landscape with Pines (pl. 6), the only extant example of Zhang Xun's landscape manner, confirms Xia Wenyan's account that he followed the style of Juran. Painted in ink on silk, the composition studiously follows tenth-century precedents. Recession is indicated schematically both through shifts in the scale of the trees and through the organization of landscape elements into overlapping foreground, middle ground, and far distance elements aligned in echelon. Following the Juran idiom, the landscape (pl. 6a) is built up of earthen mountains with clustered alum-head hummocks described by ropey hemp-fiber texture strokes with dark foliage dots along the contours. When Zhang's painting is compared with an early attribution to Juran (fig. 21, page 29), however, its later date is immediately apparent. In spite of his conscientious revival of the Juran manner, Zhang's more advanced rendering of recession along a low, continuous plane of water and his more assertive, calligraphic brushwork clearly distinguish his work from that of his Northern Song sources.

Wu Zhen is commonly regarded as the first Yuan artist to revive the Juran manner, in works datable to the late 1320s and early 1330s such as his *Autumn Mountains* (fig. 26, page 32). But *Rocky Landscape*, made about 1346, and landscapes by Li Shixing (1283–1328)

6a. Detail, plate 6

datable to the 1320s (fig. 27, page 33) and by Wang Meng (ca. 1308–1385) dated 1354 (fig. 30, page 37) all show fairly literal interpretations of the Juran style. This would suggest that Wu Zhen's revival was actually part of a much broader phenomenon, in which the idioms of such early southern masters as Dong Yuan and Juran gradually replaced northern models among scholars living south of the Yangzi River. Compared with the interpretations of Juran by these other artists, however, Zhang Xun's painting is notable for its extreme simplicity. It shows none of the narrative detail found in the other works—neither figures nor architectural elements appear in Zhang's image—nor is the landscape structure as complex. While the other paintings present elevated views across winding river valleys and layered mountains that recede into the far distance, Zhang Xun's mountains are viewed frontally and screen off any distant vista. Adhering more strictly to tenth-century models, Zhang Xun's landscape is uncompromisingly austere and abstract.

Inscriptions by the artist and two contemporaries added to the upper left corner (pl. 6b) shed light on the various ways in which such an image was read. The middle inscription by Li Zuan (active mid-14th century), a friend of Zhang Xun's, characterizes Zhang's work specifically as a revival of the Juran manner:[68]

> *Layered peaks gather alum-head rocks,*
> *Cloudlike groves hold deep shadows.*
> *If you are not the Buddhist monk Juran,*
> *How can you understand the meaning of this brushwork?*

The painter and connoisseur Ni Zan, who may have been the scroll's original owner, added an inscription at the upper right when, in 1346, he chose to present the scroll to an unidentified acquaintance named Zhongwen. Ni offers a more lyrical response to Zhang's landscape, reading it as a vision of remote mountains at sunset:

> *On the far shore forests and peaks glow with sunset clouds;*
> *At the foot of the mountains round boulders are gathered beside the winding stream.*
> *When will I put on [hiking] socks and sandals,*
> *And visit the Cloud Gate [Temple] and Ruoye Stream?*[69]

The poem in the upper left, by Zhang Xun himself, echoes the melancholy of the uninhabited landscape:

> *In the rocky [landscape] pine blossoms fall and bloom again.*
> *The mountain Ailanthus, useless [for its timber], has grown to full size.*
> *No cart has ever reached this woodcutter's path.*
> *Now with gray hair, I have passed fifty years in vain.*

Zhang Xun, at the age of fifty, here expresses his growing sense of isolation. Comparing himself to the useless Ailanthus, he acknowledges that while he has managed to survive, he feels as well the pain of being forgotten. Mocked by the yearly cycle of decay and renewal in the natural world, the aging artist reveals a deepening awareness of his own mortality.

If the austerity of the landscape expresses Zhang's sense of loneliness, the

individualized treatment of the trees may reveal another, quite different meaning. Like Ni Zan, whose images of isolated groves often symbolize the artist and his coterie of friends, Zhang may have intended the trees in his painting to represent the close-knit circle of literati with whom he associated.[70] During a period when civil order was crumbling and men of learning had to rely on one another rather than on position or court patronage, he may have seen himself not as an isolated figure but as a member of a community of like-minded men. In this capacity Zhang Xun, though not a major master, played a valuable supporting role in the transmission and enrichment of southern literati culture, helping to establish the Dong Yuan–Juran idiom as the primary bearer of expressive meaning in landscape painting.

Traveling through Snow-Covered Mountains

Prior to the 1350s, the Dong Yuan–Juran, or Dong–Ju, landscape idiom shared the stage with another Northern Song tradition, that of Li Cheng (919–967) and Guo Xi

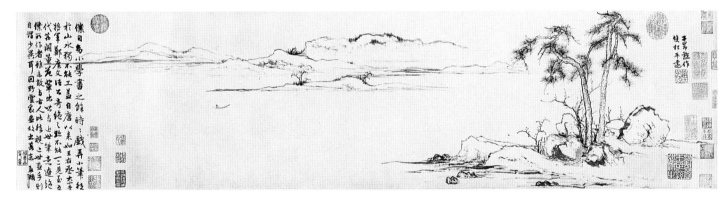

Figure 74. Zhao Mengfu (1254–1322), *Twin Pines, Level Distance*, ca. 1310. Handscroll, ink on paper, 10⅝ x 42¼ in. (26.9 x 107.4 cm). The Metropolitan Museum of Art. Ex coll: C. C. Wang Family, Gift of The Dillon Fund, 1973 (1973.120.5)

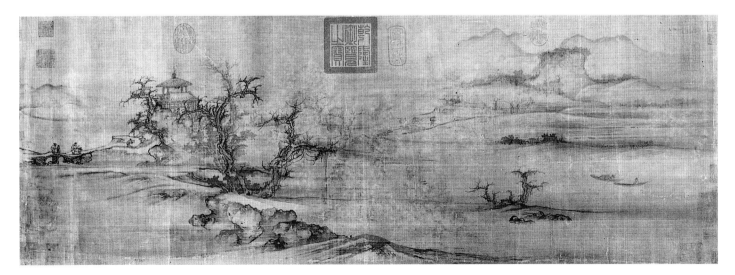

Figure 75. Guo Xi (ca. 1000–ca. 1090), *Old Trees, Level Distance*. Handscroll, ink and color on silk, 14⅛ x 41¼ in. (35.9 x 104.8 cm). The Metropolitan Museum of Art. John M. Crawford Jr., Collection, Gift of John M. Crawford Jr., in honor of Douglas Dillon, 1981 (1981.276)

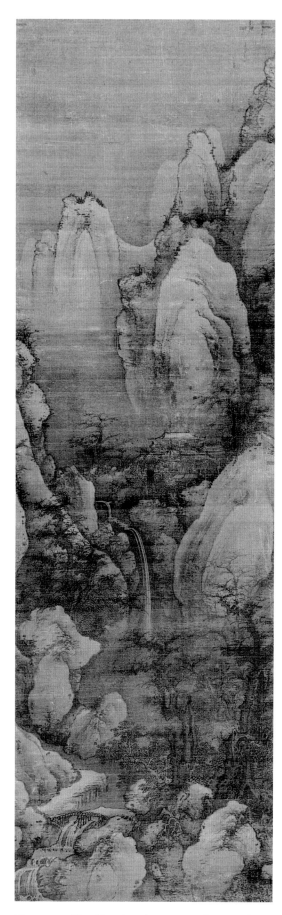

Figure 76. Yao Yanqing (ca. 1300–after 1360), *Winter Landscape*, 1330s. Hanging scroll, ink and color on silk, 62⅝ x 19 in. (159.2 x 48.2 cm). Museum of Fine Arts, Boston

(ca. 1000–ca. 1090). The Dong–Ju tradition held the greatest appeal for southern scholars living in retirement, both because of its regional connection to the Jiangnan landscape and because its imagery celebrated a life in reclusion. The Li–Guo style, on the other hand, was the preferred choice of scholars living in northern China, where Northern Song painting styles, long neglected in the south during the Southern Song period, had persisted and continued to evolve under the Jin dynasty (1115–1234). During the Northern Song, the Li–Guo style had enjoyed state sponsorship, with court artists creating idealized visions of towering pines and majestic mountains presiding over hierarchically ordered landscapes that could be interpreted metaphorically as images of enlightened rulership engendering a prosperous and stable domain.[71] Understandably, this style also became the preferred choice for Yuan court commissions and for works produced for northern patrons serving as officials in the south.

With the reunification of China by the Mongols in 1279, Chinese scholars living in the former Southern Song realm were once again exposed to northern cultural traditions. The artist who initiated the revival of Northern Song styles in the south was Zhao Mengfu.[72] Zhao not only resurrected the southern landscape idiom of Dong Yuan, he also explored the styles of the northern masters Li Cheng and Guo Xi. *Twin Pines, Level Distance* (fig. 74), a short handscroll painted by Zhao about 1310 and based on a composition by Guo Xi (fig. 75), exemplifies Zhao's transformation of the earlier style.[73] Like its source, Zhao's painting evokes the broad river valleys of central China, where isolated clusters of trees and rocky outcrops punctuate watery lowland plains. But in Zhao's re-creation, the earlier master's richly descriptive vocabulary of texture strokes and graded washes is transformed into a terse set of calligraphic brush conventions. Using a minimalist treatment Zhao strips the landscape down to its skeletal structure, removing the veiling effects of atmosphere, the play of light and shadow across the surface, and all sense of mass, and focusing instead on brushwork and on the abstract qualities of line on paper. He thus transforms an essentially representational idiom into an abstract vocabulary of brush marks that he uses for distinctly expressive ends.

The Li–Guo revival initiated by Zhao Mengfu continued to flourish among a second generation of southern artists, including Tang Di (1287–1355) and Zhu Derun (1294–1365), both of whom served at the Yuan court, and Cao Zhibo (1272–1355), who was on close terms with northerners serving in the south.[74] Yao Yanqing (ca. 1300–after 1360), a native of Wuxing in Zhejiang Province, followed in the footsteps of his fellow townsmen Zhao Mengfu and Tang Di

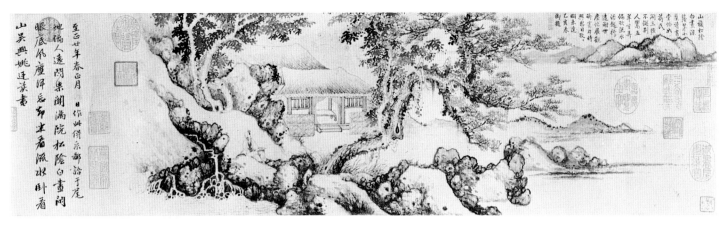

Figure 77. Yao Yanqing (ca. 1300–after 1360), *Leisure Enough to Spare*, dated 1360. Handscroll, ink on paper, 9 x 33⅛ in. (23 x 84 cm). The Cleveland Museum of Art

in taking up the Li–Guo manner.[75] Yao's paintings, like those of Tang Di, are far more literal in their adaptation of the grand Northern Song manner than Zhao's simplified interpretations, making them more suitable for mural paintings and other large-scale decorative works in which the narrative content remains important. But Yao Yanqing was more than a professional artisan. A seminal article by Richard M. Barnhart has established that Yao, who sometimes used his style name, Tingmei, was a scholar-painter who also worked in a sketchy, calligraphic manner derived from the stylistic tradition of Dong Yuan and Juran. Yao's use of different styles and names led to his being identified as two different painters, Yao Yanqing and Yao Tingmei.[76] By demonstrating the underlying stylistic consistency of Yao's variously attributed works, Barnhart not only shows that they are the product of a single hand but underscores the ability of scholar-painters to work in different stylistic traditions according to the demands of the occasion. Shih Shou-chien offers the further suggestion that Yao's different painting styles reflect a broader pattern of social change.[77] According to Shih, during the first half of the Yuan a number of southern scholar-painters, who either served in government or made paintings for northern patrons, worked in the Li–Guo style. Beginning in the early 1350s, however, there was a marked decline in the demand for Li–Guo-style landscapes, as the deteriorating political situation led to less frequent exchanges between northerners and southerners.

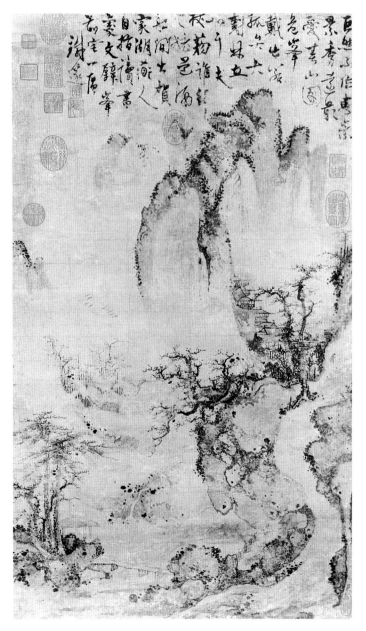

Figure 78. Attributed to Yao Yanqing (ca. 1300–after 1360), *Spring Mountains*. Hanging scroll, ink on paper, 28⅞ x 16⅝ in. (73.2 x 42.3 cm). National Palace Museum, Taipei

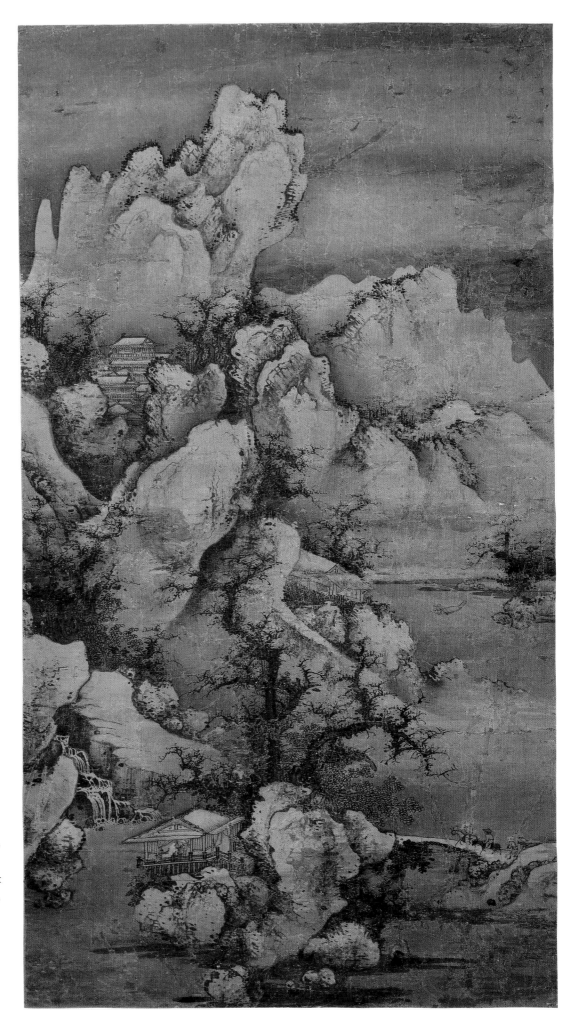

Plate 7. Yao Yanqing
(ca. 1300– after 1360),
*Traveling through Snow-
Covered Mountains*, 1340s.
Hanging scroll, ink
and color on silk, 38¾ x
21¼ in. (98.5 x 54 cm).
The Metropolitan
Museum of Art.
Ex. coll.: C. C. Wang
Family, Promised
Gift of the Oscar L.
Tang Family

Only three works bearing Yao's signature or seals have survived: *Winter Landscape* (fig. 76) and *Fisherman in a Wintry Riverscape* (an undated work now in the Palace Museum, Beijing), both executed in the northern Li–Guo manner; and *Leisure Enough to Spare* (fig. 77), painted in the southern Dong–Ju mode.[78] A fourth painting, *Spring Mountains* (fig. 78), in a sketchy style that combines elements from both the Li–Guo and Dong–Ju idioms, bears no artist's seal or signature, but may also be attributed to Yao.[79] Within this small oeuvre, *Winter Landscape*, which accords well with the kind of work that would have been suitable decoration for a formal reception hall or office, is probably an early work, dating to the 1330s. The more informal *Spring Mountains*, like *Leisure Enough to Spare*, is probably a late work. These two later paintings also exemplify a new genre that developed during the late Yuan: idealized "portraits" of retirement villas.[80] Yao painted *Spring Mountains* for the noted literatus Yang Weizhen (1296–1370), whose bold inscription, added to the upper portion of the scroll, identifies the painting as a depiction of his studio. *Leisure Enough to Spare* was painted as a tribute to a retired scholar, Master Du. Executed in the first lunar month of 1360, the painting and Yao's

accompanying poem were part of a collection of twenty-three such poetic tributes made between 1359 and 1360, including a long biographical sketch by Yang Weizhen.[81] Yao's diverse oeuvre demonstrates his ability to adapt his style to suit changing circumstances, while the scholarly status of the recipients of his works establishes him as at least a peripheral member of literati circles.

Traveling through Snow-Covered Mountains (pl. 7) no longer bears an artist's signature or seals, but its stylistic idiosyncracies identify it unmistakably as the work of Yao Yanqing, an attribution first given to the painting by C. C. Wang in a label strip added in 1989.[82] A hanging scroll painted in ink and touches of color on silk, the painting presents a rugged landscape of massive boulders and craggy promontories whose snowy whiteness is set off by expanses

7a. Detail, plate 7

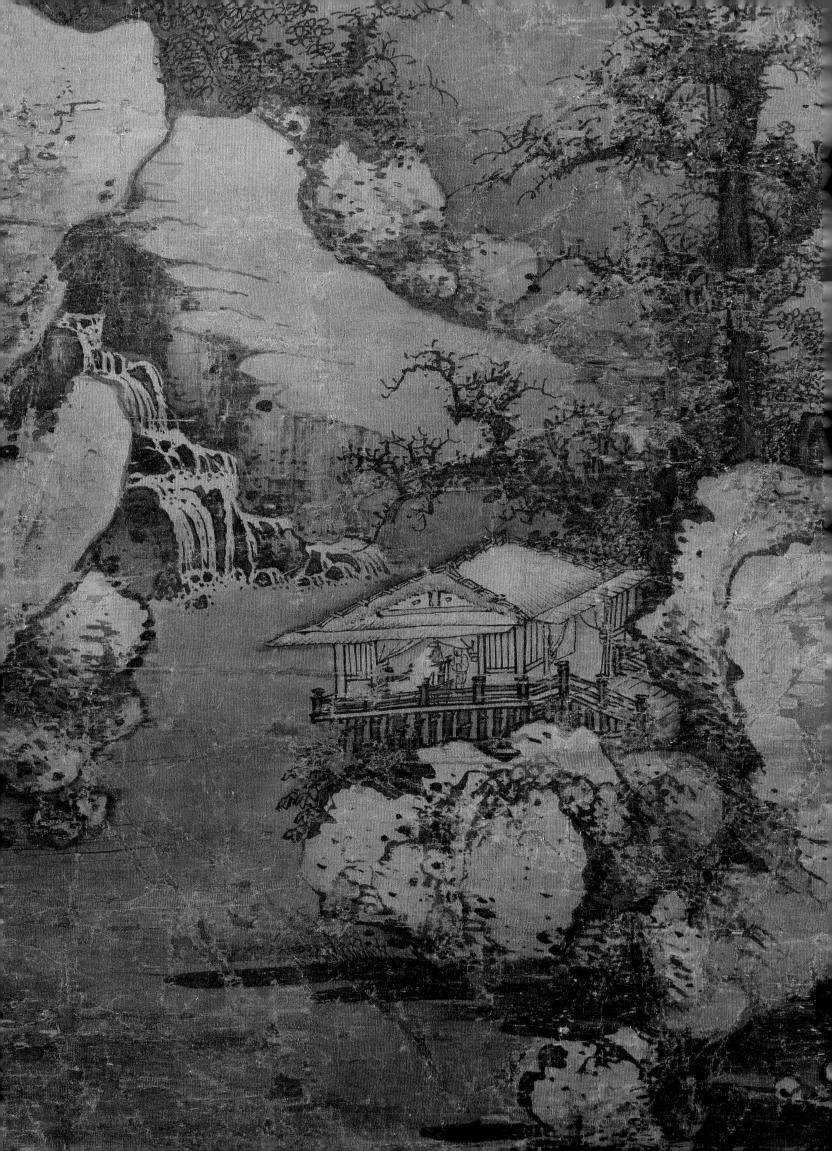

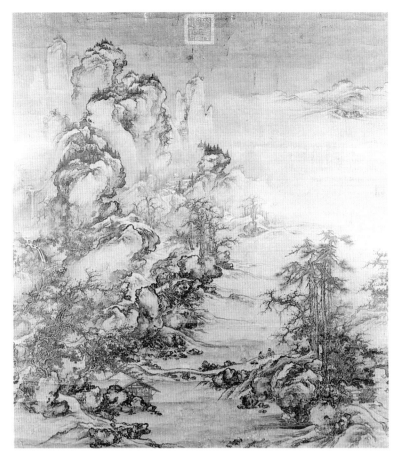

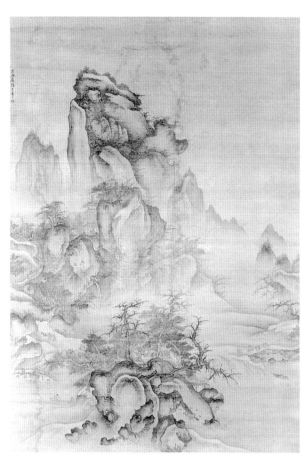

Figure 79. Unidentified artist (12th century), *Min Mountains.* Hanging scroll, ink on silk, 45¼ x 39⅝ in. (115.1 x 100.7 cm). National Palace Museum, Taipei

Figure 80. Tang Di (1287–1355), *After Guo Xi's "Travelers amid Autumn Mountains."* Hanging scroll, ink and color on silk, 59¾ x 40⅞ in. (151.9 x 103.7 cm). National Palace Museum, Taipei

of gray water and sky and by the black silhouettes of contorted trees. Following Northern Song and Jin prototypes, the dominant mountain, built up of large bulging shapes, rises along the left half of the composition while a river valley recedes into the distance along the right. In the foreground, where a bridge spans the river, two gentlemen riding on mules and accompanied by two attendants draw the viewer into the composition. The roadway passes behind a foreground promontory and up the slope toward an isolated temple complex nestled in a high mountain valley (pl. 7a). Other dwellings are similarly secluded within their own pockets of space. In the foreground is a pavilion raised on stilts over the water. Inside, a scholar attended by a servant faces away from the viewer toward a waterfall (pl. 7b). Farther up the mountainside, a thatched house overlooks the river, where a lone figure oars his boat.

The billowing-cloud rocks and crab-claw tree branches immediately identify the painting as belonging to the stylistic lineage of Guo Xi (fig. 4, page 4), as do the dramatically modulated contour lines and thick layering of ink wash and texture strokes. But whereas Guo Xi seeks to describe nature, Yao seeks to create a style, reducing Guo's varied texture strokes and contour lines to a limited repertoire of calligraphic conventions. Each motif is a schematic pattern. As a result, individual landscape elements no longer merge into a coherent whole and the composition begins to fragment and

flatten, becoming an uneasy pattern of contending shapes. Exaggerations in shading and the fragmentation of forms were already common features in Jin interpretations of the Guo Xi style (fig. 79). But Yao's pursuit of calligraphic effects has gone far beyond the simplification and exaggeration found in earlier interpretations and more closely resembles the mid-Yuan reinterpretation of the Guo Xi style, particularly as practiced by Yao's near contemporary Tang Di (fig. 80).[83]

Within Yao's own oeuvre, *Traveling through Snow-Covered Mountains* stands midway between *Winter Landscape* and *Leisure Enough to Spare* in both subject and style. Thematically, it includes the travelers and remote temple that are hallmarks of the Li–Guo tradition, and it celebrates the pleasures of rustic retirement. Stylistically, *Traveling* and *Winter Landscape* both present typical Li–Guo snowscapes, with white peaks defined by deeply shadowed valleys and foreground promontories dominated by contorted trees with clawlike branches. The distant temple complexes in both paintings also show the same dense cluster of halls defined by wide eaves and massive beams highlighted in umber and red. But *Traveling* differs from *Winter Landscape* in the degree to which Yao has departed from representational values in favor of the abstract compositional patterns that are most fully developed in *Leisure Enough to Spare*. The mountain forms are delineated through a schematic alternation of densely textured fissures and stark white areas that resemble pathways or flat bands, while prominent black dots, intended to indicate cavities, seem to sit on the painting surface. In *Traveling*, the flattened-out pattern formed by the stream as it divides and subdivides into multiple rivulets also closely parallels the same motif in *Leisure Enough to Spare*. If *Leisure*, dated 1360, and the more conservative *Winter Landscape*, from the 1330s, define the parameters of Yao's stylistic evolution, then *Traveling through Snow-Covered Mountains* most likely dates to the 1340s, when the Li–Guo manner was still a viable stylistic choice but when new ways of animating landscape compositions had begun to emerge.

Exemplifying a taste for abstract form that accompanied the new self-expressive aims of late-Yuan scholar-painters, *Traveling through Snow-Covered Mountains*, Yao Yanqing's most ambitious surviving composition, not only adds significantly to the small corpus of his works but provides a fuller understanding of the mid-Yuan transformation of the Northern Song monumental landscape mode from representational to calligraphic goals, setting the stage for the highly personal expressive works of the late Yuan.

Simple Retreat

The final two decades of the Yuan dynasty were a time of disintegrating social order and convulsive political change. Uprisings broke out in nearly every province, leading to the rise of several rival warlords in a contest that would determine the inheritance of the Mandate of Heaven. In 1368 one of the rebel leaders, Zhu Yuanzhang, emerged victorious and proclaimed himself Taizu, the first emperor of the Ming dynasty (r. 1368–98).

A revolutionary change also occurred in painting during the mid-fourteenth century, indelibly influencing how later Chinese artists would perceive and represent space. Having mastered the illusion of continuous recession on a two-dimensional surface, fourteenth-century artists then rejected it. Extending the implications of Zhao Mengfu's subordination of representational objectives in favor of expressive calligraphic brushwork and following Zhao's pursuit of antique models, late-Yuan artists used the archaic spatial schema of tenth-century landscapes to animate their compositions, a process not unlike that of Picasso when he abandoned one-point perspective and explored more primitive ways of visualizing forms in space as a means of imparting new energy to his images.

The landscapes of Wang Meng (ca. 1308–1385) epitomize the transformation of painting from a descriptive and symbolic language to an abstract and personal one. Wang, the youngest of the four masters of the late Yuan, was deeply influenced by the crumbling social order in which he grew to maturity.[84] Born into a culturally prominent family in Wuxing, Wang's father, Wang Guoqi (ca. 1285–after 1366), was a poet, connoisseur, and minor painter who belonged to the same circle of literati as Huang Gongwang (1269–1354) and Yang Weizhen (1296–1370) and who knew the hermit painter Wu Zhen (1280–1354).[85] Wang Meng's maternal grandfather was Zhao Mengfu. Zhao had retired to Wuxing in 1319, so the young Wang would have had ample opportunity to become personally acquainted with him. Wang also remained close to Zhao Mengfu's son Zhao Yong (1289–after 1360) and grandson Zhao Lin (active ca. 1350–70), connections that afforded Wang the opportunity to familiarize himself with Zhao's painting style as well as to view early paintings from the family collection.[86]

Wang Meng spent much of his life in retirement, residing at Yellow Crane Mountain northeast of Hangzhou, and he made reclusion one of the dominant themes of his art. In the late 1350s and early 1360s, however, Wang was often in Suzhou, where he may have held an official post under the local strongman, Zhang Shicheng (1321–1367). Zhang had gained the support of many scholars after pledging nominal submission to the Yuan government in 1357, but his fealty to the Yuan was brief. In 1363, he renounced his allegiance to the central government and proclaimed himself Prince of Wu.[87] Wang Meng and many of his friends nevertheless remained in Suzhou through its siege and fall to the troops of Zhu Yuanzhang in 1367.

In spite of his possible association with Zhang Shicheng or with scholars serving under him, Wang quickly found employment under the new dynasty. From 1368 to 1371 he served as magistrate of Tai'an, in Shandong Province. He then returned south, residing in the Ming capital at Nanjing, where he spent most of the remaining years of his life. At the capital his circle of friends included a number of eminent Buddhist monks as well as artists and officials, many of whom eventually fell victim to the bloody purges of the increasingly paranoid first Ming emperor. In 1385, Wang was himself arrested and thrown into prison, where he died a short time later.

Except for his intermittent engagement in political affairs, Wang Meng defined his life by his connections to the small coterie of like-minded Jiangnan literati who

often gathered at one another's homes to converse, view works of art, listen to music, paint, and compose poetry. The gatherings and the residences where these men sought refuge from the political world themselves became the subject of works of art, the studio, library, and garden serving as the loci of an alternative life, one defined not by the civil service examination or government office but by withdrawal from public life—an act of protest, self-protection, and self-cultivation.

The revolutionary change in late-Yuan landscape art is clearly documented in Wang Meng's shifting attitude toward stylistic precedents. In *Dwelling in Seclusion in Summer Mountains* (fig. 30, page 37), a small, conservative painting on silk dated 1354, Wang studiously revived the archaic landscape manner of the tenth century: schematic buildings and frontally disposed landscape elements step back to an axially aligned central peak that is densely built up in the Dong–Ju idiom of hemp-fiber texture strokes and foliage dots.[88] The painting surpasses its tenth-century models in its effective description of spatial recession, but is otherwise rather dry and derivative. By the early 1360s, Wang had liberated himself from the strictures of too literal an interpretation of earlier models. In *Fisherman's Retreat on a Flowering Stream* (fig. 32, page 38), the monumental landscape imagery of the early Northern Song has been transformed. In marked contrast to the controlled formality and stability of the earlier painting, the later work pulses with a restless energy barely contained within the traditional landscape structure. The uniform application of parallel texturing in *Dwelling in Seclusion* is replaced by richly varied brushstrokes that fluctuate in thickness, length, direction, density, and tonality. The exploration of the abstract and expressive possibilities of brushwork is complemented by a calculated destabilization of the mountain forms, which slant implausibly to accord with larger compositional movements. As Wang was drawn deeper into the turmoil that engulfed his home region after 1363, the dynamic equilibrium of his compositions was lost as mountain forms, wracked by convulsive brushwork and conscious distortions of spatial logic, became increasingly unstable.

Significantly, it was at just this time that the Dong Yuan manner, as exemplified by such paintings as *Riverbank* (pl. 1), had a major impact on landscape imagery. *Simple Retreat* (pl. 8), datable stylistically to around the time of the founding of the Ming dynasty in 1368, is one of several paintings by Wang Meng that reflect the importance of *Riverbank* as a compositional and thematic model. It is dominated by a towering mountain peak that rises above a foreground river and trees in a series of thrusting ridgelines. The mountain fills almost the entire picture space, leaving only a small corner of sky in the upper right where Wang has inserted the title, *Simple Retreat* (*Su'an tu*), in archaic seal script and a brief dedication in regular script: "The Yellow Crane Mountain Woodcutter, Wang Meng, painted this for the lofty scholar of the Simple Retreat" (pl. 8a).

The narrative elements of *Simple Retreat* also bear a striking similarity to those of *Riverbank*: a spacious hermitage, nestled between the side of the mountain and a stream, is approached by a traveler along a winding pathway while another figure, accompanied by two deer, has just arrived at the compound's gate (pl. 8b). As in the earlier painting, the hermitage is a thatched structure built around a central courtyard, with

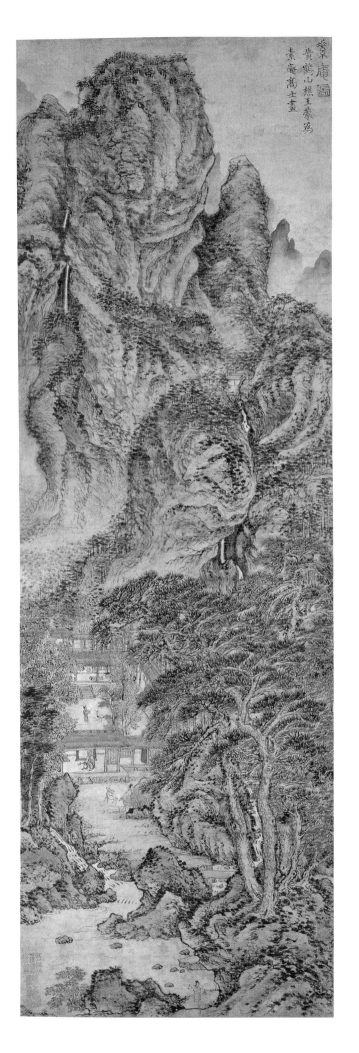

Plate 8. Wang Meng (ca. 1308–1385), *Simple Retreat*, ca. 1368. Hanging scroll, ink and color on silk, 53½ x 17¾ in. (136 x 45 cm). The Metropolitan Museum of Art. Ex. coll.: C. C. Wang Family, Promised Gift of the Oscar L. Tang Family

8a. Detail, plate 8

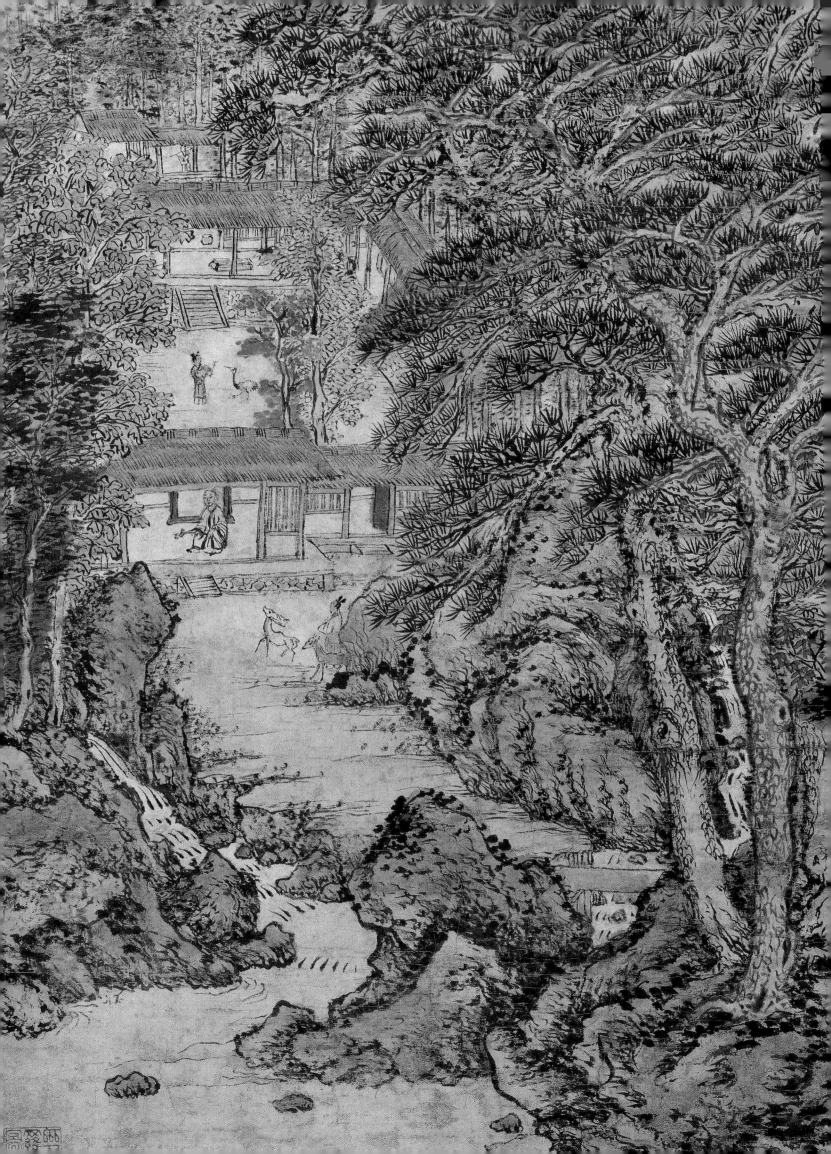

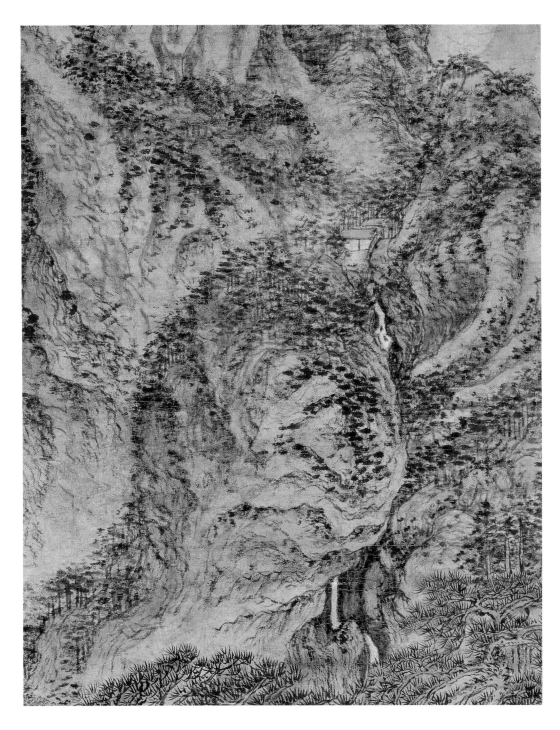

8c. Detail, plate 8

another building behind and figures that inhabit the household: someone looks out from the rearmost structure, a servant offers a sprig of herbs to a crane in the court-yard, and the master himself gazes out from his prominent position at the front gate, a scepterlike magic fungus in his hand. The auspicious Daoist imagery of fungus, crane, and deer, as well as the archaic simplicity of the figures and dwelling—pro-tected by overarching mountains and trees—evokes a dreamlike vision of reclusion.

While the subject matter of *Simple Retreat* closely parallels that of *Riverbank*, the landscape structures of the two paintings are quite different. Rocks and trees in *Simple Retreat*, animated by fluttering texture strokes, dots, color washes, and daubs of bright mineral pigment, are vibrant with calligraphic energy (pl. 8c). Renouncing the advances made by the early fourteenth century in the depiction of spatial recession, Wang rejects the illusion of a continuous ground plane in favor of a schematic

compositional structure that exploits the tension between the illusion of three-dimensional form and the flat patterning of brushstrokes on a two-dimensional surface. The blank paper of the waterways and the rustic compound serves as a graphic counterbalance to the densely textured mountain, creating a *yin-yang* interplay of mass and void that further energizes the composition. Encircled by this charged landscape of mountains and water, the retreat becomes a reservoir of calm at the vortex of a world whose dynamic configurations embody both nature's creative potential and a different, man-made turmoil—the shifting terrain of political power that characterized the latter part of the fourteenth century.

Although Wang Meng's revival of imagery first created during the chaotic Five Dynasties period served as a thinly veiled allusion to the political upheavals of his own time, the earlier embodiment of the eremetic ideal is here undermined by a nonrealistic style. The pictorial narrative can no longer be taken at face value. While the scholar-recluse in *Riverbank* appears protected from the storm that swirls around him, the security of the master in *Simple Retreat* is symbolically contradicted by the tumultuous brushwork. The tempest that blows through the later painting is no longer an autumn storm but the inner tumult of the artist manifested through expressive brushwork.

MANDARIN DUCKS AND HOLLYHOCKS

The founder of the Ming dynasty, Zhu Yuanzhang (1328–1398), having successfully defeated his rivals and expelled the Mongols from China, immediately set about reestablishing imperial institutions, rebuilding the central bureaucracy, and asserting his place as the inheritor of the Mandate of Heaven. The Ming dynasty, thus begun, lasted nearly three hundred years. At the outset it witnessed a period of dynamic political and cultural expansion as early Ming emperors actively directed military campaigns, proclaimed new laws, and managed state affairs. After the death of the Xuande emperor (r. 1426–35), however, a succession of young, willful rulers grew increasingly passive and self-absorbed and the dynasty entered a period of military setback and political decline. During the sixteenth and early seventeenth centuries corruption at court led to political disillusionment, but a burgeoning urban life and expanding literati culture provided a stimulus to change and innovation, reflected in increased social mobility and in a diversity of artistic expression.

In the arts, the early Ming dynasty was a period of cultural restoration and expansion. With the defeat of the Mongols and the reestablishment of an indigenous Chinese ruling house came a reassertion of imperial power and the imposition of court-dictated styles. As part of the official policy of institutional revival and the renewal of a state ideological orthodoxy, the painters recruited by the early Ming court were directed to return to didactic and realistic representation and to emulate the styles of the Imperial Painting Academy of the Song dynasty. Large-scale landscapes, flower-and-bird compositions, and figural narratives were particularly favored as images that would glorify the new dynasty and convey its majesty, benevolence, and virtue.

Lü Ji (ca. 1430–ca. 1504) was one of the three leading artists at the Ming court responsible for the revival of the Song academic tradition of decorative, meticulously realistic flower-and-bird painting. Following in the footsteps of Bian Wenjin (ca. 1354–ca. 1428) and Lin Liang (ca. 1430–ca. 1490), Lü was the most influential in transforming the inherited Song tradition into a distinctively Ming idiom that became the model for all later practitioners. Because of his status as a professional painter rather than a scholar, however, and the fact that virtually none of his extant paintings are dated, relatively little is known of his life.[89]

Lü was a native of the port city of Ningbo in Zhejiang Province, where the Southern Song academic manner had remained popular through the intervening centuries. Traditional accounts state that he began his study of painting by modeling his work on that of Bian Wenjin. His talent was soon recognized by his fellow townsman Yuan Zhongche (1376–1458), a physiognomist and high court official who probably met Lü sometime after he had retired from government service in 1439.[90] Inviting the young artist to become a member of his household, Yuan encouraged Lü to broaden his skills through the study and copying of pre-Ming paintings, no doubt including works from Yuan's own collection.[91] Although nothing is known of Lü's career after Yuan died, he was probably already at court during the Chenghua era (1465–87), when he would have served in the Renzhi Hall, the informal painting academy in the Forbidden City. In Beijing, Lü would have come into contact with Lin Liang (fig. 86), a professional artist from Guangdong Province who specialized in a dashing ink-wash style animated by bravura brushwork. While Lü also produced monochrome works on paper that show his awareness of Lin's brush techniques, he is best known for his meticulous, richly colored works on silk.

During the Hongzhi era (1488–1505), Lü attained one of the highest ranks possible for a court painter, Battalion Commander of the Embroidered Uniform Guard. He was held in particular esteem because despite the strictures placed on his commissions, the finished paintings "still preserved his original concept."[92] This approach earned him the emperor's praise: "Lü Ji has the ability to offer admonitions through his art."[93] Howard Rogers has observed that the Hongzhi emperor's appreciation of the didactic function of Lü Ji's art was at least in part motivated by his desire to influence the heir apparent, the future Zhengde emperor (r. 1506–21), to whom he once observed: "The paintings of Lü Ji marvelously surpass the wellsprings of nature itself; such pictures as *The Talented Listening to Admonitions* and *Ten Thousand Years of Clear Purity* [both, whereabouts unknown] are very much concerned with administration and are worthy to be handed down as treasures."[94]

Lü Ji's skill as a figure painter was also admired by several high officials of the time. In 1499 the minister of revenue, Zhou Jing (1440–1510), commissioned Lü Ji and the artist Lü Wenying (active late 15th century) to paint a record of his sixtieth-birthday celebration at his Bamboo Garden in Beijing, and the grand secretary, Li Dongyang (1447–1516), requested a painting of the *Ten Graduates of the 1464 Examination* (whereabouts unknown) in 1503. Shortly thereafter, Lü fell ill. After the emperor had inquired repeatedly about his health, Lü observed: "To be so favored is difficult to bear; this [must portend] my death." Whereupon he died.[95]

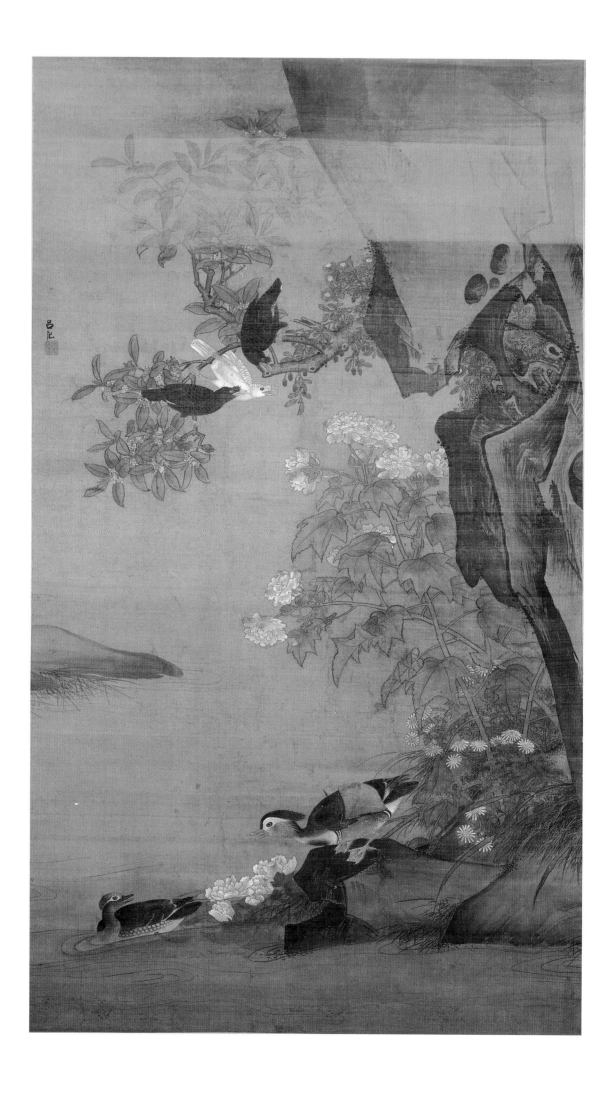

Lü's surviving paintings are distinguished by images that are rich with symbolic motifs. For all their realistic detail, the images often juxtapose birds and plants that would not necessarily be found together in nature, clearly indicating that they are artificial constructs intended to fulfill specific social functions: to offer admonitions to the emperor and his court, to extend congratulations or good wishes for success in examinations; to celebrate an official promotion, a birthday, or a marriage; or to convey good wishes for the New Year. Typically, the dense imagery of his paintings was intended to be read as a series of rebuses or pictorial puns, a conceit already in use during the Northern Song period.[96]

Mandarin Ducks and Hollyhocks (pl. 9), a large hanging scroll painted in ink and color on silk and bearing the artist's signature and seal, presents a concentration of auspicious images that symbolize marital happiness. Most prominent is the pair of mandarin ducks, a traditional emblem of conjugal harmony, as the species was believed to mate for life.[97] The ducks turn toward one another, the felicity of their relationship underscored by the nearby cluster of hollyhocks (*furong*) and overhanging branch of flowering cassia (*gui*) which together form a rebus (*furong qigui*): "prosperous groom, honorable bride."[98] The three mynahs (*bage*)—one a rare albino—perched on the cassia greedily eyeing some plump red berries must also add to the painting's auspicious significance, but their exact meaning is unclear. Perhaps their name (*ge*), which is homophonic with "to sing," and their high position in the composition were meant to suggest high-spirited singing (*gao ge*), adding further to the painting's celebratory air. The conjunction of these auspicious motifs would not only have enhanced the painting's decorative function but made it a fitting wedding gift, with felicitous wishes for a successful marriage.

The composition—an array of precisely defined picture elements organized within a shallow foreground to create a dense, tightly structured composition that has an almost geometric rigor—is typical of Lü Ji's interpretation of the Song flower-and-bird genre. Further, the combination of intricacy and measured order, suggesting a harmonious natural hierarchy, made his paintings effective symbols for the Ming court and its ideal of a well-ordered empire.

The hollyhock, cassia, and two varieties of chrysanthemum are signs of autumn and suggest that the painting may originally have formed part of a set illustrating the four seasons. Nearly the same constellation of birds, flowers, rocky outcrop, and sandy embankment appears in the autumn scene from Lü Ji's four-scroll set *Birds and Flowers of the Four Seasons* (fig. 81).[99] But in the present scroll, the picture elements are more numerous and more crowded. The cliffside takes the place of the cassia tree's trunk

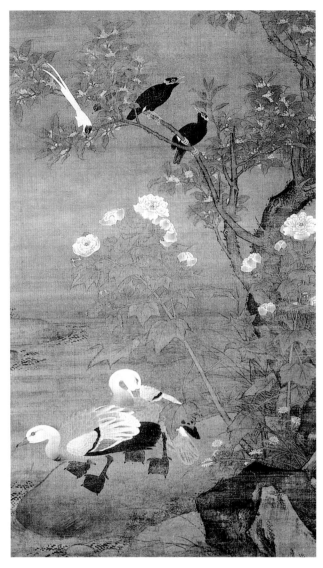

Figure 81. Lü Ji (ca. 1430–ca. 1504), "Autumn," from *Birds and Flowers of the Four Seasons*. Set of four hanging scrolls, ink and color on silk, each 69¼ x 39¾ in. (176 x 100.8 cm). Tokyo National Museum

Plate 9 (opposite). Lü Ji (ca. 1430–ca. 1504), *Mandarin Ducks and Hollyhocks*. Hanging scroll, ink and color on silk, 68⅛ x 39⅛ in. (173 x 99.5 cm). The Metropolitan Museum of Art. Ex. coll.: C. C. Wang Family, Promised Gift of the Oscar L. Tang Family

Plate 10. Liu Jun (active ca. 1475–ca. 1505), *Remonstrating with the Emperor*. Hanging scroll, ink and color on silk, 65 x 41⅞ in. (165 x 106.5 cm). The Metropolitan Museum of Art. Ex. coll.: C. C. Wang Family, Promised Gift of the Oscar L. Tang Family

and makes possible the addition of more chrysanthemums and red berries at the level of the three mynahs. As if to compensate for the added concentration of motifs, the foreground shoreline in the present painting is separated from the bottom edge of the composition by a narrow band of water, but this device does little to alleviate the sense of spatial compression. The flat texture patterns of the rocks and the stylized band of mist that cuts across the top of the composition further emphasize the schematization of pictorial elements. The flattening of the picture space is a device also used in the works of Lü's early-sixteenth-century followers Yin Hong and Xiao Zeng and his nephew Lü Tang. It is therefore possible that the present work was a product of Lü's studio.[100]

It is the interchangeability of composition and brush manner between members of the same workshop that marks the work of the Ming professional painters, who followed the representational idiom of the Song, creating technically virtuoso images that featured vivid coloring, intricate brushwork, and bold compositional design. Scholar-artists, by contrast, developed the calligraphic idiom of the Yuan, producing works that were more individualistic and self-expressive. The scholar-artist Shen Zhou (1427–1509) summed up the difference when he compared his own art to that of Lü Ji: "Lü paints with his hand; I paint with my heart."[101]

REMONSTRATING WITH THE EMPEROR

Another product of the Ming Painting Academy made to enhance the prestige and further the propagandistic aims of the dynasty is *Remonstrating with the Emperor* (pl. 10), bearing the signature and seal of the court artist Liu Jun (active ca. 1475–ca. 1505). This large colorful hanging scroll, executed in ink and vivid mineral pigments on silk, testifies to the continuation of the Song academic tradition of narrative art under the sponsorship of the Ming. Following Song precedents, paintings of loyal officials shown remonstrating with the emperor were commissioned to enhance the image of the emperor as a just ruler who welcomed frank criticism and encouraged honest admonitions from his officials. The reality was often quite the reverse.

Remonstrating with the Emperor depicts an imperial audience that takes place in a palatial garden with an elaborate balustrade, ornamental rocks, towering pines, and blossoming hollyhocks and chrysanthemums. The emperor, seated on a throne backed by a large freestanding screen, leans forward to hear the words of an earnest official who, risking the sovereign's displeasure, dares to

Figure 82. Unidentified artist (12th century), *Breaking the Balustrade.* Hanging scroll, ink and color on silk, 68½ x 40⅛ in. (173.9 x 101.8 cm). National Palace Museum, Taipei

criticize him. The official stands his ground despite the efforts of a palace guard to drag him off, while a second guard behind the screen seems uncertain whether or not to intervene. At the left, attendants with a fan and the imperial sword gesture nervously and exchange glances; two officials in the foreground bow silently, holding up the ivory tablets traditionally used in imperial audiences.

In its subject matter and general composition, *Remonstrating with the Emperor* closely resembles the anonymous *Breaking the Balustrade* (fig. 82), a product of the Song Imperial Painting Academy.[102] The earlier work illustrates a story from the *Hanshu* (Han Documents) in which a low-ranking official angers his sovereign by advocating the execution of a corrupt marquis. Confronting the emperor's rage the official stands his ground, clinging to a railing until it breaks, while a loyal general intercedes on his behalf. In the end, the emperor relents and orders that the broken balustrade remain unrepaired as a reminder of the official's courage.

Liu Jun's work includes many of the same elements as the Song painting, but their treatment and placement in the composition reveal a strikingly different conception. In the earlier work

Figure 83. Liu Jun (active ca. 1475–ca. 1505), *Emperor Taizu Calling on Zhao Pu on a Snowy Night*. Hanging scroll, ink and color on silk, 56⅜ x 29½ in. (143.2 x 75 cm). Palace Museum, Beijing

the figures are part of a larger, well-ordered universe, highlighted by the spaciousness of the composition. The Ming painting focuses on the figures, in a compressed space that gives no sense of the universe beyond. While both artists narrate a story, the Song painter is concerned specifically with graphic representation; the Ming artist emphasizes symbolic content. In the Song painting, both the psychological and the spatial dimensions of a specific historical event are clearly delineated. Picture elements are ordered to create a believable spatial framework for the action, while the figures convey a sense of individual personality through facial expression and gesture. In the Ming painting, by contrast, the symbolic significance of remonstration rather than the illustration of a particular story is what matters. The image is intended to be read as an

emblem of the Ming ruler's enlightened attitude toward honest criticism. As in Lü Ji's images of birds and flowers, the painter's objective is no longer to achieve an accurate description of nature but to convey a message through images imbued with symbolic meaning.

We know next to nothing about Liu Jun's life. He was already a court painter in 1480 when he received a promotion; eventually he attained the honorary rank of Commander in Chief of the Embroidered Uniform Guard, probably under the Hongzhi emperor (r. 1488–1505), the same patron who approved of the didactic content of Lü Ji's paintings.[103] While most of his surviving works depict Daoist immortals, images that would connote the wish for longevity, Liu seems to have had a secondary specialization in paintings of the monarch taking counsel from his inferiors. In *Emperor Taizu Calling on Zhao Pu on a Snowy Night* (fig. 83), he depicts the founder of the Song dynasty calling on his minister Zhao Pu on a cold, wintry night. The stately simplicity and spaciousness of this composition recall Song prototypes and stand in marked contrast to *Remonstrating with the Emperor*, which exhibits a compositional density and schematization that typify works of the Ming Academy at the end of the fifteenth century.

Drunken Immortal beneath an Old Tree

During the first half of the Ming dynasty, the principal patron of professional artists was the court, but by the end of the fifteenth century imperial patronage had declined and professional artists turned increasingly to private sponsors and to the marketplace as outlets for their art. While court painters favored a meticulous, representational style appropriate to the didactic, symbolic, and decorative functions of their commissions, artists working outside the strictures of court dictates favored bravura execution to give their images fresh appeal. Artists such as Wu Wei (1459–1508), Guo Xu (1456–1532), and Zhang Lu (ca. 1490–ca. 1563) approached painting as a kind of performance art.[104] Working in an idiom of bold monochrome brushwork and graded ink washes first employed by Chan Buddhist monk-artists during the Southern Song period, they made compositions with dazzling virtuosity, often before astonished onlookers. Although such artists were later loosely identified as belonging to the Zhe school, so named for the stylistic roots of this art in the Southern Song academic idioms that continued to be practiced around Hangzhou in Zhejiang Province, this tradition also thrived in the secondary Ming capital of Nanjing and in the southeastern provinces of Jiangxi, Fujian, and Guangdong, where artists produced work both for local patrons and for the lively maritime trade in painting that existed with Korea and Japan.

Chen Zihe (active late 15th–early 16th century) was a significant regional master in this tradition, a painter who came from the city of Pucheng in the northwest corner of Fujian, where it abuts Zhejiang and Jiangxi.[105] The earliest account of his work appears in a brief biographical notice in He Qiaoyuan's *Minshu* (History of Fujian), of 1629: "Chen Zihe excelled at figure painting. His brush ideas are free and untrammeled and

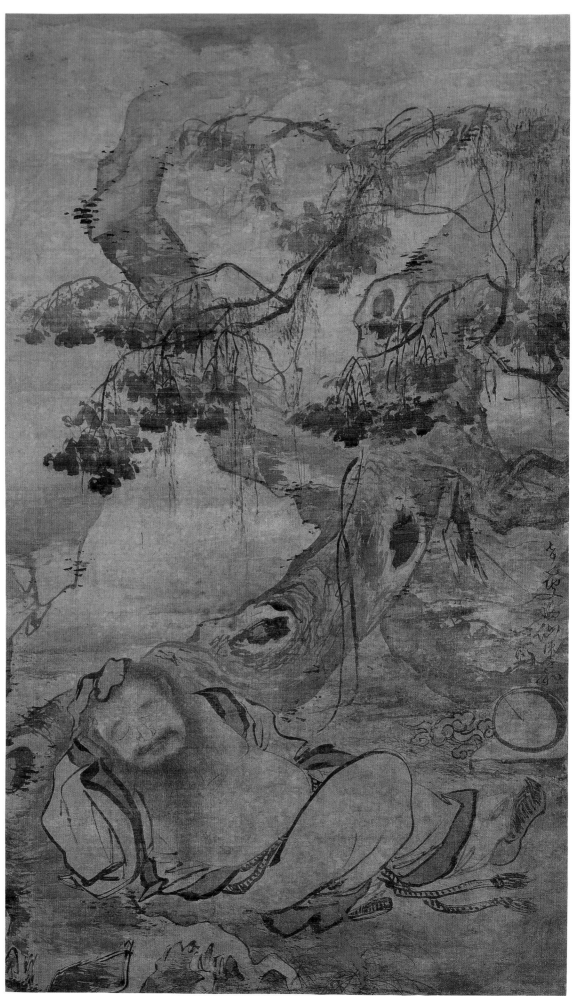

Plate 11. Chen Zihe (active late 15th–early 16th century), *Drunken Immortal beneath an Old Tree*. Hanging scroll, ink and color on silk, 68¾ x 40⅜ in. (174.5 x 102.5 cm). The Metropolitan Museum of Art. Ex. coll.: C. C. Wang Family, Promised Gift of the Oscar L. Tang Family

he called himself the Uninhibited Immortal [Saxian]. His cliffs and trees are strange and richly antique. Critics consider him to be on a par with Wu Wei and Guo Xu."[106] Zhu Mouyin, writing in the *Huashi huiyao* (Outline History of Painting; preface dated 1631,) adds that Chen began his artistic career as a sculptor, but when he took up painting his "figural ink renderings were filled with the spirit of the immortals."[107] Shih Shou-chien suggests that Chen's bold ink-wash style derives in part from a local tradition connected to the Daoist centers of Mount Longhu and Mount Wudang—the latter only forty miles from Chen's hometown—that favored ink-wash images executed in spontaneous brushwork. According to Shih, in Fujian this style overshadowed the literati traditions of the Jiangsu region through the mid-sixteenth century, which helps explain Chen's subject matter and stylistic choices.[108] In choosing his sobriquet, Uninhibited Immortal, Chen consciously linked his personality to that of another Daoist painter, Wu Wei, known as the Little Immortal, and to Guo Xu, who called himself the Pure Madman.[109] Chen's affinities to Guo Xu may also be an outgrowth of a common regional background: Guo Xu's hometown of Taihe, Jiangxi Province, is not far from Chen Zihe's home in Pucheng. In his seventies, Chen began to proudly proclaim his age on his paintings. From these signatures we know that he was still painting at the age of eighty-three.

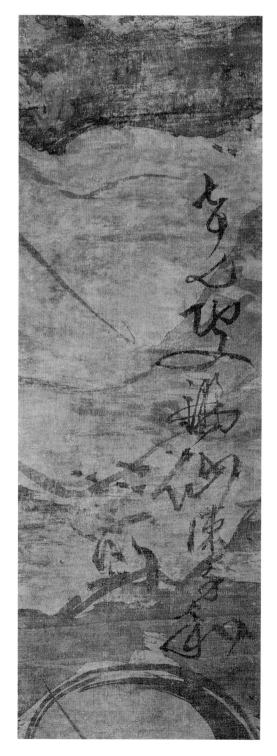

None of Chen's extant paintings are dated, but a tentative sequence of his paintings is suggested by the changing way in which he signed his works and by the parallel changes in his painting style from a more meticulous manner to a looser, more spontaneous one. Chen's most detailed, and therefore probably his earliest, works follow a style closely modeled on that of Lin Liang, one of the leading masters of flower-and-bird painting in the Ming Academy (fig. 86, page 138). These carefully executed flower-and-bird paintings bear only one artist's seal or the modest signature "Zihe."[110] In the 1490s, after Lin Liang had died and Wu Wei and Guo Xu had become the new artistic trendsetters, Chen's work underwent a noticeable shift that is paralleled by a change in the way he signed his paintings: "Sketched by Chen Zihe" or "Uninhibited Immortal."[111] While he continued to produce flower-and-bird compositions during this period, Chen also pursued a varied repertoire of ambitious figural compositions. In both genres the work shows a bolder conception and brush style, indebted to the spontaneity and bravura execution of Wu and Guo. Chen's signature also becomes more prominent and more flamboyant. In his later years, between the ages of seventy and eighty-three, the compositions become even simpler and freer, the brushwork is at its most unrestrained, and the signatures are highly conspicuous as Chen confidently declares his age in a dashing cursive script (pl. 11a).[112]

Drunken Immortal beneath an Old Tree (pl. 11), a humorous and somewhat provocative image, exemplifies Chen's late style. The painting presents a sleeping, bearded man, his robe loosened to reveal an ample belly, lean-

ing against the trunk of a large tree. The clawlike root of the massive trunk and some wisps of grass establish a token separation between the viewer and the picture space. In the distance, a cliff drawn in pale ink tones frames a receding shoreline, an image that perhaps suggests a grotto opening onto a Daoist paradise or cave heaven.[113] A sundial and a magic fungus at the right allude to the passing of time and immortality. The work is signed in bold cursive script, "Sketched by the seventy-seven-year-old Uninhibited Immortal Chen Zihe." The painting exhibits all the key conventions of Chen's craft. The shallow picture space and tight composition are constructed of powerful diagonals that intensify the dramatic focus, and highly animated brushwork offers a lively counterpoint to the massive scale of the picture elements, many of which are truncated by the picture frame, another focusing device.

Much admired by his contemporaries, Chen's style was also appreciated in Japan, where most of his extant works have been preserved. By the end of the sixteenth century, however, Chen's spontaneous ink-wash manner had begun to decline in popularity in China, disparaged by such critics as Xiang Yuanbian (1525–1596) and He Liangjun (1506–1573), who castigated professional artists working in the late Zhe school manner as "wild and heterodox."[114] In contrast to the earlier, more conservative masters who had found employment at court, these painters were seen as decadent, having willfully perverted inherited traditions. In part, this criticism was motivated by the attempt of the literati elite to defend itself against the incursions of the new monied class and an art form that it viewed as synonymous with crass bourgeois taste; and in part, it was justified by a real decline in the quality of the work. Many lesser masters working in the Zhe school idiom used bravura brushwork at the expense of descriptive function, enlivening their images through stylistic extremism.

But embedded in the "wild and heterodox" art of men like Guo Xu and Chen Zihe were the seeds of a new artistic independence. Heretofore, professional painters had serviced either the court or the growing urban class with a stock group of conventional images—subjects appropriate for auspicious events such as birthdays or weddings, escapist visions of scholars dwelling in retirement, or fishermen and woodcutters living in the wilderness. The uninhibited figure in *Drunken Immortal beneath an Old Tree* reflects a new disregard for social conventions. Does the sleeping figure offer commentary on the artist or his patrons? The sardonic nature of the subject perhaps implies a subversive element of rebellious individualism, criticism aimed at the very literati who disapproved most strongly of this kind of art and the merchant class with which it was associated. Social commentaries of this nature are rare in sixteenth-century painting, becoming more common by the early seventeenth century in the work of professional artists such as Ding Yunpeng (1547–ca. 1621), Wu Bin (active ca. 1583–1626), and Chen Hongshou (1598–1652). Chen Zihe's painting is an important early precursor of this new artistic genre. Such defiantly rebellious and individualistic images also provide the context for a new form of protest art that developed in the later seventeenth century, after the Ming dynasty was vanquished by the Manchus.

In 1644 the Ming capital, Beijing, fell to rebels and the Manchus, a nomadic people from the frontier lands of the northeast, seized the opportunity to invade China, establishing the Qing dynasty, which survived until the founding of the Republic of China in 1911. Combining their native skills as warriors with Chinese techniques of administration, the new Manchu regime gradually softened its early policy of intimidation with a concerted effort at accommodation, winning Chinese allegiance by adopting much of the Ming bureaucratic structure and espousing Confucian ideals of government. The suppression of civil uprisings and the integration of Ming loyalists were not, however, achieved for two generations, and it was not until the Kangxi emperor (r. 1662–1722) assumed the throne that peace was reestablished.

The Manchu conquest instigated a period of traumatic change in the arts, when established patterns of culture were threatened. Ming loyalists, disillusioned by the failure of traditional Confucian values to keep corruption at bay, sought refuge in the anonymity of the Buddhist church or withdrew to the countryside to escape persecution. With time to pursue more solitary and personal interests, and working in isolation far from the traditional centers of culture, they found renewed meaning in the landscape, transforming images of precipitous cliffs or craggy pine trees into symbols of personal survival.

Bada Shanren (1626–1705), born Zhu Da, in Nanchang, Jiangxi Province, was raised in an environment of cultivation and privilege.[115] Educated for a career in government, he passed the first-level civil service examination in the early 1640s, shortly before the Manchu conquest thwarted all hope of an official appointment. Taking refuge in a Buddhist temple and adopting the religious name Chuanqi as a means of disguising his identity as a member of the Ming imperial family, Bada became a disciple of Chan Buddhism and earned a reputation as a distinguished teacher. In 1672, he was appointed abbot of a local temple, but toward the end of the 1670s he began to show signs of mental instability, possibly feigned. About 1680, he renounced his status as a monk, returned to Nanchang, and was briefly married. After suffering from an emotional breakdown, he began to produce paintings and calligraphy as a means of supporting himself, and in 1684 he took the *biehao*, or artistic name, Bada Shanren (Mountain Man of the Eight Greats). A staunch Ming loyalist throughout his life, Bada used painting as a means of protest. His is the poignant voice of the *yimin*, the leftover subjects of the fallen dynasty.

Two Eagles (pl. 12), a large hanging scroll painted in 1702, when Bada was seventy-six years old, is a heroic image of defiance. The two proud birds, each on a separate boulder, face in different directions, like vigilant sentries surveying their domain. One eagle peers to the left as if to fix some invisible intruder in its gaze; the other cranes its neck upward, its regal bearing suggesting the commanding presence of a monarch. Aside from the boulders and a tree that stands largely outside the picture frame, there is no other indication of a setting. Occupying the craggy summit of their world, the birds stand forth in solitary splendor, silhouetted against the sky.

Figure 84. Bada Shanren (1626–1705), *Two Eagles*, dated 1699. Hanging scroll, ink on paper, 35¾ x 28⅝ in. (90.8 x 72.7 cm). Shanghai Museum

Figure 85. Bada Shanren (1626–1705), *Eagle*, ca. 1700–1701. Hanging scroll, ink on paper, 73½ x 34⅞ in. (186.6 x 88.5 cm). Shanghai Museum

Bada often painted series of images that employ the same motif. *Two Eagles* is closely related to two very similar works. The earliest, dated 1699 (fig. 84), depicts two eagles in nearly the same positions seen here, but within a more complex landscape setting. Another, undated image of a solitary bird probably painted about 1700–1701 (fig. 85) shows the same majestic bird seen in *Two Eagles*. In both earlier images, the silhouette of the bird is interrupted by groundlines or by intrusive branches that diminish the impact of the eagle's form. In the 1702 composition these elements are separated, liberating the silhouette and lending grandeur to the image.

In contrast to Bada's earlier images of small, vulnerable birds huddled close to the earth, often threatened by a precarious overhang or half-hidden beneath a tree or lotus, these birds seem almost aggressive in their self-assured independence. After decades of concealing his identity as a member of the Ming royal house, Bada in these depictions of eagles seems to declare his defiance of Manchu Qing rule. Richard Barnhart detects in the eagles' proud stance and glaring eyes a return to the angry, brooding images that Bada had made a decade earlier and suggests that the impetus for its creation was the third southern inspection tour of the Kangxi emperor in 1699.[116]

Plate 12 (opposite). Bada Shanren (1626–1705), *Two Eagles*, dated 1702. Hanging scroll, ink on paper, 73 x 35⁷⁄₁₆ in. (185.4 x 90 cm). The Metropolitan Museum of Art. Ex. coll.: C. C. Wang Family, Lent by Oscar L. Tang

137

Figure 86. Lin Liang (ca. 1430–ca. 1490), *Two Hawks in a Thicket*. Hanging scroll, ink and color on silk, 58⅝ x 33⅛ in. (149 x 84 cm). The Metropolitan Museum of Art. Gift of the Bei Shan Tang Foundation, 1993 (1993.385)

Figure 87. Qi Baishi (1863–1957), *Eagle in a Pine*, late 1930s. Hanging scroll, ink on paper, 68⅛ x 21½ in. (173 x 52.1 cm). The Metropolitan Museum of Art. Gift of Robert Hatfield Ellsworth, in memory of La Ferne Hatfield Ellsworth, 1986 (1986.267.216)

Significantly, the immediate sources of Bada's imagery are the powerful representations of eagles and hawks created for the Ming court, in particular the dashing monochrome works of Lin Liang (fig. 86) and Chen Zihe. Under the Ming, heroic images of eagles were emblems of strength and courage and often presented on celebratory occasions to military officials. Bada personalized this imagery, transforming the conventional symbolism into an expression of confrontation and loyalty, his noble birds standing sentinel over a land now occupied by foreign conquerors.

In addition to drawing inspiration from Ming sources, the bold brushwork and carefully crafted geometry of Bada's composition reflect his understanding of Zhe school conventions. Bada embraced the schematic qualities of late Zhe school art,

organizing flattened motifs into interlocking patterns that create unsettling ambiguities of positive and negative, mass and void. Compared with Lin Liang's depictions of eagles, in which the twisting poses of the birds and layered bamboo and tree branches create a shallow space, Bada treats his image as a calligraphic design, setting the birds against the blank paper with almost no overlapping of forms and no suggestion of atmosphere. In his radically minimal brushwork, every nuance and gesture is deliberate and significant. The bravura brushwork is also natural and unforced. Bada painted *Two Eagles* when he was the same age (by Chinese count) as Chen Zihe when the latter painted *Drunken Immortal* (pl. 11). Bada shows the same combination of bold brushwork and easy assurance that marks a total confidence in his craft.

Throughout his life Bada remained unbroken by the Manchus and immune to the blandishments that attracted his cousin Shitao (1642–1707) to Beijing.[117] Ironically, it was the Manchus' very success at subduing and winning over the vast majority of Chinese that enabled them to tolerate the kind of lingering protest to their rule that Bada represented. His achievement became over time a paradigm for many later artists. If Dong Yuan's scholar-recluse represents one image of the scholar in retreat from political discord, Bada's eagle came to represent another, more defiant stand. In the early twentieth century, the artist Qi Baishi (1863–1957) drew on Bada's imagery in his *Eagle in a Pine* (fig. 87), a work painted sometime in the late 1930s. Against the advice of his friends, Qi stayed in Beijing when the Japanese invaded China in 1931, being, as he wrote in his diary, too old to flee either with ease or by stealth. Qi's eagle conveys the artist's own resistance. Borrowing lines from the eighth-century poet Du Fu, Qi's poem, inscribed at right, gives the image an ambiguous twist:

> *Why attack ordinary birds,*
> *Spraying blood and feathers on the ground?*[118]

Whether Qi's eagle personifies artist or aggressor, its symbolic role follows unmistakably in the tradition of Bada Shanren, whose art, like that of Dong Yuan and indeed all the artists here represented, served as a vehicle for political comment and self-expression.

1. For the royal patrons of the Southern Tang, see the series of articles by Ch'en Pao-chen (1995–98).

2. Since the Zhou dynasty two first-magnitude stars, Vega and Altair, situated at either end of the Milky Way, have been identified as the Herdboy (Niulang) and the Weaving Maid (Zhinü). Under the reign of Emperor Han Wudi (r. 140–87 B.C.) a section of Shanglin Park was excavated to form Kunming Lake, which was compared to the Milky Way, and stone statues of the Herdboy and Weaving Maid were erected on either side. See Ban Gu (A.D. 32–92), "Xidu fu" (Western Capital Rhapsody), in Xiao Tong (501–531), *Wen Xuan* (Literary Selections), 1974, p. 17.

3. I am indebted to the essay by He Qi for the identification of the painting's subject; see He Qi 1988, p. 4. For a thirteenth-century account of this festival, see Zhou Mi, *Wulin jiushi* (Old Tales of Hangzhou; ca. 1280), *juan* 3, pp. 10–11; reprinted in *Wenyuange Siku quanshu* 1986, vol. 590, pp. 202–3.

4. See Wu Hung 1996.

5. After the translation by Witter Bynner in Birch 1965, pp. 266–69. For the original text, see Zhu Jincheng 1988, vol. 2, pp. 659–81.

6. One possible interpretation of the painting is that it is a copy based on a Tang model. Zhang

Xuan (active ca. 714–42), a noted painter of palace scenes, for example, is recorded to have done a painting entitled *Entreating Skills Festival in the Palace*. The *Xuanhe huapu* (Catalogue of the Imperial Painting Collection during the Xuanhe Era; preface dated 1120) lists a three-panel composition with a very similar title, *Gentle Ladies Entreating Skills on the Seventh Evening*. Both references come from the *Xuanhe huapu*, in *Huashi congshu* 1963, vol. 2, pp. 55–56.

7. For a similar railing preserved in a Sui altarpiece dated 584, see *China, 5000 Years*, 1998, pl. 160. For a high Tang example seen in a reliquary from the Guangshan Temple in Lintong, Shaanxi, see Han Wei 1989, colorpl. 2.

8. Whitfield (1998) dates *Going Up the River* to the eleventh century.

9. The architectural historian Fu Xinian has expressed the opinion (private correspondence) that the painting could be a Northern Song copy of a tenth-century composition.

10. See Munakata 1974.

11. Textual sources give two different ways of writing the character "Yuan" of Dong Yuan's given name: 源 and 元; see *Zhongguo meishujia renming cidian* 1981, pp. 1238–39. The signature on *Riverbank* appears to read 元. Early records cite Zhongling as his place of birth, but its location, usually associated with the vicinity of Nanjing, the site of the Southern Tang capital, is contradicted by the *Zhongguo meishujia renming cidian* (ibid., p. 1238), which identifies Zhongling as a town on the south shores of Lake Boyang in Jinxian, Jiangxi Province. Dong's date of death is uncertain. Bian Yongyu (1645–1712), in an unpublished history, "Shigutang shuhuaishi" (History of Calligraphy and Painting from the Shigu Hall), states that Dong died in 962. See Barnhart 1970, p. 22, n. 37; and J. D. Chen 1956, pp. 21–23.

12. See Guo Ruoxu in Soper 1951, p. 46; Shen Gua (1031–1095), *Mengqi bitan* (Notes Written at Mengqi), as cited in Chen Gaohua 1984, p. 28.

13. See Guo Ruoxu in Soper 1951, p. 101. Loehr (1980, p. 110) mentions another commission, about 937, when Dong was ordered to make a painting of Mount Lu, the great peak just upriver from the Southern Tang capital at Nanjing, but I have not found the source of this information.

14. For Li Yu, see Ch'en Pao-chen 1997 and 1998.

15. Guo Ruoxu in Soper 1951, p. 46.

16. See Loehr 1980, p. 113.

17. See Archaeological Team of the Liaoning Provincial Museum 1975; and Yang Renkai 1975.

18. This sequence is also described in Shih Shou-chien 1997, pp. 82–87.

19. The dense foliage of the trees indicates that the season is autumn rather than early spring. Thus, the plowman must have been tilling the field after the fall harvest.

20. The widespread use of chairs began in the tenth century; see Handler 1991. The tall hat worn by the master is most often dated to the eleventh century, when such headgear became known as a Dongpo hat because of its association with the poet Su Shi (Su Dongpo; 1037–1101). See, for example, *Portrait of Bi Shichang*, dated 1056, and *The Classic of Filial Piety*, ca. 1086, by Li Gonglin (ca. 1041–1106); Fong 1992, pls. 7, 8c. Nevertheless, versions of this hat already appear in a mid-tenth-century landscape excavated from a Liao tomb (fig. 14, page 20) as well as in two compositions associated with the Southern Tang dynasty: *The Night Entertainment of Han Xizai* (fig. 59), by Gu Hongzhong, and *Playing Weiqi*, attributed to Zhou Wenzhu. For *Night Entertainment*, which may be a Song copy of Gu's composition, see Wu Hung 1996, pls. 19–22. *Playing Weiqi* survives in several later versions; for the example now in the Freer Gallery of Art, Washington, D. C., see Lawton 1973, no. 3.

21. See Liu 1997 for a discussion and dating of these two paintings and related works. For a new dating of *Going up the River at the Qingming Festival*, see Whitfield 1998.

22. The painting, which retains its original early-twelfth-century mounting—complete with the yellow brocade borders, imperial seals, and title-strip of Emperor Huizong (r. 1101–25)—is the most securely documented work to survive from this era. For a discussion of Huizong's system of mounting and affixing seals, see Barnhart (1983) 1984, pp. 61–63. It is Huizong's titlestrip that supports an attribution of the painting to Wei Xian. For a discussion of the original six-panel format and iconography of this painting, see DeBevoise 1982.

23. See K. Yang 1998.

24. For a discussion of the change in household furnishings that occurred in China around the tenth century, see Handler 1991. For a rare Tang-dynasty depiction of a secular figure seated in a chair, see He Zicheng 1959, p. 33.

25. The title of this painting and its attribution to Zhao Gan come from an inscription along the right edge of the painting attributed to Li Yu,

the last Southern Tang ruler: "'First Snow along the River,' by Zhao Gan, a student at the Painting Academy." See Guo Ruoxu in Soper 1951, pp. 69, 185 n. 573; and Hay 1972.

26. For the lore of the Tiantai Mountains, see Fong 1956 and Fong 1958.

27. The earliest version of this story, attributed to the fourth-century writer Liu Yiqing, is preserved in the tenth-century Daoist anthology *Taiping yulan* (Li Fang et al. 1960, *juan* 41, pp. 194–95). The text inscribed on the painting is much wordier than the *Taiping yulan* version and also differs in several factual details. The *Taiping yulan* version, for example, states that Liu and Ruan entered the Tiantai Mountains in the fifth year of Han Mingdi's Yongping reign era (A.D. 62); in the painting's text, the date is given as the fifteenth year, and the reign name, Yongping, is transcribed incorrectly as "Yongan."

28. The *ruanqin*, or *ruanxian*, is a four-stringed instrument that originated in the Han dynasty. This same instrument also appears in *Whiling Away the Summer*, a short handscroll by Liu Guandao (active ca. 1279–1300) now in the Nelson-Atkins Museum of Art, Kansas City (*Eight Dynasties* 1980, no. 92).

29. For biographical information on Hua Youwu, see *Mingren zhuanji ziliao suoyin*, p. 671, where Hua's date of death is given as 1375. This date is contradicted both by this colophon, which is dated 1379, and by Yao Guangxiao's colophon of 1386, in which he mentions spending two weeks with Hua.

30. For Zhao Mengjian and Zhao Mengfu, see Fong 1992, pp. 302–9, 421–27, 432–42.

31. For a biography of Yao, see *Dictionary of Ming Biography* 1976, pp. 1561–65.

32. Because Hua Youwu's colophon is dated four years after the recorded date of his death and because Yao Guangxiao's colophon does not match other examples of his writing, it is possible that the colophons now attached to the painting are copies with spurious dates added, the originals having been transferred to another work of art. Dated examples of Yao's writing include: a colophon, dated 1394, to Deng Wenyuan's (1259–1328) transcription of the *Jijiuzhang* in the Palace Museum, Beijing (*Gugong bowuyuan cang lidai fashu xuanji, dierji* 1977, fasc. 13); a colophon, dated 1403, to Zhao Mengfu's (1254–1322) transcription of the *Jijiuzhang* in the Liaoning Provincial Museum (*Liaoning sheng bowuguan cang fashu xuanji* 1962, fasc. 15); and a

colophon, dated 1416, to the *Five Old Men of Suiyang*, in The Metropolitan Museum of Art (17.136). I am indebted to Joseph Chang, Associate Curator of Chinese Art at the Freer Gallery of Art, for these references.

33. A similar geometric purity of line is seen in Zhao's *Groom and Horse* of 1296, now in the Metropolitan Museum (Fong 1992, pl. 100).

34. For a discussion of Fanlong's painting, see Lawton 1973, no. 20. For the *Odes of the State of Bin*, see Fong 1992, pl. 30. Another Song monochrome drawing of the *Odes of Bin* theme is also illustrated and discussed in Lawton 1973, no. 6.

35. For a discussion of Wen Tong's painting and the development of scholar painting in the eleventh century, see Fong, Watt, et al. 1996, pp. 151–52.

36. For a further discussion of this theme, see Li Lin-ts'an 1970, pp. 8–11; and Barnhart 1972.

37. For biographical information, see Cahill 1958; Cahill 1976, pp. 68–74; and Fong, Watt, et al. 1996, pp. 306–11.

38. For other translations of this poem, see Cahill 1958 or Sungmii Lee Han 1983.

39. For a full discussion of Su Wu and his significance to the Yuan artists, particularly Zhao Mengfu, see Chu-tsing Li 1968.

40. For an example of Huaisu's cursive script, see Fong, Watt, et al. 1996, pl. 56.

41. This technique corresponds to Mi Fu's (1052–1107) observation that Wen Tong "used the darkest tones in leaves in the foreground and lighter, more diluted ink on the leaves in the background." See Sirén 1956–58, vol. 2, p. 15.

42. For the two later inscriptions on this painting, see Fong, Watt, et al. 1996, p. 280.

43. For a fuller discussion of *Crooked Pine*, see Fong 1992, pp. 46–49.

44. For a translation, see Cahill 1958, p. 221.

45. See Franke 1953.

46. For the role of Yu Ji (1272–1348), another southern Chinese scholar at the Mongol court, see Langlois 1978.

47. For biographical information on Ke Jiusi, see Zong 1985; see also Cleaves 1957 and Harrist, Fong, et al. 1999, pp. 289–93.

48. See Chiang I-han 1981; also Langlois 1978, esp. pp. 105–9.

49. For a discussion and translation of Ke's poems written in this vein, see Cleaves 1957.

50. For an account of works in Wenzong's collection, see Yoshikawa 1969; also Fu Shen 1981.

51. After Cleaves 1957, pp. 408–9, n. 115.

52. See ibid., pp. 408–9. Among others, Ke associated with Huang Gongwang (1269–1354), Zhang Zhu (1279–1368), Zhang Yu (1283–1350), Zheng Yuanyou (1292–1364), Zhu Derun (1294–1365), Yang Weizhen (1296–1370), and Ni Zan (1306–1374). For a discussion of the life-style and literary pursuits of one of Ke's friends and patrons, Gu Ying (Gu Dehui; 1310–1369), see Sensabaugh 1981.

53. See Cahill 1980, pp. 290–92.

54. For a translation of Ke Qian's preface, see White 1939, pp. 17–19. For biographical information about Li Kan, see Chang Kuang-pin 1979; also "Li Kan," in Chen Gaohua 1980, pp. 100–121; and Kao Mu-sen 1981. For an example of Li's monochrome painting of bamboo on silk, see Fong, Watt, et al. 1996, pl. 145; for his album of bamboo, see Cahill 1958, pp. 139–53.

55. For Su Shi's praise of Wen Tong's bamboo painting, see Fong, Watt, et al. 1996, pp. 151–52.

56. The restoration work took place in 1337; see Zong 1985, p. 241. For the painting done for Ni Zan, see ibid., pp. 52, 58.

57. Xu Xian, "Baishi jizhuan," translation adapted from Cleaves 1957, pp. 412–13. Ke's thoughts on painting bamboo were apparently inscribed on one of his undated paintings by Zhao Mengfu, probably in 1319, when Ke was in the capital; see Zong 1985, p. 228.

58. For an example of Ke's standard script writing and a discussion of his calligraphic style, see Harrist, Fong, et al. 1999, pp. 132–35, 289–93. See also Fu Shen et al. 1977, pp. 142, 170–71, 255–56.

59. An analogous comparison may be made between a small horizontal painting attributed to Wen Tong and a composition by Ke Jiusi that was inspired by it and mounted together in the same handscroll, now in the Shanghai Museum. See Xia Yusheng 1965, pl. 4 and fig. 2.

60. Ke must have made many free copies of Wen Tong compositions. His "copy of an ink-play of the Master of the Stone Studio [Wen Tong]," now in the N. P. Wong Family Collection, is more elaborate in its rendering of the bamboo, but it shows the same simplified and abstracted treatment as *Bamboo after Wen Tong*. See Barnhart et al. 1994, appendix p. 276, pl. 1.

61. See Reischauer and Fairbank 1960, esp. p. 294.

62. See Vinograd 1981.

63. See Chen Gaohua 1980, pp. 434–35. Among Zhang's acquaintances were Zheng Yuanyou (1292–1364), Yang Weizhen (1296–1370), Ni Zan (1306–1374), Gu Ying (1310–1369), and Yuan Hua (1316–after 1376).

64. These comments are from Gu Ying and Xia Wenyan, respectively; ibid., p. 434.

65. From Zhang Shen's colophon; see note 66 below. A copy of this painting appeared at the auction of the estate of C. T. Loo; see *Chinese Art from the Estate of the Late C. T. Loo*, Parke-Bernet Galleries, New York, sale cat., October 10, 11, 1962, lot 416.

66. Zhang Shen's colophon reads, in part: "From the Tang dynasty [painter] Wang Mojie [Wang Wei; 701–761] the outline bamboo method was transmitted to the Jiangnan region, but most painters followed the styles of masters from Shu [i.e., Sichuan], thus Huang Quan [903–968] and his son [Huang Jucai; 933–after 993] both became famous during their time. In our present dynasty, beginning with Huanghua Laoren [Wang Tingyun; 1151–1202], there were Gao Kegong [1248–1310], the two Li of Jiqiu [Li Kan, 1245–1320, and Li Shixing, 1282–1328] and the Lord of Wei, Zhao [Zhao Mengfu; 1254–1322] of Wuxing; all worked in the monochrome bamboo method and the outline method was nearly lost. When I came to Wu, I saw the outline style of Zhang Zhongmin [Zhang Xun], who had thoroughly captured the lingering ideas of Wang Wei. In this scroll, done for his friend Wang Boshi, here and there he has also captured the manner of Dong Beiyuan [Dong Yuan; active 930s–60s] in the pines, rocks, and earthen hummocks. The painting is truly marvelous." See Bian Yongyu, *Shigutang shuhua huikao, juan* 48, pp. 26b–27a; see also Zhu Cunli (1444–1513) [Zhao Qimei; 1563–1624], ed., *Tiewang shanhu* (Coral Treasures in an Iron Net; postscript dated 1600), *juan* 4, p. 14b.

67. This colophon, dated 1362, is partially recorded in Chen Gaohua 1980, p. 434. For the full text, see Bian Yongyu, *Shigutang shuhua huikao, juan* 48, p. 26a, b; see also Zhu Cunli, *Tiewang shanhu, juan* 4, p. 14b.

68. That Zhang and Li were friends is supported by their adjacent colophons appended to a rubbing of Wang Xizhi's (ca. 303–ca. 361) *Preface to the Orchid Pavilion*. Seventeen Yuan scholars added colophons to this rubbing. The twelfth, Ting Jun (1299–1368), dated his inscription the fourth lunar month of 1347. Li Zuan and Zhang Xun are the fourteenth and fifteenth colophon writers. All three note that the rubbing was owned by a Wu Jingwen. See Christie's, New York, sale cat., September 18, 1996, lot 56.

69. The Ruoye Stream lies at the foot of Mount Ruoye in Shaoxing Xian, Zhejiang. The Cloud

Gate Temple is on Ruoye Stream. The last two lines of Ni Zan's poem paraphrase lines from "Song offered to district defender Liu for his newly painted landscape screen," a poem by Du Fu (712–770), who wonders in the poem when he will again visit such scenic spots; see Xiao Difei 1979, pp. 47–49. For translations of Du Fu's poem, see Underwood 1929, p. 97; and McClelland 1936, p. 59. I am indebted to Yiguo Zhang, Research Associate in the Department of Asian Art at the Metropolitan Museum, for this reference.

70. For Ni Zan's use of trees as symbols of himself and his friends, see Fong 1992, p. 483, fig. 196; and Fong et al. 1984, pp. 118–20.

71. For a discussion of the Yuan revival of the Li–Guo style, see Shih Shou-chien 1991. For other treatments of this revival, see Chu-tsing Li 1969 and 1970.

72. For discussions of Zhao Mengfu's works in the Li–Guo tradition, see Chu-tsing Li 1965; Suzuki 1968; Barnhart 1972; and Vinograd 1978.

73. For a fuller discussion of these paintings, see Fong 1992, pp. 93–97, pl. 11, and pp. 436–41, pl. 101.

74. For Tang Di, see Fong, Watt, et al. 1996, pp. 285–88; for Cao Zhibo, see Chu-tsing Li 1960.

75. Little evidence exists for Yao's dates. Yao was a friend of Yang Weizhen (1296–1370) and grouped by the biographer Xia Wenyan together with Meng Yujian (active ca. 1325–53) and Wu Tinghui; see Xia Wenyan, *Tuhui baojian* (Precious Mirror of Painting; preface dated 1365), in *Huashi congshu* 1963, vol. 2, juan 5, p. 133.

76. Barnhart 1977.

77. Shih Shou-chien 1991.

78. For *Winter Landscape*, see Wu Tung 1997, no. 128; also Tomita and Hsien 1961, pl. 15; for *Fisherman in a Wintry Riverscape*, see *Zhongguo meishu quanji: Huihua bian 5, Yuandai huihua* 1989, no. 91; for *Leisure Enough to Spare*, see *Eight Dynasties* 1980, no. 112. All three works are reproduced in Barnhart 1977.

79. This attribution was first made in Barnhart 1977. For an earlier interpretation of the painting as a work by Yang Weizhen, see Fu Shen 1973.

80. See Vinograd 1982.

81. See *Eight Dynasties* 1980, no. 122.

82. The absence of a signature or seals is a common problem with early paintings, from which the artist's signature and seals were often removed by unscrupulous owners who sought to reattribute the works to earlier masters. It is also possible that Yao painted the work for a patron who did not wish the artist to add his name.

83. For a discussion of Tang Di's painting and its relationship to Guo Xi, see Fong, Watt, et al. 1996, pp. 286–88.

84. For Wang Meng, see Chang Kuang-pin 1975, nos. 401–12, English text, pp. 33–38, Chinese text, pp. 27–32, 91–205; Cahill 1976, pp. 120–27; and Vinograd 1979b.

85. Wang Guoqi acquired an album of landscapes from Wu Zhen in 1351; see Chang Kuang-pin 1975, p. 22.

86. The closeness of the Wang and Zhao families is evidenced by the fact that Wang's father inscribed Zhao Yong's *Noble Steeds*, while Wang's own *Dwelling in the Qingbian Mountains* was probably done for Zhao Lin. See Silbergeld 1985; and Vinograd 1982.

87. This decision was profoundly disillusioning to Wang Meng. In 1364, Wang made a painting of bamboo and rock for Zhang Deqi in which he included four poems whose veiled imagery clearly points to the disastrous consequences of Zhang Shicheng's unrestrained ambitions. See Vinograd 1979b, pp. 100–105. Zhang Deqi and his brother Zhang Dechang were sons of the well-known scholar Zhang Qian (1281–1370).

88. For the Yuan revival of tenth-century models, see Vinograd 1981.

89. See Mu Yiqin 1985, pp. 45–48; Rogers 1988, pp. 116–17; Barnhart et al. 1993, pp. 203–18; and Sung 1993.

90. For Yuan Zhongche, see *Dictionary of Ming Biography* 1976, pp. 1629–32.

91. See Barnhart et al. 1993, p. 205.

92. Translation after Rogers 1988, p. 116; from He Qiaoyuan, *Mingshan cang* (Collection of Famous Mountains), Ming ed., as cited in Mu Yiqin 1985, p. 46.

93. Translation after Sung 1993, p. 5, from Xu Xin, *Minghualu*, juan 6, p. 77; see also He Qiaoyuan, *Mingshan cang*, in Mu Yiqin 1985, p. 46.

94. Translation from Rogers 1988, p. 116; from *Yin-xian zhi* (Gazetteer of Yin County), juan 45, as cited in Mu Yiqin 1985, p. 48.

95. Translation after Rogers 1988, p. 116; from *Yin-xian zhi*, juan 18, as cited in Mu Yiqin 1985, p. 46.

96. See Bai 1999.

97. The depiction of mandarin ducks, often conjoined with flowering peonies, is a decorative motif that dates back to at least the eighth century in China, when the birds appear on silver wine cups. See Lu Jiagao and Han Wei 1985, pls. 124, 139.

98. I am indebted to Professor Charles Hartman, State University of New York at Albany, for this interpretation (personal correspondence).

99. For illustration and discussion of all four scrolls, see Barnhart et al. 1993, pp. 209–10, figs. 125a–d.

100. For Yin Hong and Xiao Zeng, see ibid., nos. 61, 62; for Lü Tang, see Mu Yiqin 1983, pl. 42.

101. Shen Zhou inscribed this observation on a painting by Lü Ji now in the National Palace Museum, Taipei. See *Gugong shuhua tulu* 1989–, vol. 7, pp. 173–74.

102. For a fuller treatment of this painting and a related composition, *Declining the Seat*, see Fong, Watt, et al. 1996, pp. 174–77.

103. For Liu Jun, see Mu Yiqin 1995, pp. 34, 235–36; and Barnhart et al. 1993, pp. 91–92, 115–17.

104. For a discussion of these artists, see Cahill 1978, pp. 97–154; Rogers 1988, nos. 7, 8, 13; and Barnhart et al. 1993, pp. 223–49, 299–331.

105. For Chen Zihe, see Shih Shou-chien 1995; see also Minato 1980; and Mu Yiqin 1985, pp. 82, 329. Suzuki has attributed to Chen Zihe an unsigned painting in the Freer Gallery of Art, Washington, D. C., that bears the seal of Yuan Zhongche (1376–1458), the imperial physiognomist who also patronized Lü Ji. If this attribution is correct it would clarify Chen's period of activity. Presuming that Yuan added his seal in the last years of his life and that Chen was then a young painter in his twenties, Chen's dates would be about 1430 to 1515. But Joseph Chang, Associate Curator of Chinese Art at the Freer Gallery, reports (personal communication) that the Yuan Zhongche seal looks questionable and that the painting, while in the idiom of Lin Liang and Chen Zihe, cannot be confidently identified as the work of either artist. See Suzuki 1974, p. 188, fig. 70; and Suzuki 1979, p. 218, no. 8. Minato (1980) has suggested that

Chen Zihe's life was roughly contemporary with that of Wen Zhengming (1470–1559) or Zhang Lu (ca. 1490–ca. 1563), based in part on the absence of any mention of Chen in the Fujian Provincial Gazetteer of 1491.

106. He Qiaoyuan, *Minshu*, juan 135, as cited in Mu Yiqin 1985, p. 82.

107. Zhu Mouyin, *Huashi huiyao*, juan 4, as cited in Mu Yiqin 1985, p. 82. Translation after Ju-hsi Chou in Chou and Brown 1994, p. 18, no. 1.

108. Shih Shou-chien 1995.

109. The simplified form of the character *sa* (uninhibited) differs from the character *jiu* (wine) by only one stroke. This probably explains why Chen Zihe's signatures and seals reading Uninhibited Immortal (Saxian) have sometimes been misread as Wine Immortal (Jiuxian).

110. For paintings that fall into this category, see Suzuki 1974, pls. 100, 101; and Minato 1980, fig. 8.

111. For Chen's middle period, see Suzuki 1974, pl. 99; Minato 1980, fig. 9; and Barnhart et al. 1993, no. 108.

112. For late paintings with signatures, see Mu Yiqin 1985, p. 329; Chou and Brown 1994, no. 1; Minato 1980, n. 2 (13); Minato 1980, fig. 1; and Chou and Brown 1997, no. 6.

113. For Daoist conceptions of cave heavens, see Munakata 1990, pp. 111ff.

114. See Barnhart 1983b.

115. See Wang and Barnhart 1990 and Fong 1987.

116. Richard Barnhart in Wang and Barnhart 1990, pp. 86–91. Wen Fong (1987, p. 9) has also detected other subtle protests to Kangxi's actions in Bada's paintings beginning in the early 1680s.

117. For Shitao's relationship to the Kangxi emperor and members of the Manchu elite, see Fu and Fu 1973, pp. 36–40.

118. Translation from Ellsworth et al. 1987, vol. 1, p. 158.

Catalogue

Appendix

Bibliography

Index

Catalogue

MAXWELL K. HEARN WITH YIGUO ZHANG

1. Attributed to Dong Yuan 傳 董元
(active 930s–60s)

Riverbank
Xi'an tu 溪岸圖

Hanging scroll, ink and color on silk
87 x 42 7/8 in. (221 x 109 cm)
Ex. Coll.: C. C. Wang Family
Promised Gift of the Oscar L. Tang Family

ARTIST'S SIGNATURE
1 column in standard script, undated.

Painted by the Assistant Administrator of the Rear Park, Servitor Dong [Yuan].

後苑副使臣董〔元〕畫。

NO ARTIST'S SEALS

LABEL STRIP
Zhang Daqian 張大千 (1899–1983), 1 column in running script, undated, 2 seals:

Dong Yuan's *Riverbank*, an authentic work of the divine class, formerly in the collections of Zhao Oubo [Zhao Mengfu; 1254–1322] and Ke Danqiu [Ke Jiusi; 1290–1343]. A cherished work in the Dafengtang Collection; [seals] *Huaiyunlou; Mianyan.*

董源《溪岸圖》眞跡神品，趙漚波、柯丹丘遺藏，大風堂永充供養。〔印〕怀雲樓，眠燕。

COLOPHON
(on the back of the mounting below the painting):

Ye Gongchuo 葉恭綽 (1881–1968), 1 horizontal line in regular script, undated, 1 seal:

Riverbank, painted by the Southern Tang Assistant Administrator of the Rear Park, Dong Yuan, from the collection of Master Zhang's Dafengtang. Inscribed by Ye Gongchuo; [seal] *Ye Gongchuo yin.*

《溪岸圖》南唐後苑副使董源畫，張氏大風堂供養，葉恭綽題。〔印〕葉恭綽印。

COLLECTORS' SEALS
Jia Sidao 賈似道 (1213–1275): [*Yuesheng*] [悅生]; *Qiuhe* 秋壑
Zhao Yuqin 趙與懃 (late 13th century), *Tianshuijun shoucang shuhua yinji* 天水郡收藏書畫印記
Ke Jiusi 柯九思 (1290–1343): *Ke shi qingwan* 柯氏清玩; *Danqiu Ke Jiusi zhang* 丹丘柯九思章; *Ke shi Jingzhong* 柯氏敬仲
Ming palace inventory half-seal (ca. 1373–84): [?] [?] [*jicha*] *siyin* □□ 〔紀察〕司印
Zhang Shanzi 張善子 (1882–1940): *Shanzi xinshang* 善子心賞
Zhang Daqian 張大千 (1899–1983): *Zhibao shibao* 至寶是寶; *Daqian haomeng* 大千好夢; *Bufu guren gao houren* 不負古人告後人; *Daqian zhibao* 大千至寶; *Zhang shi baocang* 張氏寶藏; *Xiao Xiang hualou* 瀟湘畫樓; *Qiutubao gurouqing* 球圖寶骨肉情; *Nanbei dongxi zhiyou xiangsui wubieli* 南北東西只有相隨無別離; *Dafengtang zhenwan* 大風堂珍玩
Wang Jiqian 王季遷 (己千; C. C. Wang; b. 1907): *Wang Jiqian haiwai jian mingji* 王季遷海外見名跡; *Jiqian xinshang* 季遷心賞

REFERENCES
Zhou Mi, *Yunyan guoyan lu* (1280s), *juan* 1, p. 15; Zhao Mengfu (1254–1322), *Songxuezhai ji*, *juan* 2, p. 12; Tang Hou (act. ca. 1320s), *Huajian*, 1959 edition, p. 12; Zhang Chou, *Qinghe shuhuafang* (1616), *juan* 1, p. 15, *juan* 6, pp. 38a, 68a; Wang Keyu, *Shanhuwang hualu* (1643), *juan* 23, p. 14, *juan* 24, p. 26; Du Mu, *Tiewang shanhu* (1758), *juan* 19, p. 8b; Zhang Daqian (1954), vol. 4, pl. 1; Xie Zhiliu 1957, p. 2; Loehr 1968, pp. 52–53; Barnhart 1970, p. 39, fig. 21; Barnhart, Iriya, and Nakata 1977, pls. 2, 3; Loehr 1980, pp. 113–14, 130, fig. 54; Cahill 1980, p. 48; Suzuki 1982, A14–001; Barnhart 1983a, pp. 30–38, figs. 1–3; *Yiyuan duoying*, no. 38 (1988), pp. 1, 49–50; Dobrzynski, *The New York Times*, May 19, 1997, A1, C13; Nagin, *The New Yorker*, August 11, 1997, pp. 26–27; Cahill 1997, pp. 4–6; Fu Shen 1997, pp. 256–57; Zhou Haisheng 1997a, p. 70–71; Zhou Haisheng 1997b, p. 72; Wong (Huang Junshi) 1997, p. 73; Ding Xiyuan 1997, p. 74; Shih Shou-chien 1997, pp. 82–87; Feng Youheng 1997, pp. 88–89; Ding Xiyuan 1998a, pp. 101–07; Hearn 1997, pp. 25–27;

Barnhart 1997, p. 86; Kwong and Jia 1998, pp. 439–49; Ding Xiyuan 1998b, pp. 114–30; Yang 1998, pp. 36–42; Barnhart 1998, p. 101; Nagin 1998, p. 98; Gaskin 1998, p. 75.

2. Unidentified artist 佚名
(late 10th–early 11th century)

Palace Banquet
Qiqiao tu 乞巧圖 or *Qixi tu* 七夕圖

Hanging scroll, ink and color on silk
63 3/4 x 43 3/4 in. (162 x 111 cm)
Ex. Coll. C. C. Wang Family
Promised Gift of the Oscar L. Tang Family

No artist's signature or seals

Collector's seal
Wang Jiqian 王季遷 (己千; C. C. Wang; b. 1907): *Wang Jiqian haiwai jian mingji* 王季遷海外見名跡

Label strip
Zhenyuan 眞圓 (20th century), 1 column in clerical script, undated, 1 seal:

A Tang artist's "Sui Palace Banquet," a work of the supreme divine class. Authenticated by Zhenyuan; [seal] *Le ci bupi.*

唐人筆《隋宮讌遊圖》，無上神品。眞圓審定。〔印〕樂此不疲。

References
Smith and Weng 1972, pp. 156–57; Cahill 1980, p. 53; Suzuki 1982, A14–009; He Qi 1988, p. 4; *Yiyuan duoying*, no. 38 (1988), pp. 2–3; Hearn 1997, pp. 20–25.

3. Zhao Cangyun 趙蒼雲
(active late 13th–early 14th century)

Liu Chen and Ruan Zhao in the Tiantai Mountains
Liu Chen Ruan Zhao ru Tiantai Shan 劉晨阮肇入天台山

Handscroll, ink on paper
8 1/2 x 222 1/4 in. (21.5 x 564.4 cm)
Ex. Coll.: C. C. Wang Family
Promised Gift of the Oscar L. Tang Family

Artist's inscriptions and signature
70 columns in running script, undated:

Liu Chen and Ruan Zhao were from Shan County [in present-day Zhejiang Province]. Although they came from old Confucian families, they were particularly interested in medicinal herbs and were accustomed to remaining aloof from the world. Thus did they in the fifteenth year of the Yongan [fifth year of the Yongping] reign era of Han emperor Mingdi [A.D. 72] take up hoe and basket and set off for the Tiantai Mountains to gather herbs.

Entering the deep mountains, they filled their baskets with herbs. After a short rest they started back, but lost their way. Their food exhausted, the two men looked at one another and were filled with fear and despair. Suddenly they saw a peach tree growing from the mountainside, heavy with ripening fruit. The men clambered up the mountain and picked the fruit—each man eating two peaches—after which their strength returned.

Peaches in their hands, they descended the mountain, seeking the way back. The winding path was rugged and difficult to make out. Eventually they found themselves at the foot of the mountain, and there they saw a clear, cold stream flowing through a ravine. Rinsing their hands, the men scooped up the water and took a drink. Suddenly they saw rutabagas flowing down the mountain stream, followed by a cup filled with sesame rice. The two men looked at one another and exclaimed: "There must be a house nearby."

The air about the mountains is dense,
The green peaks, lofty and contorted.
Gazing at them you are transported
To another world.

So they lifted up their baskets of herbs and waded into the stream. Because the water was nearly four feet deep, they lifted their robes in order to cross. After a third of a mile they found a small path, which led across a mountain to another stream.

The large stream at the foot of the mountain.

On the opposite side of the stream they saw two women whose marvelous beauty was of another world. The two women waved, calling Liu and Ruan by name as if they were old friends. When the two men crossed the stream the women giggled and said, "How late you are!" Their voices were dulcet, their fragrance alluring, as they spoke to the men and took them by the hand. Although they were [to the men] as brides, they behaved as if they had known them for many years. At first the two men suspected they might be witches, but gradually they lost their fear and regarded them as human.

The two women invited the men to accompany them home, leading them along a winding mountain path through hills covered with blossoming peach trees. After about a mile they reached their residence, which was decorated in an extravagant

manner beyond the likes of any mortal dwelling. To either side were serving women in light blue clothing, their manner sober and dignified, their appearance elegant and radiant as clouds. After a brief rest the women prepared a delicious meal of sesame rice and mountain goat, after which the men were no longer hungry. They inquired about the women's families, but the ladies only laughed and made small talk, refusing to reveal anything. The two men eventually stopped asking. They realized these were strange women. And they observed that there were no men in the house.

In the courtyard a banquet was arranged, with wine and food set out to wish the men long life. After a few cups [of wine] guest immortals arrived at the ladies' residence bringing peaches of longevity and announcing, "We have come to congratulate the grooms." The two men paid their respects to the immortals, each of whom wore magical clothes and carried a musical instrument which they played in perfect harmony. For two or three hours the two men drank happily, while the two female immortals personally served them cups [of wine] and urged them to drink more. The beguiling melodies evoked an almost tangible sensation of spring, and the two men felt they were in paradise. The guests departed as the sun set.

The two women persuaded Liu and Ruan to remain for more than half a month, but then the men asked to return home. The women responded, "Coming upon us and living here is your good fortune. How can the herbal elixirs of the common world compare to this immortal dwelling?" So they begged the men to stay for half a year. Every day was like late spring, but the mournful cries of the mountain birds caused the two men to plead even more to return home. The woman said, "Traces of your karma have remained here, which is why you still feel this way." So they summoned the other female immortals to bid them farewell with music, saying, "Not far from the mouth of this cave is a roadway leading to your home. It's easy."

The two men exited the cave and reached the roadway. They looked back, but saw only the brilliant glow of peach blossoms and the layered greens of the mountain. When they arrived home, they recognized no one. Greatly perplexed, they made inquiries until they realized that [the villagers] were their seventh-generation descendants.

Finding that their homeland held neither close relations nor a place to live, the two men decided to reenter the Tiantai Mountains and seek out the roadway that they had just followed. But the way was obscured, and they became lost. Later, in the eighth year of the Taikang reign era of Jin Wudi [A.D. 287], the two again entered the Tiantai Mountains. What became of them remains unknown.

Painted and inscribed by Cangyun Shanren (Gathering Clouds Mountain Man).

劉晨、阮肇，剡縣人也。家世業儒，尤留意於醫，嘗飄然有霞表之氣味。漢明帝永安十五年，二人攜鋤筥，往天台山採藥焉。

入山既深，尋藥方盈筥。少憩將返，迷失來路，且糧糗俱盡，二人相顧，方狼狽失措。偶舉目，見山頭有桃木樛然，桃實累然。二人往山上取桃食之，人各食二枚，如覺少健然。

食桃尤在手，下山求歸。路轉轉崎嶇，益難辨識。行次不覺至山麓，見澗中水流潺然，清冷可可。二人以手掬水飲之，且各澡其手面。偶見蔓菁從山腹中出次，又有一杯流出，中有胡麻飯屑。二人相顧曰：「去人家不遠矣。」

巒氣瀜鬱，
山色螺聳。
望中怳然，
如接異境。

因負藥筥，以鋤挺探水，水繞四尺許，二人褰裳渡之。行及一里餘，得小徑，又度一山，又見一溪焉。

山麓處大溪。

隔溪見二女顏色絕妙，世所未有，便揮手喚劉阮姓名，似有舊交。二人渡溪，二女喜笑而語，曰：「郎來何晚也！」意味和懌，香氣襲人，相語相攜，雖合巹之協情，經數載未有如此之婉好也。二人始疑為媚，久之方辯識為人，而亦不之懼焉。

二女因邀歸家，所過山徑崎嶇，滿山桃花爛然，行及三里餘，到其所居廳館，朴廠服飾，非如人間所有。左右女侍息青衣，皆端正莊靚，爛然如雲。少憩，煮胡麻飯、山羊脯，食之甘美。二人食方畢，不覺飢，欲訊家世。二女但相與談笑亂之，略不之告，二人亦不敢固問，知其為異人。久之，亦不見其家有男子也。

既而又當庭設席，陳酒肴為二人壽。方飛觴次，有數仙客，持三、五仙桃至女家，云：「來慶女婿，各至席。」二人禮之，數仙客皆仙服，各出樂器奏之，肅雝和鳴。暢飲逾二、三時候，二女親各舉卮，勸二人酒。欵曲之情，春氣可挹，二子怳然，如在天上也。日向暮，仙客各還去。

二女邀劉阮偕止宿，約半月餘，二子求還。女答曰：「今來此，皆汝宿福所招得。至予仙館，比之流俗，有此藥否？」遂懇留住及半年。天氣常如三春，山鳥哀鳴，二子求歸甚切。女曰：「葉根未滅，使令子心如此。」於是喚諸仙女，共作鼓吹，送劉阮歸，遂告之曰：「從此山洞口出去不遠，至大道、至家，易矣！」

二子出洞口，行至大道，回首，惟桃花燦爛，山色堆青而已。甫至家鄉，並無相識，鄉里怪異乃聞，得七代子孫，傳上祖入山不出，不知今何在。

二子在鄉，既無親屬，棲泊無所，卻同入天台山，尋當年所往。山路已迷，而不知所在。後至晉武帝太康八年，二子後入天台，不知其所之也。

蒼雲山人畫書。

Colophons

Hua Youwu 華幼武 (1307–after 1386), 10 columns in regular script, dated 1379:

High-minded and eccentric and fond of drinking, Cangyun Shanren was a member of the Song imperial clan. His paintings often attained the divine class. His landscapes, mostly in the boneless ink-wash style, are boldly conceived and filled with vitality. His delicate figure paintings possess a distinctive character rare to behold. This painting, "Liu [Chen] and Ruan [Zhao in the] Tiantai Mountains," is free and unfettered, relaxed and elegant. Its draperies of Cao [Zhongda; active ca. 550–77] and scarves of Wu [Daozi; 710–60] and its marvelous tonalities are unattainable by most artists. I think the story of Liu and Ruan may not be entirely without basis. Tang authors have observed that female immortals belong also to the demon world. And he who acquires this ink masterpiece may indeed believe that Spiritual Mountain and Western Garden still exist. Unrolling this scroll, I felt I was amid clouds of peach blossoms and waves of willow, cooled by a breeze and warmed by the sun. In his youth Cangyun was more famous than [his fellow clansmen] Ziang [Zhao Mengfu; 1254–1322] and Zigu [Zhao Mengjian; 1195–before 1267], but because he never married and never served as an official, but withdrew to live as a recluse amid the mountain forests and lakes, his presence was elusive. So when one of his paintings was acquired, it was considered precious as jade. He was a man of remarkable ingenuity but one who also suffered; alas, there can never be another like him.

In autumn, the ninth month, in the twelfth year of the Hongwu reign [1379], Hua Youwu wrote this at the Spring Thatch Hall.

蒼雲山人，本趙宋宗室。高奇嗜酒，繪事入神。山水橫放，大都做沒骨圖，而生動過之。人物工緻，別有姿韻，世不多見。所作《劉阮天台圖》，意境蕭散，神趣閒逸。曹衣吳帶，設色妍妙，有諸家所不能及者。竊意劉阮未必非烏有子虛，唐人云：「仙姝宜屬魅界。」但得此墨

妙，覺靈山儼然，西園猶在，展卷不知身在桃雲柳浪、清風紅日間也。蒼雲早歲，名在子昂、子固上，不婚不宦，每隱於山林湖舫，雖親串無從蹤跡，世人得其片幀，幾如拱壁，此其匠心運意，備極慘澹，當不能有二也。

洪武十二年秋九月，華幼武書於春草軒。

Yao Guangxiao 姚廣孝 (1335–1418), 7 columns in running script, dated 1386:

In the second month of spring in the *bingyin* [year, 1386], I was feeling bored and so took a boat with Hua Qibi [Hua Youwu] and sailed about the lakes for a full month. Hua's conversation and poetry were eloquent, his eyes were keen. He was very knowledgeable and loved antiques and had a large collection of stele calligraphies. Contentedly we passed the time, discussing and evaluating [works of art] and sharing interests beyond the ordinary. From time to time we would view Zhao Cangyun's "Princely Grandsons in the Tiantai [Mountains]," admiring the animation and emotion of his figures and scenery and delighting at his conception as we rolled and unrolled the scroll. It is a painting that has attained the three perfections. Qibi had already added a colophon, and so I added mine. I have been a traveler for a long time; these days I am almost never able to quit this wandering. Do I live in this painting?

Recorded by Daoyan.

丙寅春仲，無憀中鼓枻過。華棲碧湖上留連匝月，談詠甚適，且目洞爽。華君沉博嗜古，所藏碑版甚夥。商確評品，彼此恍然，盡得象外物表之趣。偶示趙蒼雲《王孫天台圖》，人物景色飛動有情，宛轉離合，極快意事，作愕愕之狀，是入繪中三昧者。棲碧有題，予踵其後。予久作東西南北人，他年一會儼然未散，其在斯乎？

道衍識。

Song Yong 宋邕 (unidentified), 13 columns in running script, undated:

"Liu and Ruan Encounter Immortals in a Cave"

The sky merges with the verdant color of the trees,
Layered clouds and mountain mists obscure the road.
Rising vapors envelop the mountains; the birds are silent.
The murmur of the valley stream is like the music of pipes
 and reeds.
In the green cave, there is no gulf between heaven and earth,
The red branches of the trees are as long lived as the sun and
 the moon.

If only people would appear among the flowers,
Instead of the wailings of the immortals beckoning Liu.

"The Immortals Escort Liu and Ruan Out of the Cave"

Solicitously they are escorted from the Tiantai Mountains.
How can the immortals' paradise be regained?
Drink of the cloud's nectar before going home,
The jade scriptures cannot be opened at will.
Flowers at the mouth of the cave will blossom forever,
But water that flows into the mortal world never returns.
Sadly the stream flows out from this other world,
As the bright moon shines on the jade-green mountains
 illuminating the verdant moss.

Song Yong.

劉阮洞中遇仙人

天和樹色靄蒼蒼，霞重嵐深路渺茫。
雲竇滿山無鳥雀，水聲沿澗有笙簧。
碧沙洞裡乾坤別，紅樹枝邊日月長。
願得花間有人出，免令仙犬吠劉郎。

仙人送劉阮出洞

殷勤相送出天台，仙境那能卻再來。
雲液既歸須強飲，玉書無事莫頻開。
花當洞口應長在，水到人間定不迴。
惆悵溪頭從此別，碧山明月照蒼苔。

宋邕。

LABEL STRIP
Zhao Heqin 趙鶴琴 (20th century), 1 column in clerical
script; 2 columns in regular script, undated, 1 seal:

Song Zhao Cangyun's handscroll "Liu Chen and Ruan Zhao
in the Tiantai Mountains," his sole surviving work, with a
colophon by Yao Guangxiao. Inscribed at the front by
Heqin; [seal] Zhao Heqin.

宋趙蒼雲《劉阮入天台圖》，卷子，孤本，姚廣
孝有跋，鶴琴署耑。〔印〕趙鶴琴。

COLLECTORS' SEALS
Zhang Bowen 張伯文 (unidentified): Zhang Bowen fu 張伯
文父
Wang Jiqian 王季遷 (己千; C. C. Wang; b. 1907): Wang
Jiqian shi shending zhenji 王季遷氏審定眞跡
One unidentified half seal: Zhuchuang shou [?] [?] [?] 竹窗壽
□□□

REFERENCE
Barnhart 1983a, pp. 102–5, figs. 145, 146.

4. Wu Zhen 吳鎮
 (1280–1354)

Lofty Virtue Reaching the Sky
Gaojie lingyun tu 高潔凌雲圖
Dated 1338

Hanging scroll, ink on silk
65 1/2 x 38 1/2 in. (166.4 x 98 cm)
Ex. Coll: C. C. Wang Family
Promised Gift of the Oscar L. Tang Family

ARTIST'S INSCRIPTION AND SIGNATURE
4 columns in cursive script, dated 1338:

Tall stalks pierce the clouds.
Perhaps you find it strange,
Not recognizing the wings of a phoenix.
A pure sound enters the realm of the soundless,
Don't let Zhonglang blow his long-necked flute.

In the fifth month of summer, the fourth year of the
Zhiyuan reign era [1338], Meihua Daoren [the Plum Blossom
Daoist] played with ink.

高潔凌雲只自奇，誰人識是鳳凰枝。
至音已入無聲譜，莫把中郎籲笛吹。

至元四年夏五月，梅花道人戲墨。

ARTIST'S SEALS
Meihuaan 梅花盒
Jiaxing Wu Zhen Zhonggui shuhua ji 嘉興吳鎮仲圭書畫記

LABEL STRIP
Zhao Shigang 趙世棡 (1874–1945), 1 column in clerical
script, 2 columns in running script, dated 1939:

Yuan Wu Zhonggui's "Ancient Tree, Bamboo, and Rock," an
authentic work collected in Banjiao Hall of the Lin family.
Inscribed in the autumn of the yimao year [1939] by Zhao
Shigang; [seal] Shuru.

元吳仲圭《古木竹石》眞蹟，林氏半角草堂珍
藏，己卯秋月趙世棡署。〔印〕叔儒。

COLLECTORS' SEALS
Liang Qingbiao 梁清標 (1620–1691): Jiaolin 蕉林; Guanqi
dalue 觀其大略; Jiaolin shoucang 蕉林收藏 (remounted
onto the outside of the present mounting)
Qian Yue 錢越 (1743–1815): Jiashan Qian Yue Motang jiancang 嘉
善錢越樗棠鑒藏
Wang Jiqian 王季遷 (己千; C. C. Wang; b. 1907): Wang shi
Jiqian zhencang zhi yin 王氏季遷珍藏之印; Wang Jiqian shi
shending zhenji 王季遷氏審定眞跡
One unidentified seal: illegible

REFERENCES

Wang Keyu, *Shanhuwang hualu* (1643), *juan* 20, p. 1236; Bian Yongyu, *Shigutang shuhua huikao* (1682), *juan* 5, pp. 4b–5a; Gu Fu, *Pingsheng zhuangguan* (1692), *juan* 9, p. 65; *Weida de yishu chuantong tulu* 1951–54, vol. 8, pl. 9; Lee 1954, no. 29; Zhang Daqian 1955–56, vol. 1, pl. 13; Sirén 1956–58, vol. 7 (lists); p. 143; Cahill 1958, pp. 176–78, pl. 27a; Cahill 1980, p. 350; Suzuki 1982, A14–042; Barnhart 1983a, pp. 130–33, fig. 59; Han 1983, pp. 78–81, fig. 49.

5. Ke Jiusi 柯九思
(1290–1343)

Bamboo after Wen Tong
Lin Wen Tong mozhu tu 臨文同墨竹圖
Dated 1343

Hanging scroll, ink on silk
42 1/8 x 18 3/4 in. (107 x 47.5 cm)
Ex coll: C. C. Wang Family
Promised Gift of the Oscar L. Tang Family

ARTIST'S INSCRIPTION AND SIGNATURE
2 columns in running script, dated 1343:

The first day of winter in the *jiyou* year of the Xining reign era [1069], Wen Tong, Yuke, of Bajun

On the Duanwu Festival of the *guiwei* year of the Zhizheng reign era [May 28, 1343], Ke Jiusi, Danqiu, made this copy.

熙寧己酉冬至日，巴郡文同與可。

至正癸未端陽節，丹丘柯九思臨。

ARTIST'S SEALS
Xixun 錫訓
Ke shi Jingzhong 柯氏敬仲
Yunzhenzhai 縕真齋

LABEL STRIPS
Unidentified, 1 column in running script, undated:

Yuan Ke Jiusi's imitation of Wen Yuke's [Wen Tong's] bamboo branch.
元柯九思倣文與可竹枝。

Bi Long 畢瀧 (active late 18th century), 2 columns in regular script, undated, 1 seal:

A true [ink] trace of Yuan Ke Danqiu's [Ke Jiusi's] copy of Wen Huzhou's [Wen Tong's] "Pendant Branch of Bamboo," formerly in the collection of Liang Jiaolin [Liang Qingbiao]

of Zhending. A work of the supreme divine category; [seal] *Bi Long jianshang*.

元柯九思臨文湖州《倒垂竹枝》真跡，真定梁蕉林藏本，無上神品。〔印〕畢瀧鑒賞。

COLLECTORS' SEALS
Liang Qingbiao 梁清標 (1620–1691): *Tangcun shending* 棠村審定; *Jiaolin* 蕉林
Bi Long 畢瀧 (active late 18th century): *Bi Jianfei miji yin* 畢澗飛祕笈印
Feng Gongdu 馮公度 (dates unknown): *Gongdu suocang Song Yuan mingji* 公度所藏宋元名跡; *Feng Gongdu* [?] [?] [?] 馮公度□□□
Two unidentified seals: *Kezhu jiacang zhenwan zisun baozhi* 可竹家藏珍玩子孫寶之; [?] [?] [?] *xia* □□□暇
Wang Jiqian 王季遷 (己千; C. C. Wang; b. 1907): *Wang shi Jiqian zhencang zhi yin* 王氏季遷珍藏之印

REFERENCES
Lu Shihua, *Wuyue suojian shuhua lu* (1776), *juan* 3, p. 12; Dubosc 1954, no. 786; Chiang I-han 1976, p. 41; Chiang I-han 1977, p. 108; Cahill 1980, p. 291; Barnhart 1983a, pp. 136–39, fig. 62; Han, 1983, p. 141, fig. 44; Zong Dian 1985, p. 57.

6. Zhang Xun 張遜
(active ca. 1295–after 1349)

Rocky Landscape with Pines
Shishang songhua tu 石上松花圖
ca. 1346

Hanging scroll, ink on silk
35 1/2 x 16 1/2 in. (90 x 42 cm)
Ex coll: C. C. Wang Family
Promised Gift of the Oscar L. Tang Family

ARTIST'S INSCRIPTION AND SIGNATURE
3 columns in regular script, undated (top left):

In the rocky [landscape] pine blossoms fall and bloom again.
The mountain Ailanthus, useless [for its timber], has grown to full size.
No cart has ever reached this woodcutter's path.
Now with gray hair, I have passed fifty years in vain.

Zhang Xun.

石上松花落又開，山樗無用亦成材。
蒲輪不到樵人徑，白髮徒過五十來。

張遜。

ARTIST'S SEAL
Zhang Xun siyin 張遜私印

INSCRIPTIONS ON THE PAINTING
Li Zuan 李纘 (active mid-14th century), 2 columns in
regular script, undated (top middle):

Layered peaks gather alum-head rocks,
Cloudlike groves hold deep shadows.
If you are not the Buddhist monk Juran,
How can you understand the meaning of this brushwork?

Li Zuan.

層巒聚礬石，雲木中蔽芾。
自非僧巨然，熟識用筆意？

李纘。

Ni Zan 倪瓚 (1306–1374), 4 columns in regular script, dated
1346 (top right):

On the far shore forests and peaks glow with sunset clouds;
At the foot of the mountains round boulders are gathered
 beside the winding stream.
When will I put on [hiking] socks and sandals,
And visit the Cloud Gate [Temple] and Ruoye Stream?

This painting, together with the poem inscribed above, is my
gift to Zhongwen. Ni Zan from Wu, on the twelfth day of
the eighth month, in the sixth year of the Zhizheng reign era
[August 28, 1346].

隔浦林巒映暮霞，縈紆溪足聚圓沙。
青鞋布襪何午始，往問雲門與若耶。

余既以此畫贈仲文併賦其上句，吳倪瓚。至正
六年八月十二日。

LABEL STRIP
Unidentified, 1 column in regular script, undated:

Yuan Zhang Xun's "Rocky Landscape with Pines," a work of
the divine class.

元張遜《石上松花圖》，神品。

COLLECTORS' SEALS
Wang Jiqian 王季遷 (己千; C. C. Wang; b. 1907): *Zhenze
Wang shi*
Baowutang tushuji 震澤王氏寶武堂圖書記
Two unidentified seals: *Si gu* 思古; illegible

REFERENCES
Cahill 1980, pp. 240, 309; *Yiyuan duoying*, no. 38 (1988), p. 17.

7. Yao Yanqing 姚彦卿
(Yao Tingmei 姚廷美; ca. 1300–after 1360)

Traveling through Snow-Covered Mountains
Xueshan xinglu tu 雪山行旅圖

Hanging scroll, ink on silk
38 3/4 x 21 1/4 in (98.5 x 54 cm)
Ex coll: C. C. Wang Family
Promised Gift of the Oscar L. Tang Family

NO ARTIST'S INSCRIPTION, SIGNATURE, OR
SEALS

LABEL STRIP
Wang Jiqian 王季遷 (己千; C. C. Wang; b. 1907), 1 column
in running script, dated 1989:

Yao Tingmei's [Yao Yanqing's] masterpiece, "Traveling
through Snow-Covered Mountains." Inscribed on the fifth
day of the twelfth month of the *jisi* year [1989].

姚廷美《雪山行旅圖》，神品。己巳十二月五日
署。

NO COLLECTORS' SEALS

NO REFERENCES

8. Wang Meng 王蒙
(ca. 1308–1385)

Simple Retreat
Su'an tu 素庵圖
ca. 1368

Hanging scroll, ink and color on silk
53 1/2 x 17 3/4 in. (136 x 45 cm)
Ex coll: C. C. Wang Family
Promised Gift of the Oscar L. Tang Family

ARTIST'S INSCRIPTION AND SIGNATURE
1 column in seal script, 2 columns in regular script, undated:

"Simple Retreat."

The Yellow Crane Mountain Woodcutter, Wang Meng,
painted this for the lofty scholar of the Simple Retreat.

《素庵圖》

黃鶴山樵王蒙，爲素庵高士畫。

ARTIST'S SEAL
Wang Meng yin 王蒙印

LABEL STRIP
Boheng 伯珩 (dates unknown), 2 columns in running script, undated:

The Mountain Woodcutter's [Wang Meng's] "Simple Retreat," on paper, a work of the supreme divine class; recorded by Boheng.

山樵《素庵圖》軸，紙本，無上神品。伯珩記。

COLLECTORS' SEALS
Luo Feng 羅鳳 (1465–after 1536): *Yingang Luo Feng tuji* 印岡羅鳳圖籍
He Liangjun 何梁駿 (1506–1573): *Qing-senge shuhua yin* 清森閣書畫印; *He shi Yuanlang* 何氏元郎
Yue Zhongqi 岳鐘琪 (1686–1754): *Chen Yue Zhongqi gongcang* 臣岳鐘琪恭藏
Qian Daxin 錢大昕 (1728–1804): *Daxin* 大昕; *Zhuting* 竹汀
He Yuanyu (2nd half of 19th century): *Ju'an shending zhenji* 遽盦審定眞蹟
Wang Jiqian 王季遷 (己千; C. C. Wang; b. 1907): *Wang shi Jiqian zhencang zhi yin* 王氏季遷珍藏之印

REFERENCES
Guan Mianjun 1928, *juan* 1, p. 24; *To-So-Gen-Min meiga taikan* 1929, vol. 1, pl. 171; Sirén 1956–58, vol. 6, pl. 110b, 7 (lists), p. 139; Lee and Ho 1968, no. 258; Ho, Iriya, and Nakata 1979, frontispiece; Cahill 1980 p. 344; Suzuki 1982, A14–040; Barnhart 1983a, pp. 149–55, figs. 69, 70; *Yiyuan duoying*, no. 38 (1988), pp. 2–4; Hearn 1997, pp. 27–29.

9. Lü Ji 呂紀
(ca. 1430–ca. 1504)

Mandarin Ducks and Hollyhocks
Yuanyang furong tu 鴛鴦芙蓉圖

Hanging scroll, ink and color on silk
68 1/8 x 39 1/8 in. (173 x 99.5 cm)
Ex coll: C. C. Wang Family
Promised Gift of the Oscar L. Tang Family

ARTIST'S SIGNATURE
2 characters in running script, undated:

Lü Ji

呂紀

ARTIST'S SEAL
Siming Lü Tingzhen yin 四明呂廷振印

LABEL STRIP
Unidentified, 1 column in clerical script, undated:

Ming Lü Ji's flower-and-bird painting on silk, "Mandarin Ducks and Hollyhocks." No. 77.

明呂紀絹本花鳥《鴛鴦芙蓉圖》。柒拾柒。

COLLECTOR'S SEALS
Wang Jiqian 王季遷 (己千; C. C. Wang; b. 1907): *Wang shi Jiqian zhencang zhi yin* 王氏季遷珍藏之印; *Wang Jiqian shi shending zhenji* 王季遷氏審定眞跡

REFERENCE
Barnhart et al. 1993, no. 58.

10. Liu Jun 劉俊
(active ca. 1475–ca. 1505)

Remonstrating with the Emperor
Najian tu 訥諫圖

Hanging scroll, ink and color on silk
65 x 41 7/8 in. (165 x 106.5 cm)
Ex coll: C. C. Wang Family
Promised Gift of the Oscar L. Tang Family

ARTIST'S SIGNATURE
2 characters in regular script, undated:

Liu Jun

劉俊

ARTIST'S SEAL
Liu [?] [?] [?] *tushu* 劉□□□圖書

LABEL STRIP
Unidentified, 1 column in running script, undated:

Ming Liu Jun "Remonstrating with the Emperor."

明劉俊《訥諫圖》。

COLLECTOR'S SEALS
Wang Jiqian 王季遷 (己千; C. C. Wang; b. 1907): *Wang shi Jiqian zhencang zhi yin* 王氏季遷珍藏之印; *Wang Jiqian shi shending zhenji* 王季遷氏審定眞跡

REFERENCE
Barnhart et al. 1993, no. 29.

11. Chen Zihe 陳子和
(active late 15th–early 16th century)

Drunken Immortal Beneath an Old Tree
Gumu jiuxian tu 古木酒仙圖

Hanging scroll, ink on silk
68 3/4 x 40 3/8 in. (174.5 x 102.5 cm)
Ex coll: C. C. Wang Family
Promised Gift of the Oscar L. Tang Family

ARTIST'S INSCRIPTION AND SIGNATURE
2 columns in cursive script, undated:

Sketched by the seventy-seven-year-old Uninhibited
Immortal Chen Zihe.

七十七叟酒仙陳子和寫。

ARTIST'S SEAL
Pucheng Chen Lang zhi yin 浦城陳郎之印

NO COLLECTORS' SEALS

REFERENCES
Minato 1980, pp. 19, 23, fig. 14; Suzuki 1980, A14–017;
Yiyuan duoying, no. 38 (1988), p. 18.

12. Bada Sharen 八大山人
(Zhu Da 朱耷; 1626–1705)

Two Eagles
Erying tu 二鷹圖
Dated 1702

Hanging scroll, ink on paper
73 x 35 1/2 in. (185.4 x 90 cm)
Ex coll: C. C. Wang Family
On loan from Oscar L. Tang

ARTIST'S INSCRIPTION AND SIGNATURE
1 column in running script, dated 1702:

Painted in the *renwu* year, the sixteenth day of the third
month [April 12, 1702], Bada Shanren.

壬午三月既望寫，八大山人。

ARTIST'S SEALS
Bada Sharen 八大山人
Heyuan 何園
Zhenshang 眞賞

LABEL STRIP
Unidentified, 1 column in clerical script, undated:

The Daoist Xuege's [Bada Shanren's] painting "Spiritual
Eagles," [a work of the] divine class.

雪個道人《靈鷲圖》，神品。

COLLECTORS' SEALS
Hu Boxuan (dates unknown): *Juchao Hu Jizhitang zhencang zhi yin*
居鄛胡集祉堂珍藏之印; *Hu shi Boxuan zhencang* 胡氏伯
宣珍藏
Wang Jiqian 王季遷 (己千; C. C. Wang; b. 1907): *Wang shi
Jiqian zhencang zhi yin* 王氏季遷珍藏之印; *Wang Jiqian shi
shending zhenji* 王季遷氏審定眞跡

REFERENCES
Sirén 1956–58, vol. 7 (lists), p. 323; Sickman and Soper 1968,
p. 198, pl. 151A; Contag 1969, pl. 23; Giacalone 1972, no. 5; Zhou
Shixin 1974, pl. 147; Akai 1975, p. 231; Wu and Kohara 1977,
pl. 100; Chen Huisun and Zhong Wenbin 1985, pl. 134; *Bada,
Shitao shuhuaji* 1984, no. 1; Wang and Barnhart 1990, no. 64.

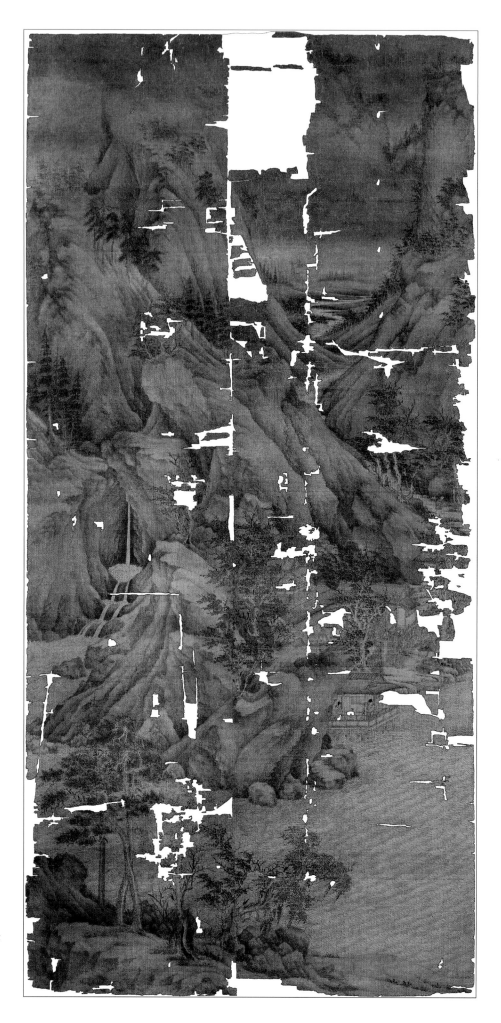

Figure 88. Schematic diagram of *Riverbank* showing principal areas of repair

Appendix

Riverbank: The Physical and Documentary Evidence

Maxwell K. Hearn

THE PHYSICAL EVIDENCE

In 1998–99, *Riverbank* (pl. 1, page 2) was given a detailed examination by members of the Starr Asian Art Conservation Studio of The Metropolitan Museum of Art. This examination made extensive use of digital photography to create enhanced computer images of the entire painting, including the signature and early collectors' seals. From the full-size digital reproduction of the scroll a precise map of all repaired areas was produced. This map was the basis for the schematic diagram seen on the facing page (fig. 88). Carbon dating of the painting's silk was deemed unfeasible as it would require subjecting the painting to a complete remounting in order to secure a sample.

Painted on silk that is darkened with age, *Riverbank* is worn from repeated handling and remounting. Presently mounted as a hanging scroll 87¼ inches high by 43¼ inches wide, it is formed of two unequal widths of silk, the left width measuring 20¼ inches, the right 23 inches. These two panels reflect the standard loom width of about 23 inches for painting silk used through the early Northern Song era.[1]

While fourteenth-century seals along both outside edges attest to the composition's being in this form as early as the Yuan dynasty, most early paintings of this scale originally functioned as multipanel screens within an architectural framework. It is therefore likely that *Riverbank* as it now survives formed only the left panel of a three-panel screen composition similar to that seen in *Scholar Examining Books* (fig. 10, page 15). Assuming that the lost central panel was twice the width of each of the side panels, the original three-panel screen would have been made up of eight widths of silk measuring more than seven feet high and fourteen feet wide.

Since its remounting as a hanging scroll, probably in the Song dynasty, the painting has suffered additional losses along the exterior edges as a result of fraying or trimming during subsequent remountings. This is most evident along the left border, where the artist's inscription and several early collectors' seals have been closely cropped or partially lost. Strips of silk have been added along the borders as a way of restoring the even contours of the composition. The interior seam, where the two lengths of silk are joined, has fared better. While the two panels are not perfectly aligned, the composition is without appreciable interruption on either side of the join. The painting surface is thus fairly well preserved, though numerous small areas of wear and damage have been repaired by the addition of silk patches cut to the exact shape of the missing fabric and inserted so as to be flush with the original surface. In some instances, the silk used in these repairs appears to be identical in weave to the original. The most prominent example is the large rectangular repair, about ten by nine inches, at the top of the composition just to the right of the central seam. Slightly darker than the surrounding silk, it most closely matches the darkened silk at the top left. If the silk was taken from the top of the left panel, then the original composition would have been nearly twelve inches taller. Presumably, the panel was cut down either to better align the two panels or simply to allow the painting to fit more comfortably within the hanging-scroll format. Because the same silk was used extensively for other repairs to the painting, it would appear that *Riverbank* was restored most extensively when it was transformed from a screen panel to a scroll.

Where repairs have interrupted the original composition, the in-filled portions have been painted with sketchy suggestions of the missing information and then repainted in ink tones slightly lighter than those of the original. On the river-

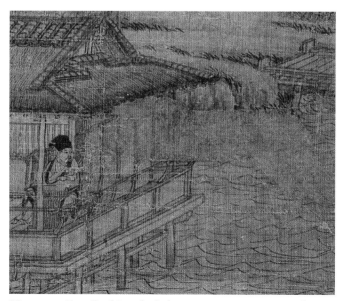

Figure 89. Detail of *Riverbank* showing restoration around riverside pavilion

Figure 90a. Detail of collectors' seals on the lower left corner of *Riverbank*

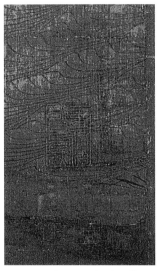

Figure 90b. Detail of collectors' seals on the lower right corner of *Riverbank*

Signatures and seals may be added to a work of art at any time as a way of enhancing its pedigree, while written sources are usually not specific enough to allow conclusive identification; they may also serve as the point of departure for a later forger. This said, once the painting's period of execution has been established through stylistic analysis, other sources of evidence may be judiciously employed to fill out the painting's likely history of transmission.

The physical documentation of *Riverbank* begins with the inscription in the lower-left corner: "Painted by the Assistant Administrator of the Rear Park, Servitor Dong Yuan" (pl. 1a, page 6). Although no reliable signatures of Dong Yuan survive to corroborate the authenticity of this inscription, the calligraphic style, which follows that of the leading Tang calligrapher Yan Zhenqing (709–785), is typical of the tenth and eleventh centuries. It compares closely, for example, in both form and brush technique, to the calligraphy of the Northern Song scholar Ouyang Xiu (1007–1072; fig. 15, page 21). We may therefore conclude that the inscription dates to no later than the early Song period.

There are nineteen collectors' seals impressed on *Riverbank*, including seven that range in date from the mid-thirteenth to the late-fourteenth century (figs. 90a, 90b; see pages 147-55 for the identification and transcription of all the seals). The two earliest seals, impressed along the lower-left edge of the painting, are those of the Southern Song prime minister and collector Jia Sidao (1213–1275; fig. 91). The upper seal, only the top portion of which has survived, corresponds to a gourd-shaped

side pavilion, for example (fig. 89), the patch covering part of the right corner is painted with lines that continue those that delineate the original architecture and surrounding waves. There is no indication of retouching on the original silk.

Riverbank's antiquity can be inferred not only from its physical condition but from the physical evidence of its inscription and collectors' seals and through references to the painting that appear in textual sources. This evidence is necessarily circumstantial.

Figure 91. Detail of *Yuesheng* and *Qiuhe* seals of Jia Sidao (1213–1275) on *Riverbank*

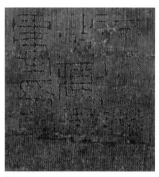

Figure 92a

Figure 92b

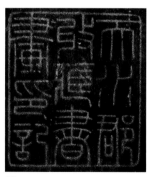

Figure 92c

Figure 92a. Detail of *Tianshuijun shoucang yinji* seal of Zhao Yuqin (late 13th century) on *Riverbank*

Figure 92b. Detail of *Tianshuijun shoucang yinji* seal of Zhao Yuqin (late 13th century) on *Gentlemen on a Spring Outing*, attributed to Zhao Yan (d. 923). Hanging scroll, ink and color on silk, 63¾ x 40⅛ in. (161.9 x 102 cm). National Palace Museum, Taipei

Figure 92c. Detail of *Tianshuijun shoucang yinji* seal on *Model Calligraphies from the Chunhua Pavilion*, engraved 992. Song rubbings mounted as an album, ink on paper. Sold at Christie's, New York, September 18, 1996

seal of Jia's with the legend *Yuesheng*, but it is too fragmentary to compare with other known examples. Directly below is a rectangular seal with the legend *Qiuhe*, one of Jia Sidao's sobriquets. Similar seals with this legend exist, but the size and cutting of this impression do not match those of published examples.

The next oldest seal on the painting, "seal of the Tianshui Commandary Calligraphy and Painting Collection" (*Tianshuijun shoucang yinji*; fig. 92a), is impressed several inches below Jia Sidao's seals and may be identified as belonging to Zhao Yuqin (late thirteenth century), a collector and member of the Song imperial family who is recorded as having owned *Riverbank*.[2] "Tianshui Commandary" refers to the Zhao family's ancestral home in northern Shaanxi and Gansu Provinces.[3] During the Song dynasty, this title was conferred upon some members of the royal house and during the Yuan several descendants of Song royalty continued to use seals that included "Tianshui Commandary" in their legends. Zhao Mengfu (1254–1322) employed a seal reading "Painting and calligraphy seal of the Tianshui Commandary" (*Tianshuijun tushuyin*; fig. 93); his wife, Guan Daosheng (1262–1319), and his son Zhao Yong (1289–1360) also used seals that included "Tianshui Commandary" in their legends.[4] But the Tianshui seal on *Riverbank* cannot be that of Zhao Mengfu. That seal was used specifically for collected works, and it appears on Zhao Mengfu's own *Old Tree, Bamboo, and Rock* of about 1320, as well as on seven other early paintings and calligraphies (figs. 92b, 92c).[5] The most logical explanation is that the Tianshui seal on *Riverbank* belonged to Zhao Yuqin and that it continued to be used by members of his family during the early Yuan period, as evidenced by the seal's appearance on several works that postdate Zhao Yuqin's lifetime.

The chronological sequence of seals on *Riverbank* continues

 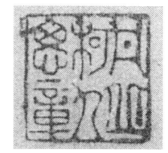

Figure 94a Figure 94b

Figure 94a. Detail of *Danqiu Ke Jiusi zhang* seal of Ke Jiusi (1290–1343) on *Riverbank*

Figure 94b. Detail of *Danqiu Ke Jiusi zhang* seal of Ke Jiusi (1290–1343) on his *Palace Poems*. Handscroll, ink on paper, 12 x 20⅞ in. (30.5 x 53 cm). John B. Elliott Collection, The Art Museum, Princeton University

Figure 95. Detail of *Ke shi qingwan* seal of Ke Jiusi (1290–1343) on *Riverbank*

Figure 96. Detail of *Ke shi Jingzhong* seal of Ke Jiusi (1290–1343) on *Riverbank*

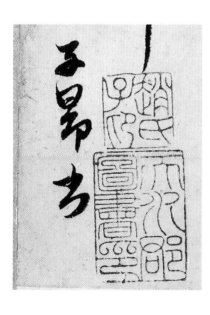

Figure 93. Detail of Zhao Mengfu's (1254–1322) signature and two seals including *Tianshuijun tushuyin* (bottom) on his *Four Anecdotes from the Life of Wang Xizhi*, 1310s. Handscroll, ink on paper, 9½ x 48⅞ in. (24.2 x 116.5 cm). The Metropolitan Museum of Art. Bequest of John M. Crawford Jr., 1988 (1989.363.30)

with three seals belonging to Ke Jiusi (1290–1343), a noted collector and bamboo painter (pl. 5, page 101) who also served as connoisseur for the Yuan imperial collection under emperor Wenzong (r. 1328–32). Two of Ke's seals appear in the lower-left corner of the painting; a third is situated in the lower-right corner. This unusual disposition of a single collector's seals has led Richard Barnhart to suggest that the two lengths of silk that make up the present composition may have been mounted separately as independent hanging scrolls.[6] If that is the case, it is possible that Ke Jiusi was responsible for reuniting the two panels. That parts of Ke's seals are now missing attests to the continued repairs and loss of silk that the painting sustained subsequent to Ke's ownership. The upper seal on the left (fig. 94a) compares closely with another extant example (fig. 94b), while the other two seals (figs. 95, 96) are distinct from published examples.

The latest early seal on *Riverbank*, impressed in the lower-right corner, is the official inventory seal of the Ming imperial collection, used about 1374–84 (fig. 97a). Numerous works that bear Song and Yuan imperial seals also bear the left half of this seal (fig. 97b), which suggests that it was used to record works seized at the beginning of the Ming dynasty, most notably those pieces assembled in the Yuan imperial collection. Because Ke Jiusi is known to have presented works to the throne during his tenure as official connoisseur under Wenzong, it is possible that *Riverbank* entered the Yuan palace at this time.[7] Because Wenzong's reign ended abruptly and because his successors had little concern for art, it is not surprising that the scroll never received an official Yuan seal.

The remaining twelve seals are twentieth century in date and are those of the painting's recent owners, Zhang Daqian (1899–1983—one seal is in fact that of Zhang's brother, Zhang Shanzi, 1882–1940) and C. C. Wang (b. 1907).

THE DOCUMENTARY EVIDENCE

The physical evidence of *Riverbank*'s transmission is complemented by the documentary evidence found in early textual sources. Three late-thirteenth-century references to *Riverbank* attest to the renewed interest in Dong Yuan on the part of artists and collectors living in South China during the early Yuan period. The earliest source is Zhou Mi's (1232–1298) *Record of What Was Seen as Clouds and Mists*, in which a listing of works in the collection of the late-thirteenth-century collector Zhao Yuqin includes the entry "Dong Yuan's *Riverbank*."[8] The same source also notes that the painting later entered the holdings of the early-Yuan collector Wang Ziqing (active ca. 1290–1310).[9] A third mention of the painting appears in the collected poetry of Zhao Mengfu. Zhao, a friend of both Zhou Mi and Wang Ziqing, composed a poem entitled "For Dong Yuan's *Riverbank*" sometime before he went north to present himself at the Mongol Yuan court in Beijing in 1286.[10] Although no further references to *Riverbank* appear in Yuan written sources, numerous works by the late-Yuan landscape master Wang Meng (ca. 1308–1385; see pl. 8, page 121), a grandson of Zhao Mengfu, suggest that he too was familiar with *Riverbank*, which he could have seen as a young man either at his grandfather's house or through Ke Jiusi.

Once the painting entered the Ming imperial collection, it was removed from circulation and remained unavailable to Ming scholar-artists, including Dong Qichang (1555–1636), whose investigations into Dong Yuan's painting style indicate that he had no knowledge of the painting. *Riverbank* was also unknown to Qing artists. The next written reference to the painting is in a letter dating from late 1938 or early 1939 that was sent from Singapore by the painter Xu Beihong (1895–1953; fig. 40, page 47) which attests to his rediscovery of *Riverbank* in

Figure 97a Figure 97b

Figure 97a. Detail of official Ming inventory seal of ca. 1374–84 on *Riverbank*

Figure 97b. Detail of official Ming inventory seal of ca. 1374–84 on *Poem Written in a Boat on the Wu River*, ca. 1100, by Mi Fu (1052–1107). Handscroll, ink on paper, 12¼ x 220¼ in. (31.3 x 559.8 cm). The Metropolitan Museum of Art. Gift of John M. Crawford Jr., in honor of Professor Wen Fong, 1984 (1984.174)

Guilin. In his letter, Xu notes the presence of both the artist's inscription and the early seals discussed above. Because Guilin was the seat of an important Ming princedom, it is possible that *Riverbank* was removed from the main Ming imperial collection early in the dynasty and found its way into the holdings of the Guilin branch of the Ming royal family where it would have been inaccessible to Ming artists, even those serving at court. The painting apparently remained in the Guilin area during the ensuing Qing dynasty.

Shortly after acquiring the painting, Xu Beihong relinquished it to the noted artist-collector Zhang Daqian (1899–1983). The painting remained with Zhang for thirty years. About 1968, Zhang sold the painting to C. C. Wang. As soon as he acquired it, Mr. Wang enlisted the services of Meguro Sanji, a Japanese restorer also used by Zhang Daqian, to remount *Riverbank* in its present state. In 1973, when the Metropolitan Museum acquired a group of twenty-five Song and Yuan paintings from C. C. Wang, he declined to include *Riverbank* in the group. At the time, his son, S. K. Wang, was still living in China and Mr. Wang believed that he might have to relinquish *Riverbank* to the Chinese government in order to secure his son's emigration. Only after

S. K. Wang and his family had moved to the United States did C. C. Wang consider parting with the scroll. He has regarded the painting, since its acquisition, as his most important possession.

1. See Barnhart 1983a, p. 37.
2. Zhao Yuqin's exact dates are unknown, but a rough idea of his period of activity is established by the dates of two other Zhao clan members who share the same first character in their given names, Zhao Yuqi (1224–1297) and Zhao Yupiao (1242–1303), thus identifying them as belonging to the same genealogical generation. For Zhao Yuqin's ownership of *Riverbank*, see Zhou Mi, *Yunyan guoyan lu*, in *Qinghe shuhuafang*, juan 1, p. 156.
3. For a brief discussion of the Zhao family's use of the title "Tianshui Commandary," see Yang 1998, pp. 39–41. For the historical area known as Tianshui Commandary, see *Cidian*, vol. 2 (Shanghai: Shanghai cishu chubanshe, 1979), p. 2860. For Emperor Huizong's (r. 1101–25) use of a seal with this legend, see *Xuanhe yishi* (Historical Remnants from the Xuanhe era) in *Congshu jicheng* (Gathered Collectanea) 1985, vol. 3889, p. 68. For an early-twelfth-century use of the title "Tianshuijun" by a fifth-generation descendant of Emperor Taizu (960–76), see Mi Fu's (1052–1107) *Epitaph for the Marquis of Zong* (*Zongguo Gong Muzhi*; private collection, Japan), dated 1107, in *Shodō zenshū* 1930–32, vol. 18, pp. 199–202.
4. For Guan Daosheng's seal "Zhao Family from Tianshui" (*Tianshui Zhao shi*), see *Gugong shuhua tulu* 1989, vol. 5, pp. 95–96; for Zhao Yong's seal, "Tianshui Painting and Calligraphy" (*Tianshui tushu*), see *Zhongguo shuhuajia yinjian* 1991, vol. 2, pp. 12–13.
5. Kathleen Yang (1998, pp. 39–41, and personal correspondence) was the first to document other examples of the Tianshui seal also found on *Riverbank*. Works identified by Yang that bear this seal are: *Gentlemen on a Spring Outing*, attributed to Zhao Yan (d. 923),

see *Gugong shuhua tulu* 1989, vol. 1, pp. 49–50; *Bamboo in the Wind*, attributed to Li Po (937–975), see ibid.; *Listening to Wind in the Pines*, dated 1246, by Ma Lin (ca. 1180–after 1256), see ibid., vol. 2, pp. 193–94; *Luohan*, attributed to the Song dynasty, see ibid., vol. 3, pp. 31–32; a volume of rubbings from the *Chunhuage* compendium (engraved 992), see *Fine Chinese Painting, Calligraphy, and Rubbings*, sale cat., Christie's, New York, Sept. 18, 1996, lot 70; and *Old Tree, Bamboo, and Rock*, by Zhao Mengfu (1254–1322), see *Gugong shuhua tulu* 1989, vol. 4, pp. 57–58. In addition, Yang has discovered two recorded references to a seal with this legend: *Compendium of Six Song Calligraphies* (whereabouts unknown), see *Shiqu baoji xubian*, vol. 3, p. 1671; and a manuscript of poetry in regular script by Yu Ji (1272–1348), leaf 29 in *Album of Precious Writings of the Song and Yuan* (whereabouts unknown), see *Shiqu baoji*, vol. 1, p. 466. Yiguo Zhang, of the Metropolitan Museum, has discovered another example of this seal on a painting of plum blossoms by Wang Mian (1287–1359); see *Garland of Chinese Painting* 1967, vol. 2, pl. 33.
6. Barnhart 1983a, p. 30.
7. In the *Huajian* (1959 ed., p. 12), Tang Hou (active ca. 1320s) lists *Riverbank* as one of the paintings he saw in the imperial collection. Another version of Tang Hou's text appears in *Gujin huajian*, 1937 ed., p. 6. The two versions are nearly identical, but several characters in the *Gujin huajian* version appear to be erroneous transcriptions, including the rendering of the painting title *Kongzi ku yu Qiuzi tu* as *Huang Zijiu yu Qiuzi tu*. Because Huang Zijiu is another name for Huang Gongwang (1269–1354), this error led Barnhart to suggest that *Riverbank* could have been in Huang's collection, but this seems unlikely; see Barnhart 1970, p. 39, n. 116.
8. Zhou Mi, *Yunyan guoyan lu*, in *Qinghe shuhuafang*, juan 1, p. 156.
9. Ibid.
10. Zhao Mengfu, *Songxuezhai ji*, juan 2, p. 12. For an English translation of this poem, see page 30 in this volume.

Bibliography

Edited by Jean Wagner

A note on romanization: Chinese words and names appear in the pinyin system of romanization except where these names and words appear in Western-language sources, in which case the romanization follows that used in the original (often the Wade-Giles system in older sources). In those instances where a Chinese source has been romanized but the author uses another romanization system for the spelling of his name, that spelling has been retained, followed by the pinyin spelling in parantheses. The surnames of these authors has also been set off from their given names by a comma, in Western fashion.

Acker, William. *Some T'ang and Pre-T'ang Texts on Chinese Painting.* Leiden: E. J. Brill, 1954.

Akai Kiyomi. *Hachidai Sanjin shoga shu* (Collection of Calligraphy and Paintings by Bada Shanren). Tokyo, 1975.

Archaeological Team of the Liaoning Provincial Museum. "Faku Yemaotai Liaomu jilue" (Excavation of the Liao Tomb at Yemaotai in Faku County, Liaoning Province). *Wenwu* (Cultural Relics), no. 12 (1975), pp. 26–39.

Bada Shitao shuhuaji (The Paintings and Calligraphy of Bada and Shitao). Taipei: National Museum of History, 1984.

Bai, Qianshen. "Image as Word: A Preliminary Study of Rebus Play in Song Painting (960–1279)." *Metropolitan Museum Journal* 34 (1999). Forthcoming.

Barnhart, Richard M. *Marriage of the Lord of the River: A Lost Landscape by Tung Yüan.* Artibus Asiae Supplementum, 27. Ascona, Switzerland: Artibus Asiae, 1970.

———. *Wintry Forests, Old Trees: Some Landscape Themes in Chinese Painting.* Exh. cat. New York: China House Gallery, China Institute of America, 1972.

———. "Yao Yen-ch'ing, T'ing Mei of Wu-hsing." *Artibus Asiae* 39 (1977), pp. 105–23.

———. *Along the Border of Heaven: Sung and Yüan Paintings from the C. C. Wang Family Collection.* New York: The Metropolitan Museum of Art, 1983a.

———. "The Wild and Heterodox School of Ming Painting." In *Theories of Art in China,* edited by Susan Bush and Christian Murck, pp. 365–96. Princeton: Princeton University Press, 1983b.

———. "Wang Shen and Late Northern Sung Landscape Painting." In *International Symposium on Art Historical Studies, 2d, 1983, Kyōto,* pp. 61–70. Kyoto: National Museum and Taniguchi Foundation, 1984.

———. Letter to the Editor. *Orientations* 28, no. 11 (December 1997), p. 86.

———. Letter to the Editor. *Orientations* 29, no. 8 (September 1998), p. 101.

Barnhart, Richard M., et al. *Painters of the Great Ming: The Imperial Court and the Zhe School.* Dallas: Dallas Museum of Art, 1993.

———. *The Jade Studio: Masterpieces of Ming and Qing Painting and Calligraphy from the Wong Nan-p'ing Collection.* Exh. cat. New Haven: Yale University Art Gallery, 1994.

Barnhart, Richard M., Iriya Yoshitaka, and Nakata Yūjirō, eds. *Tō Gen, Kyonen* (Dong Yuan, Juran). Vol. 2 of *Bunjinga suihen* (Selected Masterpieces of Literati Painting). Tokyo: Chūōkōronsha, 1977.

Bian Yongyu. *Shigutang shuhua huikao* (Compilation of Writings on Calligraphy and Painting; 1682). Reprint of the 1921 facsimile. Taipei: Zhengzhong shuju, 1958.

Birch, Cyril, comp. and ed. *Anthology of Chinese Literature.* [Vol. 1,] *From Early Times to the Fourteenth Century.* New York: Grove Press, 1965.

Bush, Susan, and Hsio-yen Shih, comps. and eds. *Early Chinese Texts on Painting.* Cambridge, Massachusetts: Harvard University Press, 1985.

Cahill, James. "Wu Chen: A Chinese Landscapist and Bamboo Painter of the Fourteenth Century." Ph.D. dissertation, University of Michigan, Ann Arbor, 1958.

———. *Hills Beyond a River: Chinese Painting of the Yüan Dynasty, 1279–1368.* Vol. 1 of *A History of Later Chinese Painting, 1279–1950.* New York and Tokyo: Weatherhill, 1976.

———. *Parting at the Shore: Chinese Painting of the Early and Middle Ming Dynasty, 1368–1580.* Vol. 2 of *A History of Later Chinese Painting, 1279–1950.* New York and Tokyo: Weatherhill, 1978.

———. *An Index of Early Chinese Painters and Paintings: T'ang, Sung, and Yüan.* Berkeley and Los Angeles: University of California Press, 1980.

———, ed. *Shadows of Mount Huang: Chinese Painting and Printing of the Anhui School.* Berkeley: University Art Museum, 1981a.

———. "Some Aspects of Tenth Century Painting as Seen in Three Recently-Published Works." In *Guoji Hanxue huiyi lunwenji* (Proceedings of the International Sinological Conference), pp. 1–36. Taipei: Zhongyang yanjiuyuan, 1981b.

———. *The Compelling Image: Nature and Style in Seventeenth-Century Chinese Painting*. Cambridge, Massachusetts: Harvard University Press, 1982a.

———. *The Distant Mountains: Chinese Painting of the Late Ming Dynasty, 1570–1644*. Vol. 3 of *A History of Later Chinese Painting, 1279–1950*. New York and Tokyo: Weatherhill, 1982b.

———. "Authenticity Issues Re-emerge in Chinese Painting Studies." *Lotus Leaves* (San Francisco: Society for Asian Art) 1, no. 1 (fall 1997), pp. 4–6.

Chang, Kang-i Sun. *The Evolution of Chinese Tz'u Poetry from Late T'ang to Northern Sung*. Princeton: Princeton University Press, 1980.

Chang Kuang-pin (Zhang Guangbin). *Yuan sidajia* (Four Great Masters of the Yuan). Translated by Karen L. Brock and Robert L. Thorp. Taipei: National Palace Museum, 1975.

———. "Li Kan: Wen Huzhou zhupai de zhongxingzhe" (Li Kan: The Painter Who Revived Wen Tong's School of Bamboo Painting). In *Yuanchao shuhuashi yanjiu lunji* (Collection of Essays on the History of Yuan-Dynasty Calligraphy and Painting). Taipei: National Palace Museum, 1979.

Chen Gaohua, ed. *Yuandai huajia shiliao* (Historical Materials on the Painters of the Yuan Dynasty). Shanghai, 1980.

———. *Song Liao Jin huajia shiliao* (Historical Materials on Painters of the Song, Liao, and Jin Dynasties). Beijing: Wenwu chubanshe, 1984.

Chen Huisun and Zhong Wenbin. *Bada Shanren huaji* (A Collection of Bada Shanren Paintings). Jiangxi, 1985.

Chen, J. D. (Chen Rentao). *The Three Patriarchs of the Southern School in Chinese Paintings*. Hongkong: Union Syndicate, 1955.

———. *Jingui canghua ji* (Chinese Paintings from the King Kwei Collection). 2 vols. Hongkong: Tongying gongsi, 1956.

Ch'en Pao-chen (Chen Baozhen). "Nan Tang Liezu de gexing he wenyi huodong" (The First Emperor of the Southern Tang Dynasty [937–975]: His Personality and Artistic Activities). *Taida Journal of Art History*, no. 2 (1995), pp. 27–46.

———. "Nan Tang Zhongzhu de zhengzhi yu wenhua jianshe" (The Second Emperor of the Southern Tang Dynasty [937–975]: His Political Achievements and Artistic Activities). *Taida Journal of Art History*, no. 3 (March 1996), pp. 41–93.

———. "Yishu diwang Li Houzhu (yi)" (Li Houzhu as an Artist and Emperor, Part One). *Taida Journal of Art History*, no. 4 (March 1997), pp. 43–58.

———. "Yishu diwang Li Houzhu (er)" (Li Houzhu as an Artist and Emperor, Part Two). *Taida Journal of Art History*, no. 5 (March 1998), pp. 41–76.

Chiang I-han (Jiang Yihan). "Ke Jiusi shu gongci juan" (*Palace Poems*, a Handscroll by Ke Jiusu). *Wenwu huikan, dierhhao chiuyinben. Nanyang daxue, Li Guangqian wenwuguan*, June 1976, pp. 36–54.

———. "Yuandai Kuizhangge he Xuanwenge zhong de qiwei jianshu boshi (shang)" (Seven Doctors of Authenticating Calligraphy in the Kuizhang Pavilion and the Xuanwen Pavilion during the Yuan Period, Part One). *Zhongguo xueren*, no. 6 (September 1977), pp. 97–117.

———. *Yuandai Kuizhangge ji Kuizhang renwu* (The Star of Literature Pavilion and Its Personalities during the Yuan Period). Taipei: Jinglian chuban shiye gongsi, 1981.

China 5,000 Years: Innovation and Transformation in the Arts. Selected by Sherman Lee. Exh. cat. New York: Guggenheim Museum, 1998.

Chou, Ju-hsi, and Claudia Brown. *The Scent of Ink: The Roy and Marilyn Papp Collection of Chinese Painting*. Exh. cat. Phoenix: Phoenix Art Museum, 1994.

———. *Journeys on Paper and Silk: The Roy and Marilyn Papp Collection of Chinese Painting*. Phoenix: Phoenix Art Museum, 1997.

Chuang Shen (Zhuang Shen). "Gugong shuhua sojian Mingdai banguanyin kao." *Youshi xuebao* (Taipei) 1, *juan* 3 (July 1960), pp. 25–34.

Cleaves, Francis W. "The 'Fifteen Palace Poems' by K'o Chiu-ssu." *Harvard Journal of Asiatic Studies* 20, nos. 3, 4 (December 1957), pp. 391–479.

Contag, Victoria. *Chinese Masters of the 17th Century*. Translated by Michael Bullock. Rutland, Vermont, and Tokyo: Charles E. Tuttle Co., 1969.

DeBevoise, Jane Boettger. "Wei Xian Gaoshi tu: Toward an Understanding of Five Dynasties Monumental Landscape Painting." M.A. thesis, University of California, Berkeley, 1982.

Deng Chun. *Huaji* (A Continuation of the History of Painting; preface dated 1167). In *Huashi congshu*, edited by Yu Anlan, vol. 1. Shanghai, 1963.

Dictionary of Ming Biography, 1368–1644. Edited by L. Carrington Goodrich and Chaoying Fang. New York: Columbia University Press, 1976.

Ding Xiyuan. "Xie Zhiliu shuo: *Xi'an tu* yuan shi Xu Beihong de . . ." (Xie Zhiliu Said: *Riverbank* Was Originally Xu Beihong's). *Yishu xinwen* (Chinese Art News), no. 10 (1997), p. 74.

———. "Du *Xi'an tu*" (Reading *Riverbank*). *Gugong wenwu yuekan* (National Palace Museum Monthly of Chinese Art), no. 179 (February 1998a), pp. 101–7.

———. "Tianxia diyi Dong Beiyuan; zai du *Xi'an tu*" (The Premier Dong Yuan under Heaven; a Further Reading of *Riverbank*). *Gugong wenwu yuekan* (National Palace Museum Monthly of Chinese Art), no. 189 (December 1998b), pp. 114–30.

———. "*Xiao Xiang tu* kao" (Research on *Xiao and Xiang Rivers*). *Gugong wenwu yuekan* (National Palace Museum Monthly of Chinese Art), no. 185 (August 1998c), pp. 100–116.

Dobrzynski, Judith. "11 Major Chinese Paintings Promised to Met." *New York Times*, May 19, 1997, pp. A1, C13.

Dong Qichang. *Huachanshi suibi* (Miscellaneous Notes of the Huachan Studio). Compiled by Yang Wubu; 1720.

———. *Huayan* (The Eye of Painting). In *Yishu congbian*, ser. 1, vol. 12. Reprint ed., Taipei: Shijie shuju, 1967.

Du Fu. *Du Gongbu shiji* (The Poems of Du Fu). Hongkong: Zhonghua shuju, 1972.

Du Mu (1458–1525) [sic., Anon.]. *Tiewang shanhu* (Coral Treasures in an Iron Net). Preface dated 1758.

Dubosc, Jean-Pierre. *Mostre d'arte cinese*. Exh. cat. Venice: Palazzo Ducale, 1954.

Egami Yasushi and Kobayashi Hiromitsu. *Nanzenji shozo "Hizosen" no mokuhanga / Woodcuts in the Nanzenji Bizangquan*. Tokyo: Yamakawa shuppansha, 1994.

Eight Dynasties of Chinese Painting: The Collections of the Nelson Gallery-Atkins Museum, Kansas City, and the Cleveland Museum of Art. Exh. cat. Cleveland: Cleveland Museum of Art, 1980.

Ellsworth, Robert Hatfield, et al. *Later Chinese Painting and Calligraphy, 1800–1950*. 3 vols. New York: Random House, 1987.

Feng Youheng. "*Xi'an tu de zai sikao*" (Additional Thoughts on *Riverbank*). *Yishu xinwen* (Chinese Art News), no. 12 (1997), pp. 88–89.

Fong, Wen C. "Five Hundred Lohans at the Daitokuji." 2 vols. Ph.D. dissertation, Princeton University, 1956.

———. *The Lohans and a Bridge to Heaven*. Freer Gallery of Art Occasional Papers, vol. 3, no. 1. Washington, D.C.: Smithsonian Institution, 1958.

———. "*Rivers and Mountains after Snow* (Chiang-shan hsüeh-chi) Attributed to Wang Wei (A.D. 699–759)." *Archives of Asian Art* 30 (1976–77), pp. 6–33.

———. Review of *The Compelling Image*, by James F. Cahill. *Art Bulletin* 68 (September 1986), pp. 504–8.

———. "Stages in the Life and Art of Chu Ta (1626–1705)." *Archives of Asian Art* 40 (1987), pp. 7–23.

———. *Beyond Representation: Chinese Painting and Calligraphy 8th–14th Century*. New York: The Metropolitan Museum of Art, 1992.

Fong, Wen C., and Maxwell K. Hearn. "Silent Poetry: Chinese Paintings in the Douglas Dillon Galleries." *The Metropolitan Museum of Art Bulletin* 39, no. 3 (winter 1981–82).

Fong, Wen C., Alfreda Murck, Shou-chien Shih, Pao-chen Ch'en, and Jan Stuart. *Images of the Mind: Selections from the Edward L. Elliott Family and John B. Elliott Collections of Chinese Calligraphy and Painting at The Art Museum, Princeton University*. Princeton: The Art Museum, Princeton University, 1984.

Fong, Wen C., James C. Y. Watt, et al. *Possessing the Past: Treasures from the National Palace Museum, Taipei*. Exh. cat. New York: The Metropolitan Museum of Art and National Palace Museum, 1996.

Franke, Herbert. "Could the Mongol Emperors Read and Write Chinese?" *Asia Minor* 3 (1953), pp. 28–41.

———, ed. *Sung Biographies*. 4 vols. Münchener Ostasiatische Studien, 16, 17. Wiesbaden: Franz Steiner, 1976.

Fu, Marilyn, and Fu Shen. *Studies in Connoisseurship: Chinese Paintings from the Arthur M. Sackler Collection in New York and Princeton*. Princeton: The Art Museum, Princeton University, 1973.

Fu Shen. "Notes on Chiang Shen." *National Palace Museum Bulletin* 1, no. 3 (July 1966), pp. 1–11.

———. "A Further Note on Chiang Shen." *National Palace Museum Bulletin* 1, no. 6 (January 1967a), pp. 11, 13.

———. "A Preliminary Study of the Extant Works of Chü-jan." *National Palace Museum Quarterly* 2 (1967b), pp. 51–79.

———. "A Landscape Painting by Yang Wei-chen." *National Palace Museum Bulletin* 8, no. 4 (September–October 1973), pp. 1–13.

———. *Yuandai huangshi shuhua shoucang shilue* (A Brief History of the Yuan Imperial Collections of Calligraphy and Painting). Taipei: National Palace Museum, 1981. Reprint of a four-part article first published in *Gugong jikan* 13, nos. 1–4 (1978–79).

———. "Chang Dai-chien's 'The Three Worthies of Wu' and His Practice of Forging Ancient Art." Translated by Jan Stuart. *Orientations* 20, no. 9 (September 1989), pp. 56–72.

———. *Challenging the Past: The Paintings of Chang Dai-chien*. Exh. cat. Washington, D.C.: Arthur M. Sackler Gallery, Smithsonian Institution; New York; Asia Society; St. Louis Art Museum, 1991.

———. "Chang Dai-chien and Tung Yüan." In *Proceedings of the International Conference on the Poetry, Calligraphy, and Painting of Chang Dai-chien and P'u Hsin-yu, 1993*, pp. 67–122. Taipei: National Palace Museum, 1994.

———. "*Bian Dong Yuan Xi'an tu jue fei Zhang Daqian weizuo*" (Determining that Dong Yuan's *Riverbank* Is Definitely Not a Forgery by Zhang Daqian). *Yishujia* (Artist), no. 269 (October 1997), pp. 256–57.

Fu Shen et al. *Traces of the Brush: Studies in Chinese Calligraphy*. Exh. cat. New Haven: Yale University Art Gallery, 1977.

Fu Xinian. "*Guanyu Zhan Ziqian Youchun tu niandai di tantao*" (On Dating Zhan Ziqian's *Traveling in Spring*). *Wenwu*, no. 11 (1978), pp. 40–52.

Garland of Chinese Painting. Hongkong: Cafa Company, 1967.

Gaskin, Steven P. Letter to the Editor. *Orientations* 29, no. 10 (November 1998), p. 75.

Giacalone, Vito. *Chu Ta: A Selection of Paintings and Calligraphy*. Exh. cat. Poughkeepsie: Vassar College Art Gallery; New York Cultural Center, 1972.

Gu Fu. *Pingsheng zhuangguan* (The Great Sights in My Life; a Record of Paintings and Collections; preface dated 1692). Facsimile reprint. Shanghai: Renmin meishu chubanshe, 1962.

Guan Mianjun. *Sanqiuge shuhualu* (Record of Calligraphy and Painting from the Sanqiu Pavilion). 1928 edition.

Gugong bowuyuan cang lidai fashu xuanji, dierji (Select Calligraphies from the Collection of the Palace Museum [Beijing]). Beijing: Wenwu chubanshe, 1977.

Gugong shuhua tulu (Illustrated Catalogue of Painting and Calligraphy in the Palace Museum). 24 vols. to date. Taipei: National Palace Museum, 1989– .

Guo Xi. *Linquan gaozhi* (Lofty Ambition in Forests and Streams). Compiled by Guo Si, 1117. In *Zhongguo hualun leibian*, edited by Yu Jianhua, vol. 1. Hongkong, 1973.

Han, Sungmii Lee. "Wu Chen's 'Mo-chu p'u': Literati Painter's Manual on Ink Bamboo." Ph.D. dissertation, Princeton University, 1983.

Han Wei. *Haineiwai Tangdai jinyinqi cuibian* (Masterpieces of Tang Gold and Silver from International Collections). Xi'an: Shaanxisheng xinhua shudian, 1989.

Handler, Sarah. "The Revolution in Chinese Furniture: Moving from Mat to Chair." *Asian Art* 4, no. 3 (summer 1991), pp. 9–33.

Harrist, Robert E., Jr., Wen C. Fong, et al. *The Embodied Image: Chinese Calligraphy from the John B. Elliott Collection*. Princeton: The Art Museum, Princeton University, 1999.

Hay, John. "'Along the River During Winter's First Snow': A Tenth-Century Handscroll and Early Chinese Narrative." *Burlington Magazine* 114 (May 1972), pp. 294–303.

He Qi. "Tang Gong Qiqiao tu qianxi" (A Preliminary Analysis of the Qiqiao Festival in the Tang Palace). *Yiyuan duoying* (Plucked Flowers from the Garden of Art), no. 38 (1988), p. 4.

He Zicheng. "Tang Tomb Paintings." *Wenwu* (Cultural Relics), no. 8 (1959), p. 33.

Hearn, Maxwell K. "The Changing Face of Narrative in Early Chinese Painting: Three Milestones from the Metropolitan Museum." *Orientations* 28, no. 11 (December 1997), pp. 20–29.

Ho, Wai-kam, Iriya Yoshitaka, and Nakata Yūjirō. *Kō Kōbō, Gei San, O Mō, Go Chin* (Huang Gongwang, Ni Zan, Wang Meng, Wu Zhen). Vol. 3 of *Bunjinga suihen* (Selected Masterpieces of Literati Painting). Tokyo: Chūōkōronsha, 1979.

Hualun congkan (Collected Reprints on Painting Theory). Edited by Yu Anlan. 2 vols. Reprint ed. Shanghai: Renmin meishu chubanshe, 1958.

Huang Gongwang. *Xie shanshui jue* (Secrets of Landscape Painting). In *Zhongguo hualun leibian*, edited by Yu Jianhua, vol. 2. Hongkong, 1973.

Huashi congshu (Compendium of Painting Histories). Edited by Yu Anlan. Shanghai: Renmin meishu chubanshe, 1963.

Jang, Scarlett. "Realm of the Immortals: Paintings Decorating the Jade Hall of the Northern Song." *Ars Orientalis* 22 (1992), pp. 81–96.

Jing Hao. *Bifaji* (Notes on Brush Method). In *Zhongguo hualun leibian*, edited by Yu Jianhua, vol. 1. Hongkong, 1973.

Kao, Mu-sen. "Li K'an: An Early Fourteenth-Century Painter." *Chinese Culture* 22, no. 3 (September 1981), pp. 85–101.

Kao, Yu-kung. "Chinese Lyric Aesthetics." In *Words and Images: Chinese Poetry, Calligraphy, and Painting*, edited by Alfreda Murck and Wen C. Fong, pp. 47–90. New York: The Metropolitan Museum of Art, 1991.

Kohara, Hironobu. "Tung Ch'i-ch'ang's Connoisseurship in T'ang and Sung Painting." In *The Century of Tung Ch'i-ch'ang, 1555–1636*, pp. 81–103. Exh. cat. Kansas City: Nelson-Atkins Museum of Art, 1992.

Kwong Lum and Jia Chen. "Accusations of Forgery: Who Painted the *Riverbank* Attributed to Dong Yuan? The Recovery of the Tang Dynasty Painting: Master Wang Wei's Ink-Wash Creation *On the Wangchuan River*." *International Journal of Politics, Culture, and Society* 11, no. 3 (1998), pp. 439–49.

Langlois, John D. "Yü Chi and His Mongol Sovereign: The Scholar as Apologist." *Journal of Asian Studies* 38, no. 1 (November 1978), pp. 99–116.

Lawton, Thomas. *Freer Gallery of Art Fiftieth Anniversary Exhibition, II: Chinese Figure Painting*. Exh. cat. Washington, D.C.: Smithsonian Institution, 1973.

Lee, Sherman E. *Chinese Landscape Painting*. Cleveland: Cleveland Museum of Art, 1954.

Lee, Sherman E., and Wai-kam Ho. *Chinese Art under the Mongols: The Yüan Dynasty (1279–1368)*. Exh. cat. Cleveland: Cleveland Museum of Art, 1968.

Li, Chu-tsing. "Rocks and Trees and the Art of Ts'ao Chih-po." *Artibus Asiae* 23 (1960), pp. 153–92.

———. *The Autumn Colors on the Ch'iao and Hua Mountains: A Landscape by Chao Meng-fu*. Artibus Asiae Supplementum, 21. Ascona, Switzerland: Artibus Asiae, 1965.

———. "The Freer 'Sheep and Goat' and Chao Meng-fu's Horse Paintings." *Artibus Asiae* 30 (1968), pp. 279–326.

———. "Stages of Development in Yüan Landscape Painting," parts 1, 2. *National Palace Museum Bulletin* 4, no. 2 (May–June 1969), pp. 1–10; no. 3 (July–August 1969), pp. 1–12.

———. "The Development of Painting in Soochow during the Yüan Dynasty." In *Proceedings of the International Symposium on Chinese Painting*, pp. 483–503. Taipei: National Palace Museum, 1970.

———. "*Grooms and Horses* by Three Members of the Chao Family." In *Words and Images*, edited by Alfreda Murck and Wen C. Fong, pp. 199–220. New York: The Metropolitan Museum of Art, 1991.

Li Diaoyuan. *Zhujia canghua bu* (List of Paintings in Various Collections). Preface dated 1778.

Li Fang et al. *Taiping yulan* (Imperial Readings of the Taiping Era). Beijing: Zhonghua shuju, 1960.

Li Lin-ts'an. "Pine and Rock, Wintry Tree, Old Tree and Bamboo and Rock, the Development of a Theme." Translated by John Hay. *National Palace Museum Bulletin* 9, no. 6 (January–February 1970), pp. 1–12.

Liaoning sheng bowuguan cang fashu xuanji (Select Calligraphies from the Collection of the Liaoning Provincial Museum). Beijing: Wenwu chubanshe, 1962.

Liu, Heping. "Painting and Commerce in Northern Song Dynasty China, 960–1126." Ph.D. dissertation, Yale University, New Haven, 1997.

Loehr, Max. "Studie über Wang Meng." *Sinica* 14, no. 5/6 (1939), pp. 273–90.

———. *Chinese Landscape Woodcuts from an Imperial Commentary to the Tenth-Century Printed Edition of the Buddhist Canon.* Cambridge, Massachusetts: Belknap Press, 1968.

———. *The Great Painters of China.* New York: Harper and Row, 1980.

Lu Jiugao and Han Wei. *Tangdai jinyin qi* (Gold and Silver Articles of the Tang Period). Beijing: Wenwu chubanshe, 1985.

Lu Shihua. *Wuyue suojian shuhua lu* (Record of Calligraphy and Painting Seen in the Wu and Yue Regions). Preface dated 1776. Reprinted 1879.

March, Benjamin. *Some Technical Terms of Chinese Painting.* Baltimore: Waverly Press, 1935.

McClelland, Hardin T. *Art Themes in Chinese Poetry.* Seattle: Little Tusculum, 1936.

Mi Fu. *Huashi* (History of Painting). In *Zhongguo hualun leibian*, edited by Yu Jianhua, vols. 1–2. Hongkong, 1973.

Minato Nobuyuki. "Chin Shika ni tsuite" (Concerning Chen Zihe). *Museum* 353 (August 1980), pp. 13–26.

Mingren zhuanji ziliao suoyin (Index of Biographical Materials on Ming Dynasty Personages). Taipei: Guoli zhongyang tushuguan, 1966.

Mu Yiqin. *Mingdai gongting yu Zhepai huihua xuanji* (A Selection of Ming-Dynasty Court Paintings and Zhe School Paintings). Beijing: Wenwu chubanshe, 1983.

———. *Mingdai yuanti Zhepai shiliao* (Historical Materials on Academic and Zhe School Artists of the Ming Dynasty). Shanghai: Shanghai renmin chubanshe, 1985.

Munakata, Kiyohiko. *Ching Hao's "Pi-fa-chi": A Note on the Art of Brush.* Ascona, Switzerland: Artibus Asiae, 1974.

———. *Sacred Mountains in Chinese Art.* Exh. cat. Urbana: Krannert Art Museum, University of Illinois at Urbana-Champaign, 1990.

Murck, Alfreda, and Wen C. Fong, eds. *Words and Images: Chinese Poetry, Calligraphy, and Painting.* New York: The Metropolitan Museum of Art, 1991.

Nagin, Carl. "The Met Has Just Acquired the 'Mona Lisa' of China: But Is It a Fake?" *New Yorker*, August 11, 1997, pp. 26–27.

———. Letter to the Editor. *Orientations* 29, no. 9 (October 1998), p. 98.

Ogawa Hiromitsu. "Inchu no meiga" (Famous Paintings in the Academy). In *Chūgoku kaigashi ronshū: Suzuki Kei sensei kanreki-kinen* (Essays on the History of Chinese Painting: Festschrift for Professor Suzuki Kei), pp. 23–85. Tokyo: Yoshikawa kōbunkan, 1981.

Pulleyblank, Edwin G. *The Background of the Rebellion of An Lu-shan.* London: Oxford University Press, 1955.

Reischauer, Edwin O., and John K. Fairbank. *East Asia: The Great Tradition.* Boston: Houghton Mifflin, 1960.

Rogers, Howard. Catalogue entries. In *Masterworks of Ming and Qing Painting from the Forbidden City*, by Howard Rogers and Sherman E. Lee, pp. 111–204. Exh. cat. Lansdale, Pennsylvania: International Arts Council, 1988.

Rowley, George. "A Chinese Scroll of the Ming Dynasty, 'Ming-huang and Yang Kuei-fei Listening to Music.'" *Artibus Asiae* 31 (1969), pp. 5–25.

Sensabaugh, David A. "Life at Jade Mountain: Notes on the Life of the Man of Letters in Fourteenth-Century Wu Society." In *Chūgoku kaigashi ronshū: Suzuki Kei sensei kanreki-kinen* (Essays on the History of Chinese Painting: Festschrift for Professor Suzuki Kei), pp. 44–69. Tokyo: Yoshikawa kōbunkan, 1981.

Shanghai Bowuguan, ed. *Zhongguo shuhuajia yinjian kuanshi* (Seal Inscriptions of Chinese Calligraphers and Painters). 2 vols. Beijing: Wenwu chubanshe, 1987.

Shih Shou-chien (Shi Shouqian). "You guan Tang Di (1287–1355) ji Yuandai Li-Guo fengge fazhan zhi ruogan wenti" (Tang Di [1287–1355] and the Development of the Li-Guo Style during the Yuan Dynasty). *Yishu xue* (Study of the Arts) 5 (March 1991), pp. 83–131.

———. "Shenhuan bianhua: You Fujian huajia Chen Zihe kan Mingdai Daojiao shuimohua zhi fazhan" (Magical Changes: Development of Ming Dynasty Daoist Ink-wash Paintings as Exemplified by the Fujian Painter Chen Zihe). *Taida Journal of Art History*, no. 2 (1995), pp. 47–74.

———. "Guanyu *Xi'an tu* niandai yu zuozhe wenti zhi wojian" (My Opinion Regarding the Dating and Authorship of *Riverbank*). *Yishu xinwen* (Chinese Art News), no. 12 (1997), pp. 82–87.

Shiqu baoji (Treasured Boxes of the Stony Moat [Catalogue of Painting and Calligraphy in the Qianlong Imperial Collection]; 1745). Compiled by Zhang Zhao et al. Facsimile reprint of an original manuscript copy. Taipei: National Palace Museum, 1971.

Shiqu baoji sanbian (Catalogue of Painting and Calligraphy in the Qianlong Imperial Collection, final sequel [part 3]; 1816). Compiled by Hu Jing et al. Facsimile reprint of an original manuscript copy. Taipei: National Palace Museum, 1969.

Shiqu baoji xubian (Catalogue of Painting and Calligraphy in the Qianlong Imperial Collection, sequel [part 2]; preface dated 1793). Compiled by Wang Jie et al. Facsimile reprint of an original manuscript copy. Taipei: National Palace Museum, 1971.

Shōdo zenshū (Compilation of Calligraphic Works). 27 vols. Tokyo: Heibonsha, 1930–32.

Sickman, Laurence, and Alexander Soper. *The Art and Architecture of China.* Baltimore: Penguin Books, 1956. 3d ed., 1968.

Silbergeld, Jerome. "In Praise of Government: Chao Yung's Painting 'Noble Steeds' and Late Yüan Politics." *Artibus Asiae* 46 (1985), pp. 159–202.

Sirén, Osvald. *Chinese Painting: Leading Masters and Principles.* 7 vols. New York: Ronald Press, 1956–58.

Smith, Bradley, and Wan-go Weng. *China: A History in Art.* New York: Harper and Row [1972].

Soper, Alexander C., trans. and ann. *Kuo Jo-hsü's* Experiences in Painting (*T'u-hua chien-wen chih*)*: An Eleventh Century History of Chinese Painting Together with the Chinese Text in Facsimile.* Washington, D.C.: American Council of Learned Societies, 1951.

Sullivan, Michael. *Chinese Landscape Painting in the Sui and T'ang Dynasties.* Berkeley and Los Angeles: University of California Press, 1980.

Sung, Hou-mei. "The Formation of the Ming Painting Academy." *Ming Studies* 29 (spring 1990), pp. 30–47.

———. "Lin Liang and His Eagle Paintings." *Archives of Asian Art* 44 (1991), pp. 95–102.

———. "Bian Wen-jin and His Flower and Bird Painting." *Oriental Art* 38, no. 3 (autumn 1992), pp. 154–64.

———. "Lu Chi and His Pheasant Painting." *National Palace Museum Research Quarterly* 10, no. 4 (1993), pp. 1–22, 93–94.

Suzuki Kei. *Toyo bijutsushi yosetsu.* 2 vols. Tokyo, 1962–63.

———. "A Few Observations Concerning the Li-Kuo School of Landscape Art in the Yüan Dynasty." *Acta Asiatica*, no. 15 (1968), pp. 27–67.

———, ed. *Rî To, Ba En, Ka Kei* (Li Tang, Ma Yuan, Xia Gui). Vol. 2 of *Suiboku bijutsu taikei* (Complete Collection of Ink Paintings). Tokyo: Kodansha, 1974.

———. *Chinese Art in Western Collections: Paintings II.* Vol. 2. Tokyo: Kodansha, 1979.

———, comp. *Chūgoku kaiga sōgō zuroku/Comprehensive Illustrated Catalog of Chinese Paintings.* Vol. 1. Tokyo: University of Tokyo Press, 1982.

Tang Hou (active ca. 1320s). *Gujin huajian* (Critique of Ancient and Recent Paintings). [Shanghai]: Shangwu yin shuguan, 1937.

———. *Huajian* (Critique of Paintings). Beijing: Renmin meishu chubanshe, 1959.

Tietze, Hans. *Genuine and False: Copies, Imitations, Forgeries.* New York: Chanticleer Press, 1948.

To-So-Gen-Min meiga taikan (Catalogue of an Exhibition of Chinese Paintings of the Tang, Song, Yuan, and Ming). 2 vols. Tokyo, 1929.

Tomita Kojiro and Tseng Hsien-Chi. *Portfolio of Chinese Paintings in the Museum (Yüan to Ch'ing Periods).* Boston: Museum of Fine Arts, 1961.

Underwood, Edna Worthley. *Tu Fu, Wanderer and Minstrel under Moons of Cathay.* Translated by Edna Worthley Underwood and Chi Hwang Chu. Portland: Mosher Press, 1929.

Vinograd, Richard E. "River Village—the Pleasure of Fishing and Chao Meng-fu's Li-Kuo Style Landscapes." *Artibus Asiae* 40 (1978), pp. 124–42.

———. "Some Landscapes Related to the Blue-and-Green Manner from the Early Yüan Period." *Artibus Asiae* 41 (1979a), pp. 101–31.

———. "Wang Meng's Pien Mountains: The Landscape of Eremitism in Later Fourteenth Century Chinese Painting." Ph.D. dissertation, University of California, Berkeley, 1979b.

———. "New Light on Tenth-Century Sources for Landscape Painting Styles of the Late Yüan Period." In *Chūgoku kaigashi ronshū: Suzuki Kei sensei kanreki-kinen* (Essays on the History of Chinese Painting: Festschrift for Professor Suzuki Kei), pp. 2–30. Tokyo: Yoshikawa kōbunkan, 1981.

———. "Family Properties: Personal Context and Cultural Pattern in Wang Meng's 'Pien Mountains' of 1366." *Ars Orientalis* 13 (1982), pp. 1–29.

Wakasugi Junji. "On the Landscape Screen at the Kyoto National Museum (Kyohaku-bon Senzui Byobu ni tsuite)." In *Sansui/Landscape Painting*, pp. 173–75. Tokyo: Kyoto kokuritsu hakubutsukan [1985].

Wang Fangyu and Richard M. Barnhart. *Master of the Lotus Garden: The Life and Art of Bada Shanren (1626–1705).* Exh. cat. New Haven: Yale University Art Gallery and Yale University Press, 1990.

Wang Keyu. *Shanhuwang minghua tiba; Shanhuwang fashu tiba* (Inscriptions on Famous Paintings from the Coral Net; Inscriptions on Famous Calligraphies from the Coral Net; preface dated 1643). Beijing: Wenwu chubanshe, 1992.

Wang Yuanqi. *Yuchuang manbi* (Jottings Done Beside a Rain-Splashed Window). In *Zhongguo hualun leibian*, edited by Yu Jianhua, part 1, pp. 169–73. Hongkong, 1973.

Weida di yishu chuantong tulu (The Great Heritage of Chinese Art). Compiled by Zheng Zhenduo. 12 parts in 2 vols. Shanghai: Shanghai zhuban gongsi, 1951–54.

White, William C. *An Album of Chinese Bamboos: A Study of a Set of Ink-Bamboo Drawings, A.D. 1785.* Toronto: University of Toronto Press, 1939.

Whitfield, Roderick. "Chang Tse-tuan's Ch'ing-ming Shang-ho t'u." Ph.D. dissertation, Princeton University, 1965.

———. "Chang Tse-tuan's Ch'ing-ming Shang-ho t'u." In *Proceedings of the International Symposium on Chinese Painting, National Palace Museum, Taipei, 18–24 June 1970*, pp. 351–88. Taipei, 1972.

———. "Material Culture in the Northern Song Dynasty—the World of Zhang Zeduan." In *Bright as Silver, White as Snow: Chinese White Ceramics from Late Tang to Yuan Dynasty: Examples from the Kai-Yin Lo Collection*, pp. 49–70. Hongkong: Yongmingtang, 1998.

Wong, K. S. (Huang Junshi). "Wo kan *Xi'an tu*" (My View of *Riverbank*). *Yishu xinwen* (Chinese Art News), no. 10 (1997), p. 73.

Wu, Hung. *The Double Screen: Medium and Representation in Chinese Painting.* Chicago: University of Chicago Press, 1996.

Wu Tung. *Tales from the Land of Dragons: 1,000 Years of Chinese Painting*. Exh. cat. Boston: Museum of Fine Arts, 1997.

Wu Tung and Kohara Hironobu. *Hachidai Sanjin* (Bada Shanren). In *Bunjinga suihen* (Selected Masterpieces of Literati Painting), vol. 6. Tokyo: Chūōkōronsha, 1977.

Wu Zhen. *Meidaoren yimo* (The Ink Legacy of Wu Zhen). In *Meishu congkan* (Collected Reprints on Fine Arts), compiled by Yu Junzhi, vol. 2. Taipei: Zhonghua congshu bianshen weiyuanhui, 1964.

Xia Wenyan. *Tuhui baojian* (Precious Mirror of Painting; preface dated 1365). In *Huashi congshu*, edited by Yu Anlan, vol. 2. Shanghai, 1963.

Xia Yusheng. "Ji Su Shi *Gumu zhushi* Wen Tong *Mozhu* hejuan" (The Handscroll Containing Su Shi's *Leafless Tree, Bamboo, and Rock* and Wen Tong's *Ink Bamboo*). *Wenwu* (Cultural Relics), no. 8 (1965), pp. 24–31.

Xiao Difei, ed. *Du Fu shixuan zhu* (Annotated Selection of Du Fu's Poetry). Beijing: Renmin wenxue chubanshe, 1979.

Xie Zhiliu, ed. *Tang, Wudai, Song, Yuan mingji* (Famous Paintings Surviving from the Tang, Five Dynasties, Song, and Yuan). Shanghai: Gudian wenxue chubanshe, 1957.

———. *Dong Yuan Juran heji* (Collected Works of Dong Yuan and Juran). Shanghai, 1982.

Xu Bangda. "Wei Xian *Gaoshi tu* (Wei Xian's *Lofty Scholar*)." *Zhongguo hua*, no. 2 (May 1958), p. 59.

———. *Gushuhua weie kaobian* (Studies on Forgeries in Ancient Calligraphy and Painting). Jiangsu: Jiangsu guji chubanshe, 1984.

———. "Connoisseurship in Chinese Painting and Calligraphy: Some Copies and Forgeries." *Orientations* 19, no. 3 (March 1988), pp. 54–62.

Xuanhe huapu (Catalogue of the Imperial Painting Collection during the Xuanhe Era; preface dated 1120). In *Huashi congshu*, edited by Yu Anlan, vol. 2. Shanghai, 1963.

Xuanhe yishi (Historical Remnants from the Xuanhe era). In *Congshu jicheng* (Gathered Collectanea), vol. 3889. Beijing: Zhonghua shuju, 1985.

Yang, Kathleen. "In Support of *The Riverbank*." *Orientations* 29, no. 7 (July/August 1998), pp. 36–42.

Yang Renkai. "Yemaotai Liaomu chutu guhua de shidai ji qita" (The Dating of the Ancient Paintings Excavated from the Liao Tomb at Yemaotai and Other Matters). *Wenwu* (Cultural Relics), no. 12 (1975), pp. 37–39.

Yoshikawa Kōjirō. "Gen no chotei no bungaku" (Literature at the Yuan Court). In *Yoshikawa Kōjirō zenshū*. Tokyo, 1969.

Zhang Chou. *Qinghe shuhuafang* (The Painting and Calligraphy Barge at Qinghe). Preface dated 1616.

Zhang Daqian. *Dafengtang mingji* (Famous Paintings in the Dafengtang Collection). 4 vols. Taipei: Yayuntang, 1954.

Zhang Daqian. *Dafengtang mingji* (*Taifudo meiseiki*; Famous Paintings in the Dafengtang Collection). 3 vols. Kyoto: Benrido, 1955–56.

Zhang Yanyuan. *Lidai Minghua ji* (Record of Famous Paintings in Successive Dynasties; 847). In *Huashi congshu*, edited by Yu Anlan, vol. 1. Shanghai, 1963.

Zhao Mengfu (1254–1322). *Songxuezhai ji* (Collected Works of the Songxue Studio). In *Haiwangcun guji congkai* (Series of Ancient Books of Haiwang cun). Beijing: Zhongguo shudian, 1991.

Zhongguo hualun leibian (Classified Compilation of Writings on Chinese Painting). Edited by Yu Jianhua. Hongkong: Zhonghua shuju, 1973.

Zhongguo meishu quanji: Huihua bian 5, Yuandai huihua (Complete Collection of Chinese Arts: Painting Series, vol. 5, Yuan-Dynasty Painting). Edited by Fu Xinian. Beijing: Renmin meishu chubanshe, 1989.

Zhongguo meishujia renming cidian (Dictionary of Chinese Artists' Names). Shanghai: Renmin meishu chubanshe, 1981.

Zhou Haisheng. "Yang Xin, Fu Shen Jisheng shuo: *Xi'an tu* bushi Zhang Daqian huade" (Yang Xin and Fu Shen Loudly Proclaim: *Riverbank* Was Not Painted by Zhang Daqian). *Yishu xinwen* (Chinese Art News), no. 10 (1997a), pp. 70–71.

———. "Gao Juhan wei *Xi'an tu* . . . xiele fengxin gei Wang Jiqian" (James Cahill Writes a Letter to C. C. Wang Regarding *Riverbank*). *Yishu xinwen* (Chinese Art News), no. 10 (1997b), p. 72.

Zhou Mi (1232–1298). *Wulin jiushi* (Old Tales of Hangzhou; ca. 1280). Reprinted in *Wenyuange Siku quanshu*, vol. 590. Taipei: Taiwan shangwu yinshuguan, 1986.

———. *Yunyan guoyan lu* (Record of What Was Seen as Clouds and Mists; 1280s). In Zhang Chou, *Qinghe shuhuafang* (The Painting and Calligraphy Barge at Qinghe). Preface dated 1616.

Zhou Shixin. *Bada Shanren ji qi yishu* (The Life and Art of Bada Shanren). Taipei: Yishu tushu gongsi, 1974.

Zhu Cunli (1444–1513) [Zhao Qimei (1563–1624)], ed. *Tiewang shanhu* (Coral Treasures in an Iron Net). Postscript dated 1600.

Zhu Jincheng, ed. and ann. *Bai Juyi ji jianjiao*. 6 vols. Shanghai: Shanghai guji chubanshe, 1988.

Zhu Mouyin. *Huashi huiyao* (Outline History of Painting). Preface dated 1631.

Zong Dian. *Ke Jiusi shiliao* (Research Material on Ke Jiusi). Shanghai, 1963. Revised edition, Shanghai: Shanghai renmin meishu chubanshe, 1985.

Index

COMPILED BY ROBERT J. PALMER

173

ALONG THE RIVERBANK

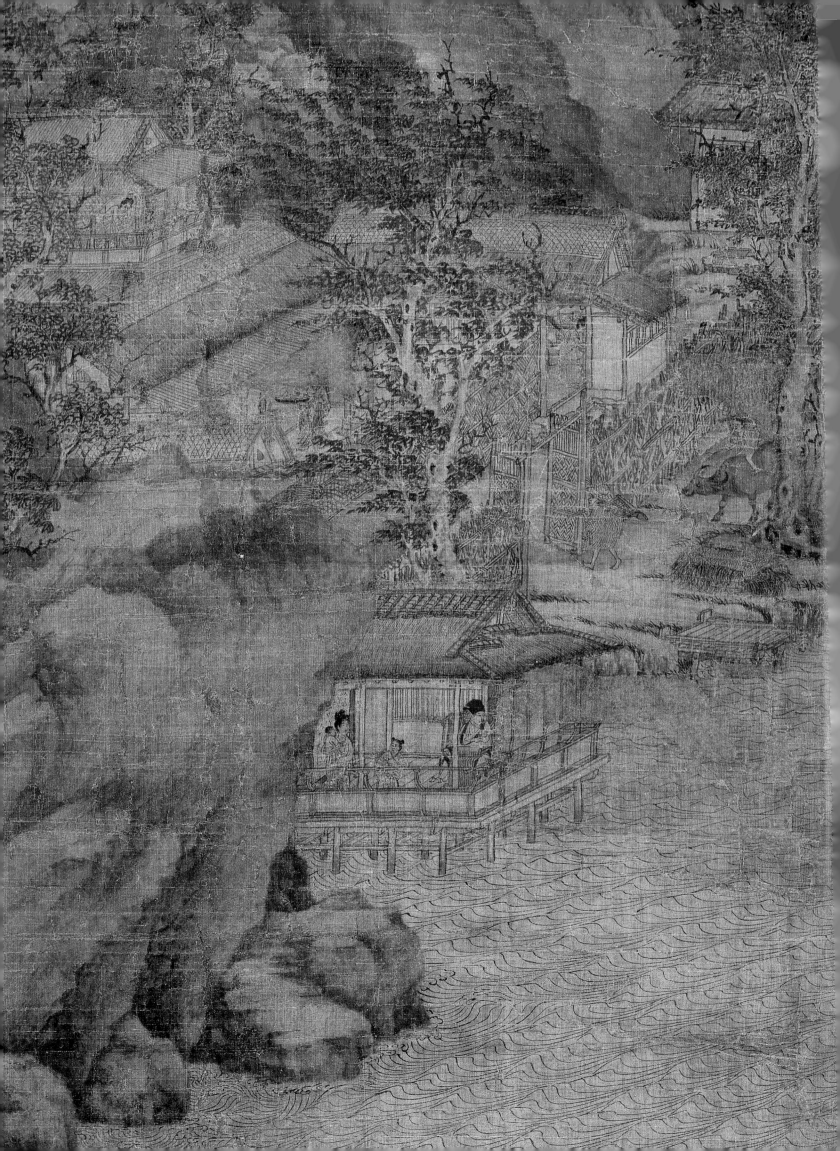